The
L. L. Bean®
Guide to
Outdoor
Photography

The
L.L.Bean®
Guide to
Outdoor
Photography

Lefty Kreh

Illustrated by Barbara Porteous Ferguson
Photography by the Author

RANDOM HOUSE • NEW YORK

Library of Congress Cataloging-in-Publication Data

Kreh, Lefty.
The L. L. Bean guide to outdoor photography.

Includes index.
1. Outdoor photography. I. L. L. Bean, Inc.
II. Title.
TR659.5.K74 1988 778.7'1 87-43225
ISBN 0-394-55035-8

Manufactured in the United States of America

24689753

First Edition

Dedicated to Angus Cameron

Without his counsel, advice, and encouragement,
I probably would never have finished this book.
He is one of the nicest friends
that ever happened to me.

Foreword

In the company archives here in Freeport, Maine, there are many photographs of our founder, Leon Leonwood Bean. It is unfortunate that most do not show "L. L." in the outdoors, and when they do, he is posed with a stringer of trout, or standing stiffly for a newspaper photograph. By all accounts, L. L. was an enthusiastic outdoorsman, yet he was rarely photographed in the outdoor places he enjoyed so much.

More recently, we have discovered the pleasure of outdoor photography. Through our association with Lefty Kreh, we have improved our personal photography immeasurably. Lefty is featured in our *L. L. Bean® Video Guide to Outdoor Photography* and has been a consultant to us for several years. Lefty is also one of our featured speakers at our free lecture series, offered locally through our retail store. In lectures and throughout the video, Lefty has shown us there is as much effort, planning, and concentration in taking a trophy deer with a camera as with a rifle or bow. Sighting a songbird through a viewfinder creates a permanent record for our enjoyment.

Outdoor trips create experiences that you will want to remember. The day your photos arrive after a trip can become a time of laughter and shared pleasure as memories are rekindled—memories of a day spent fishing, of reaching the summit, or of an osprey hovering, ready to dive for trout. Memories that might have been forgotten, except that someone took the time to create a photograph to share in the years to come.

Bernard "Lefty" Kreh is a professional photographer, columnist, and author. In his distinguished career spanning thirty years, Lefty has taught outdoor and nature photography. His photographs have illustrated several hundred magazine articles for periodicals. In addition, he is the author of *Fly Fishing in Salt Water* and *Fly Casting with Lefty Kreh.*

Lefty is a practical outdoor photographer. We have seen him improvise a tripod in the field out of a tree limb, rock, log, or stump; in fact, just about any object within reach. His advice is always aimed toward making your outdoor photos better in as simple and straight-

forward a manner as possible. From our own experience, we can say that if you follow Lefty's tips, your photographs will steadily improve.

We hope you find Lefty's advice useful and entertaining. From all of us at L. L. Bean, we wish you many hours of enjoyable photography in the outdoors.

Acknowledgments

I'm indebted to so many people who have helped me learn more about photography and its joys over the years. But there are several people to whom I'm especially indebted.

Irv Swope is my closest friend and the person whom I asked to read every word of my manuscript. His suggestions were most welcome and help make this a better book.

Walt Heun, a professional's professional photographer, who has been a friend and teacher for many years.

My wife, Evelyn, who has always supported my efforts in outdoor writing and photography. Without that confidence, I could never have stayed "in the business."

Tony Wimpfheimer, a superb editor whose advice has been invaluable—and who, moreover, has been a delight to work with.

Boyd Pfeiffer, whom I helped get started in outdoor photography, and who, over the years, has shown me many neat ideas and tricks.

Contents

Introduction

It often begins after you've witnessed a dark, savage storm slashing down on a hill, or watched a soft, silent, and brilliant sunset fade away almost like a colorful prayer, when you suddenly realize you'd like to relive or share this scene with others. Photography offers the opportunity to show others how interesting, exciting, and pleasant our outdoors can be. A double rainbow dipping into the canyon below is something that you will probably never see again. Yet a good picture of it allows you and others to continue enjoying that brief, beautiful moment.

In the beginning, you just want to "get a picture" and you aren't concerned about lighting, composition, the angle of the shot, and other factors. But as your interest in outdoor photography grows, you become aware of how others do it, and you want to improve. You begin to notice that taking pictures with the sun behind your back is, most of the time, the least interesting method of lighting the subject. The realization slowly comes that light, and how we use it, is what really makes a photograph outstanding. The exact moment you take the picture becomes critical, too; and you learn to wait for just that right time when the deer jumps over the log, the fish leaps, or the child lets go of the swimming pool rope.

If you're like most of us, during the next stage you get "equipment happy," reasoning that if you replaced your inexpensive camera with one that cost a great deal more, then you would be able to make better photographs. More expensive cameras will certainly allow you to do some things you can't do with less expensive ones, but you can't buy the ability to take good photographs. *Remember throughout your photography career that guns and cameras are very much alike—they shoot better than the people who own them.* Many experts have demonstrated how they can take beautiful pictures with very inexpensive cameras. This is not to suggest that you should use the very cheapest camera; a well-made and well-designed camera is your best working tool. Just don't waste your time and money, as I did, thinking that if I got more expensive equipment I'd take better photos. A medium-priced single-lens reflex camera will probably do a better job than you are capable of for years to come.

Working as photography consultant for L. L. Bean has been a very pleasant association—and a learning experience, too. I've realized that most of the customer/friends of L. L. Bean are also vitally interested in taking outdoor pictures of their companions, wildlife, wildflowers, and a host of other subjects. It is my hope that this book will increase the pleasure of those who enjoy the outdoors, and by taking better pictures, they will be able to share many of their experiences with friends.

The
L. L. Bean®
Guide to
Outdoor
Photography

THE CAMERA

The most popular type of camera for outdoor photography is the *single-lens reflex* (hereafter called the *SLR*). This is the type that most serious outdoorsmen own and use. For the purposes of this book, I will assume that most readers will be using it most of the time.

The Single-Lens Reflex (SLR)

The SLR is a marvelous piece of equipment that is tough and is available in many price ranges. The most important aspect of the SLR is that when you look through its viewfinder, what you see is what will be recorded on the film. When you change lenses, you immediately see what effects they create. Thus, for close-up work, long telephoto shots, and other situations where you want to create or control distortion of the subject, nothing will do the job as well as the SLR. When you look through

the viewfinder of an SLR, you are seeing the subject reflected from a mirror at the lens's widest f-stop, just as the lens sees it. When the shutter release is pushed, the lens closes to the preset f-stop, the mirror swings out of the way, and the shutter opens and closes, allowing the film to be exposed. Then the mirror drops back into place and the lens aperture returns to its widest f-stop. All of this happens in an instant.

There is a little "mirror slap" as the mirror swings up and down; this may create slight camera vibrations that can affect picture sharpness. So, for very long exposures, the mirrors on most SLRs can be manually locked up and out of the way before the film is exposed.

Advantages of the SLR

1. When you look through the viewfinder,

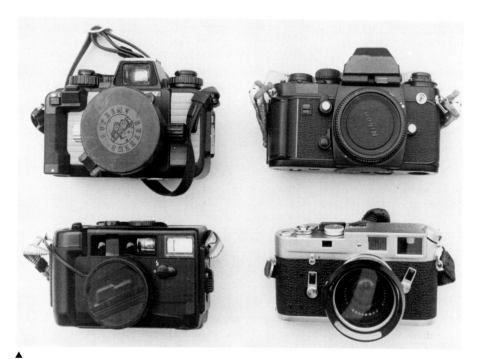

▲
Four popular types of outdoor cameras. Top row, left to right: underwater camera and SLR. Bottom row: point-and-shoot style with a fixed lens, and a rangefinder type.

At the top on the left is a single-lens reflex (SLR) camera. At the bottom is a rangefinder-style camera (many point-and-shoot cameras are of this type). The arrows indicate how the photographer views the subject: through the lens in the case of the SLR, and through the window on the upper right of the rangefinder camera body. If the lens cap is left in place no photograph will be taken. Obviously, this mistake is much easier to make with the rangefinder type of camera.

◀

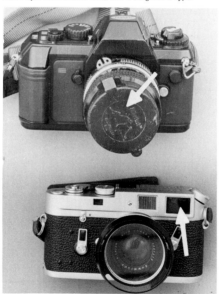

Single-lens reflex (SLR) camera body. The photographer looks through the rear viewfinder and at the subject through the lens.

▼

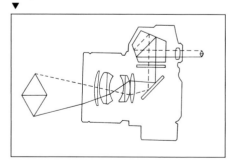

you see exactly what the lens is seeing, including depth-of-field, perspective, and filter effects.

2. With longer lenses, your camera's through-the-lens light meter becomes more of a spot meter (reading a smaller portion of the subject), giving you the ability to make more accurate readings.

3. A host of lenses exist for SLRs, ranging from ultra-short (8 mm) to longer than 1,000 mm.

4. The SLR allows you to use your light meter while you compose your picture. Various types of metering systems are offered (sometimes several options within the same camera body) such as center-weighted, multi-patterns, and spot—which will be explained later.

Viewfinders for the SLR

The viewfinder is extremely important to your ability to look through the camera and the particular lens that is mounted on it. Some manufacturers' viewfinders are brighter than those offered by others—and if you do not see well, you may want to consider looking at different models. Some cameras offer a variety of interchangeable *focusing screens*. These are etched glass focusing aids inside the camera body between you and the lens that allow you to see when the subject is in sharp focus. They vary from a plain matte, where everything is either in or out of focus, to split-image types. Making the right choice could be important to your needs.

The standard focusing screen that comes with most cameras is a good choice for the average person. With a 50-mm lens and the modern screens, you clearly see in good light what is in sharp focus to the human eye. But there are people with eye problems, as well as those who want to use their SLRs for special purposes, such as extreme close-up work. The standard focusing screen works best with lenses that range from about 35 to 90 mm. If you use longer lenses or ones with extremely wide angles, you may have focusing problems. If you want a different screen, write to the camera manufacturer; they frequently offer a variety of them. In some cases you can easily change the screen yourself, but most modern cameras will have to go to the manufacturer for a focusing screen change.

The standard screen usually has a split image in the middle circle, surrounded by a matte screen that produces a "fuzzy" image. When the subject is in sharp focus, the two halves in the split screen are aligned and the fuzzy screen is now sharp. But when you use a long telephoto, or have to "stop the lens down" for viewing or metering, half of the split screen will often go black, eliminating the possibility of focusing easily. At such times, you may be able to focus on the matte or microprism that surrounds the split-image circle. Also, split-image screens are difficult for most people to focus when the camera is held vertically. Most people will focus in the horizontal position, then turn the camera for the shot. Without being too technical, some lenses with large f-stops will focus better with certain screens. For more information on this, you can talk to the camera store personnel or write to the manufacturer.

A good option for general outdoor photography is a screen that has no split image in the middle. The screen has the same image throughout, and is a bit on the fuzzy side until the subject is in focus, then the entire screen becomes sharp. This type of screen is especially helpful when using telephoto lenses for wildlife work, since there is no blotting out of any portion of the screen.

There are a number of specialized viewfinders, many of them not of particular interest to most people who carry their cameras outdoors. But there are several viewing options. If you wear glasses, there

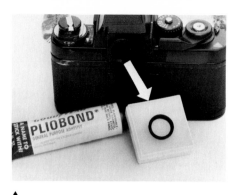

▲

Diopters loosen and sometimes fall from the viewfinder. A rubber-based or weak hobby glue helps keep them in place, but they can be removed easily if necessary.

A right-angle viewfinder. This can be attached to the viewfinder on an SLR, allowing the photographer to get a very low viewing angle.

▼

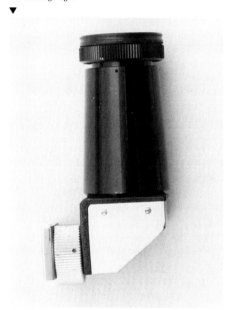

▶

Batteries should be changed at least once a year. Note the change date on the back of your camera as a reminder.

is an add-on item that could be helpful. This is a rubber eye cup that is easily fitted to the viewfinder. This is a good idea, since the eye cup fits against the glasses without scratching them. Without this item, some people who wear glasses find that when the light is bright from behind, they have difficulty composing through the viewfinder. People with poor vision can also have trouble seeing, and a magnifier may help. Even some people with good vision will use a magnifier for close-up work. This consists of a magnifying glass that is mounted on the rear of the viewfinder and that can either be permanent or hinged to swing out of the way.

Since the viewfinder is built for normal eyesight, people with vision problems may have trouble focusing. The piece of glass in the viewfinder in many cameras can be screwed out and replaced with another. This piece of glass is called a *diopter*. For years I never knew quite how to tell if you were using the correct diopter for your vision. It's very simple. Take your camera to a store and have them screw in various diopters. When you look through the right one—you'll know! If you are 40 years of age or older, a diopter check might be revealing. These diopters are inexpensive, and they can speed up focusing and often result in better photos. But remember, if someone else uses your camera and has normal vision, he or she may have trouble focusing through the diopter that fits you.

I always had trouble with the ring holding the diopter—it kept coming loose and getting lost. Finally I solved the problem by removing the ring, putting a tiny bit of rubber cement (such as Pliobond) on the threads, and screwing it back in place. I haven't lost a ring since. But don't epoxy one in—it would be too hard to remove.

If you are doing a lot of low-level work, a snap-on right-angle finder is also helpful. This allows you to place the camera very low, and the right-angle works quite similarly to a periscope. One of the best places to use this is when taking pictures of flowers close to the ground.

Some manufacturers offer other kinds of viewfinders, such as those used for quick-moving sports photography. If you have an interest in this, check with the local camera store or the camera maker.

SLRs depend on batteries for the light meter, and often for other functions. The light meter battery is usually held in a cavity designed for it in the base of the body. Manufacturers have wisely made the slot used to unscrew the retainer cap so that a coin fits it. For that reason, I carry a coin in my camera case or bag—always there when I need it. You must, of course, use the batteries designed for the camera. The wrong kind could damage it. Light meter batteries can last as long as two years, but it pays to renew them annually. Since these batteries may have numbers that are strange to you, I suggest that you place the verification number of the battery, and the date it should be changed, on the back of the camera with labeling tape. Some people use an engraving tool or a sharp needle to scratch on the battery cap the code name of the battery, too. The shelf life of these batteries is usually less than two years, so that buying extra batteries for spares isn't the best idea. However, if you're on a vacation or away from home for any length of time, it pays to take along spares, for the camera may not work, or at

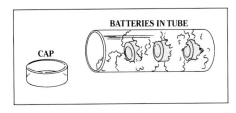

CAP · BATTERIES IN TUBE

▲

A coin tube is a good carrier of spare batteries. Keep them separated with layers of absorbent cotton.

best work at only one speed with no metering capabilities, if the battery fails. The best place I know of to carry extra batteries is in a nickel or dime coin tube (which can be purchased from a coin store). On rare occasions, if the contacts on two batteries come together, they can exhaust themselves or even become a heat source. Moisture can corrode battery contacts in a hurry, too. To prevent these things from happening, I insert a small ball of absorbent cotton in the tube, then a battery, then another ball of cotton, and so on, until all batteries are in the tube. The absorbent cotton keeps the batteries from corroding and sparking. You can also store a coin in the same tube, for removing the battery holder cap in the camera body. Incidentally, batteries can be stored in a freezer for years without losing their charge.

Several words of caution about batteries: If they leak, the acid can eat up part of your camera—leading to a stiff repair bill. I don't know why, but batteries tend to get a coating on them. This sometimes interferes with current flow. It's wise to remove batteries any time the cameras will not be used for a month or more. And I routinely remove the batteries, wipe them with a clean napkin, and reinstall them. Also, the battery receptacle should be cleaned routinely; it gets a film on it, too. Wipe the receptacle with a clean tissue and then, using a pencil eraser, scrub the contacts well. This will almost always eliminate any

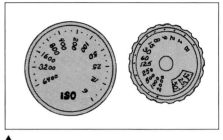

▲

On the left is a standard ISO dial, where you must place the setting that matches the film on your camera. On the right is a shutter speed adjustment dial, showing the ISO in a small window.

▲

Battery contacts should be routinely cleaned of corrosion. A pencil eraser is an excellent tool for this operation.

problems. In fact, follow this procedure with all battery contacts used in photography, including flash, motor drive, and light meters.

Another battery problem that often baffles people is that the batteries sometimes suddenly die before they should. What often occurs is that the camera is put away in its box or bag, and something in the container pushes down on the metering switch. This causes a constant drain on the battery. Some cameras have a meter-lock switch that can be used to prevent this. If yours doesn't, be sure that the metering switch can't be inadvertently pushed on while the camera is in the box or bag.

Using the Camera

The best advice you can get when buying a camera is to read the instruction booklet thoroughly before you do anything. I use a red and yellow marking pen and circle or underline the features that I feel are most important. After placing the proper batteries in the camera, be sure to adjust the light meter's ISO dial to the correct setting. Many people who use color print film like their negatives just a bit on the overexposed side, so instead of setting the cam-

eras on the correct film speed, for example, when using ISO 100, they will set it one notch (not f-stop, but notch on the meter) lower on the dial, i.e., 80. The reverse is true for many slide shooters. If they have an averaging meter and they feel they are getting slides that are a bit on the overexposed side, they will adjust the ISO setting one notch higher (for example, with ISO 64 film they will adjust the setting to ISO 80). What is best at first is to shoot several rolls on the manufacturer's recommended setting, but be aware that you can make adjustments to decide what setting pleases you. Almost all modern SLRs have an exposure-compensating option on the same dial with the ISO setting. It allows you to adjust the ISO, usually by one-third of a stop, for overexposure or underexposure. For example, if you're using the camera on automatic setting and you would like to "bracket"—to ensure that you get a good picture—you can adjust the compensating dial to one-third of a stop overexposure and one-third of a stop underexposure. This means you have made three shots, one at the desired exposure, one at one-third over, and one at one-third under. *But I urge you to take the first and second shots on under- and overexposure and the last shot on a zero setting or normal exposure.* If you don't, you'll often forget that you have the compensating dial at other

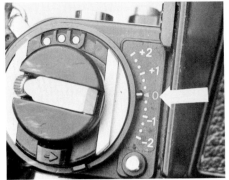
▲

This is a typical overexposure or underexposure adjustment for your camera meter. It's very important in using this device when bracketing to make your last exposure by placing the indicator on zero, so that future pictures won't be under- or overexposed.

than a normal exposure, and spoil a number of pictures before you discover it.

Loading SLRs can be accomplished very quickly, if you do it the reverse of the conventional method. Newspaper photographers had better not miss that important picture and then try telling their editor that they were changing film at the moment. Their editors will never understand. So, they have developed a method of film changing that is much faster. Open the back of the camera body. Insert the film tab end into the slots on the take-up spool *and then lay the spool of film on the open back.* Click the shutter and wind the advance lever one frame—you can see if the

Although this may seem backward, it's twice as fast as loading the camera with film in the conventional manner. The technique is explained in the text.

▼

film is being properly transported on the take-up spool. If it is, lift the cassette holding the film and drop it in the cavity on the other side and close the back. Then shoot one shot and advance the film one frame. Now turn the rewind crank until the film is tight. You may need to shoot one or two more before the camera is ready. This can be done rapidly. *But watch the rewind crank. If it's not turning as you advance the lever, the film is not being transported and you will have to open the back and check.* This method, with a little practice, is at least twice as fast as the standard method of loading film.

Many modern cameras have made it easy to avoid this problem through automatic loading. Just place the cassette of film in the body with the leader or end of the film in the correct position, close the camera back and push the shutter release button, and the camera automatically winds the film to the first frame of film. A common error in film loading is to hold the camera open so that it's exposed to direct sunlight and then load the film. When pictures are processed, some have a bright yellowish streak on them, caused by light seeping inside the film cassette. Always try to load the film in the shade—or use your body to shield the opened camera from direct sunlight.

Holding the Camera

Most photos are taken while hand-holding the camera, although serious outdoor photographers will always use a tripod when they can. More about that later. The cam-

SPEED LOADING FILM

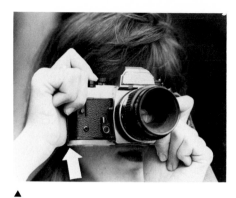

▲

A common mistake when holding the camera is demonstrated here. The arrow indicates that the camera is being held on the side. When the shutter release is pushed, there is a tendency to shove the camera downward, thus causing a fuzzy picture.

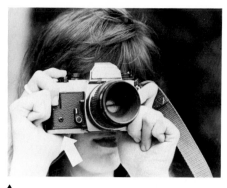

▲

Correctly held, the camera rests solidly against the palm.

This has to be about the most unstable method of holding a camera when making a vertical photo.

▼

By placing the elbows firmly against the sides (A and B) and bracing the camera firmly against the forehead (C), while using the thumb (D) to press the shutter release, with the other fingers (E) steadying the camera, you can take pictures that are surprisingly sharp at slow shutter speeds.

▼

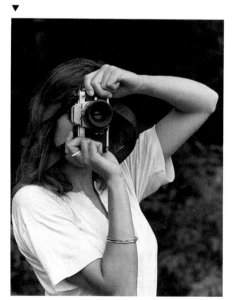

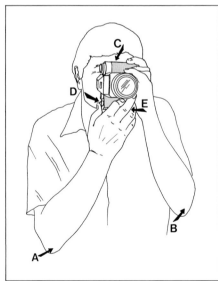

era should be rock-steady when it's fired. Any motion, especially with telephoto lenses, will result in fuzzy pictures—something no one wants to look at. Therefore, it's important that you hold the camera as steady as possible. Study the accompanying drawings and captions, for they are important to good camera work.

Shutter Speed Ring

The shutter speed ring is set by the photographer to predetermine how long the light will be allowed to flow through the shutter opening to the film. Speeds usually start on camera shutters at one second (some are much longer) and then each setting following it reduces the shutter speed opening by half, i.e., one-half second, then one-fourth, one-eighth, and so on. The shutter speed represents one half of the control you have over the exposure of a picture. The other half is the lens opening, or aperture, which will be discussed in the chapter on lenses.

Motor Drives

Motor drives have become very popular with many photographers, although they are heavy, and when they must be carried, such as in backpacking, some people will leave them at home. The best SLRs can be married to a motor drive—and some photographers never remove them. Some camera models come with the motor drive built into the body. As soon as a frame is exposed, the motor drive advances the film, cocks the shutter, and has the camera ready for the next shot. Motor drives can be set to fire single shots or a continuous high-speed sequence as long as the shutter release is held down, or until you run out of film. Most motor drives will take four to six frames a second. However, at the fastest modes, most cameras have to be set at particular speed settings to allow proper shutter operations. The camera manual will tell you exactly what you can do with your model. Some cameras also work better at higher frames per second if the mirror is locked up—but remember, that means you won't be able to view the subject.

The first thing the photographer learns is that the main beneficiaries of motor drives are film and battery manufacturers. After enough money has been shelled out, most photographers learn to control themselves and their motor drives. Motor drive operators eventually learn to plan their shots better, and don't try to shoot a lot of pictures, hoping they'll get that special one. It's obvious that motor drives work for action pictures when you are trying to get either a sequence of shots or that very special one. However, you'll find that at four frames a second, that very special photo will often be missing. If, for example, you want to get a leaping fish, it might be best to shoot a single photo, concentrating on the peak action shot. Motor drives are excellent for getting portrait shots. Quick facial changes can be recorded instantly and not missed because you had to cock the shutter.

Motor drives are extremely useful in an area where many photographers might not consider using them. When you are taking extreme close-up shots, such as of small flowers and insects, a tiny shift of the camera can occur every time you fire it and manually wind the film for the next shot, causing the subject to be out of focus. Thus, we check the focus after each shot. But with a motor drive you can just shoot and bracket, or simply shoot another—for you know the camera body didn't move.

Many people are disappointed when they fire a motor drive at a moving subject while the camera is in the automatic exposure mode. The first few shots may be perfectly exposed, and the rest badly over- or underexposed. What happens with most

cameras is that, in the automatic exposure mode, you push the motor drive *and it locks in at that exposure.* If, for example, you began shooting with the sun at your back and the subject moved to your left, the light on the subject has changed—it is now sidelit—but because the camera's meter was locked, you're getting poorly exposed shots.

Motor drives can be helpful when you are using a remote tripping device. In such a situation, the camera is mounted some distance from you (for example, near a nesting bird), and with a special device you can fire the camera. The motor drive will wind and ready the camera for another shot.

Motor drives, as mentioned above, have the disadvantage of being heavy; when coupled to a camera, they nearly double the camera's weight. Also, almost all motor drives are black in color—and so are the battery switches. It's easy to turn on a switch and not realize it. I suggest that you use a little bright paint or nail polish to touch up the on/off switch, so that you can clearly see its position.

Auto-winders are another option. They are like motor drives, except that they work much more slowly and require the photographer to depress the shutter release each time to activate the auto-winder. A skilled operator can get two and sometimes three frames a second. The auto-winder is not as fast and can't shoot sequences as well as a motor drive, but they are usually much less expensive. They generally require fewer batteries to operate, too.

Several manufacturers of motor drives offer special bulk-film packs that hold enough film to shoot 100 to 250 exposures. These special-purpose units are generally larger than the camera, but for some specific outdoor photography they are very useful.

Autofocus

Many SLRs offer bodies capable of automatically focusing on the subject. People with poor eyesight can often benefit greatly from this feature. In some action photography autofocus can also be very helpful indeed. Many people, even with superior eyesight, will encounter difficulty in properly focusing the lens when using extreme wide-angle lenses. Again, the ability of the camera body to focus on the subject can be a great asset; the ability to be able to focus swiftly when taking close-up shots of insects and similar subjects can mean the difference between getting a great shot and missing it entirely—autofocus helps here, too.

Autofocus also helps when you are photographing swift-moving subjects, such as a soaring bird or a deer leaping over a log. If you suddenly see a friend doing something you'd like to capture on film, you can swiftly raise the camera, compose the picture (not worrying about focusing), and capture a scene that would otherwise escape you.

Autofocus is not for everyone and there are disadvantages. Special lenses must be purchased that work with the camera bodies—and these cost more money than conventional lenses without the autofocus attachment. In many cases autofocus lenses are heavier, too. And the lenses are focused automatically, which means you are using battery power to drive the lenses. That means less power you can use for picture taking.

The manufacturers continue to improve the performance of autofocus cameras. The early models focused on one point (usually in the center of the viewing area) and if that was not the point you wanted in focus, you often got an out-of-focus picture. Many models now have a multi-focus pattern—not just one sensor in the center of the lens. Still, the camera is only a mechanical

device and it doesn't know where your subject is positioned in the picture. If the subject is well to the right or left, pure autofocus may result in the camera focusing on the background. This means the subject may not be sharp. There is a device on almost all autofocus cameras that allows you to move the camera so that the center of the lens points at the subject, press or hold down some adjustment lever or knob, locking in the focus on the subject, then move the camera back, compose, and take the picture. Another problem with many autofocus cameras is that they have difficulty bringing the subject into sharp focus if there is extremely low contrast (such as in fog) between the subject and the background. Sparkling water (backlit) in the background can also create problems for some autofocus cameras.

Most professional photographers who have used autofocus cameras still prefer manual focus. And few people really have had trouble with focusing. But others find them to be highly satisfactory. It's like so many things in photography—a matter of personal choice.

Point-and-Shoot Cameras

For the person who wants to get a picture and is not too concerned about the technicalities of shooting photographs, the point-and-shoot cameras are often worthwhile. These are the rangefinder type, where you don't look through the lens but through a viewing port on one side of the camera body. These kinds of cameras are constantly being improved. They usually have a fixed lens, but some come with either a fixed focus or a zoom lens. Others offer the choice of a wide-angle lens plus another one—usually a short telephoto. A few bodies even offer a macro capability, so that extra-close photos can be taken. Almost all come with a built-in flash, and many have an auto-winder. The advantage to this is

quick winding of the film. The disadvantage is that automatic winding uses up battery power that could be saved for picture taking.

Other options are that point-and-shoot cameras have DX coding, although some will handle only a limited range of films and you should check this before buying a model. Almost all have automatic film loading; just insert the film cassette in one side and place the film at a registered position on the other and close the back of the camera. Then push the shutter release and the film is automatically advanced to the first frame.

Automatic exposure is usually taken care of for both available light and flash, so that no meter readings have to be made—just point and shoot. Many of the manufacturers, recognizing that these cameras are being used outdoors under adverse conditions, have waterproofed the cases so that they can be immersed to shallow depths in the water—and of course, rain or salt spray won't get inside the body.

Point-and-shoot cameras come with three different kinds of focusing devices. One is a fixed focus, and may require that the photographer make some adjustments. The second type is manual focus, in which the operator must estimate the distance and adjust the camera accordingly. And the third type is autofocus, in which the camera automatically adjusts the focus. These are usually the most expensive of the point-and-shoot types of cameras.

Another advantage of many of these kinds of cameras, and one that endears itself to those who must backpack or carry a camera a long distance, is that they are generally lighter and smaller than regular SLR bodies.

Most models now have a viewing port in the rear of the camera, which allows you to see if the camera is loaded—and what kind of film is being used. Some models have a battery check, others do not; it is a good

feature to have, since this type of camera is totally dependent upon battery power.

Underwater Cameras

Outdoor photography includes underwater pictures. While I have no intention of getting into the subject of deep diving with scuba gear to take photos underwater, being able to shoot photos even a few feet under the surface can enhance your outdoor photography. There are several relatively inexpensive point-and-shoot cameras on the market that can be used down to several feet beneath the surface, but are designed for normal, nonaquatic use. These are especially useful to people who expose their cameras to the hazards of water, such as those who canoe, enjoy white-water paddling, or wade and fish. Most of the inexpensive ones have a permanently mounted lens, which eliminates the possibility of taking pictures with a variety of lenses. If you engage in a lot of outdoor activities in which protecting the camera from water is a real concern, you may want to consider one of these.

Although I hesitate to name brand names of cameras, there is one camera specifically made for underwater work that stands above all others for its practical underwater characteristics: the Nikon Nikonos. This camera is manufactured with an optional automatic or manual exposure setting and can be used above or below the surface. Several different lenses can be mounted on it, and for years it has been the most popular camera for underwater work. For the very dedicated person, however, greater flexibility is available through special underwater housings that are designed for use with conventional cameras.

One important factor must be considered when selecting lenses for the Nikonos. Some lenses for this camera are "air-corrected" and some are "water-corrected." Those that are air-corrected can be used both above and below the water, but those that are designed for use only underwater will deliver poor results when used above the surface.

Shutter Releases

There are several methods for releasing the shutter to take a picture other than pushing down on the button with your finger. When longer exposures are needed, it's best to use a *cable release* to trip the shutter. This is a flexible cord or cable that has a metal plunger on one end that is screwed into the shutter release button. The other end has a knob that, when pushed, trips the shutter. The best cables have a lock, so that when you push in the plunger you can lock it. Unlocking it allows the plunger to withdraw. This allows you to make long exposures—keeping the shutter open as long as you want. Whether a camera shutter dial is set on time (T) or bulb (B), as long as the shutter release button is depressed, the film is being exposed; when the button is released, the shutter closes. Many night shots are made this way. The major advantage of a cable release is that it doesn't cause any camera movement during long exposures. Cable releases come in many lengths; twelve to eighteen inches are standard, and I find that those longer than six feet often don't function well. I use a five-footer to great advantage. I tape the cable release to a five-foot pole that has a swivel ball head mounted at one end, to which I attach the camera. One way I use it is by cocking the shutter, then holding the camera outside the boat or above the crowd with a wide-angle lens in place. Using the cable release, I can shoot pictures looking back into the boat or over people's heads to get a totally different angle.

Another form of cable release is a unit with a long rubber hose, often twenty to thirty feet in length, which has a plunger

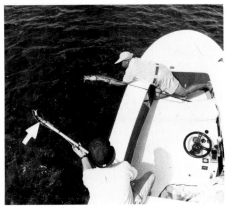

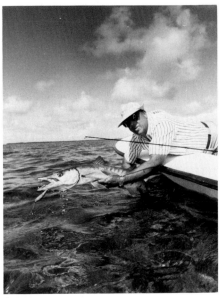

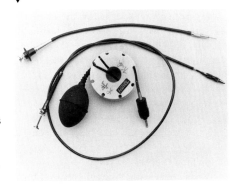

▲
The author is taking a picture of outdoor writer Mark Sosin holding a barracuda. With a monopod and a long cable release, the camera can be prefocused and held overboard to get an unusual angle.

on one end and a rubber bulb on the other. When the bulb is squeezed, the plunger is depressed and the camera is fired. This is especially useful when the camera is mounted near the subject, but the photographer must remain a short distance away, as in a number of wildlife situations. However, the distance you can fire a camera with this unit is limited to the maximum twenty to thirty feet of hose length.

There are other ways of tripping the shutter that give the photographer more flexibility. Many manufacturers supply a cable that you hold at one end; the other is attached to the camera or the motor drive. You can trigger an electrical impulse that fires the camera on your command. This is infinitely better than the cable-release and rubber-hose units. But these electrical units rarely work well beyond 100 feet, and you do have a cable dragging around between you and the camera that impedes your movements.

Infrared systems are also available, which allow you to fire the camera from great distances by simply aiming the trig-

▲
Result of holding the camera at the end of a monopod.

Three shutter releases: short and long cable releases and, in the center, an air-operated type with a thirty-foot extension tube.
▼

gering device at the camera. There are some minor complications to this unit, but with a little investigative work this is a terrific tool for many serious wildlife photographers.

You can also use a radio-controlled unit to trip the camera; this is the most flexible

method of all. Again, you will need to investigate its potential and drawbacks. But where extreme mobility is needed, or where you must fire the camera at relatively long ranges, these radio units are superb.

An automatic shutter trip is often used for animal photography at night, and has been successfully used for a long time in photographing flying birds. An infrared transmitter and receiver are set up, so that when anything breaks the beam between them, the camera shutter is fired. This is a rather complex unit; anyone seriously considering this should talk to someone who is an expert at this technique.

Self-Timer

There is a self-timer on almost all SLR cameras. Here's how it works. The timer lever is cocked, and then the shutter release is tripped. Up to about nine seconds later, the camera shutter is fired. The self-timer is a simple delay switch, used for two major purposes. The most common is in photographing a group of people. The photographer mounts the camera on a tripod, pushes down the self-timer lever, and runs to be included in the shot when the film is exposed. It can also be used to advantage when you either don't have or don't want to use a cable release, and you are making long exposures. By mounting the camera on a tripod and using the self-timer, the camera has time to settle down before the shutter is tripped, and sharper pictures often result.

A very inexpensive little gadget that I use every now and then is a self-timer that can be bought in camera stores. Most of them will give you an extra 15-second to one-minute delay from the time the shutter release is pushed. It is a small metal unit that is screwed into the shutter-release button. A small timer, with a lock, is dialed to the desired number of seconds delay,

▲

A self-timer allows you to extend the period between the time the shutter is released and when the picture is exposed. These are inexpensive tools. The unit shown can be combined with a camera's built-in timer to increase shutter delay.

and, when ready to take the picture, you simply release the lock. After the proper delay, the unit's plunger fires the camera. You can combine the unit with the built-in nine-second self-timer on the camera to obtain an even longer delay. Once in Yellowstone Park, I needed a person in a scenic picture on the Firehole River, and no one was around. I set the camera up on a tripod, wound the self-timer unit to 60 seconds, depressed the camera's self-timer, pushed the lock release, and ran to the river bank. I had 69 seconds, which was plenty of time to include myself in the picture.

Double or Multiple Exposures

There are times when you may want to double-expose a photograph, or even expose it more than twice. Most of the more expensive SLRs have a double-exposure device. You take the first picture, then you activate the device, which allows you to recock the shutter without moving the film, and the camera is ready for another shot. *It's a good idea to wind the film tight before the first shot, and hold the rewind crank handle during both shots.* This prevents the film from moving during the two exposures.

▲

Many leather straps wear through from hard use. Large guitar-style straps are comfortable, but take up a lot of room in a camera bag or box. The author removes the core from parachute cord and then sews it inside a nylon web strap, available in most marine stores. This makes a very strong connection that doesn't take up much room in a bag or box.

▶

If you carry two cameras, make one strap shorter than the other to prevent the camera bodies from banging together.

▲

Never set a camera down in this position. A magnifying glass can be used to start a fire—and the sun coming through the lens can quickly burn a hole in your camera shutter.

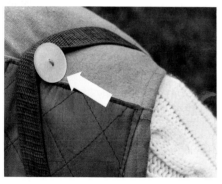

▲

One method of preventing a camera from slipping off the shoulder while hiking or walking is to sew on a large button as shown here.

▶

A better method, the author believes, is to sew on a wide section of Velcro strap, with the closure in position as shown. The author has never had a camera come loose in the field using this method.

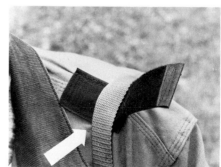

CHAPTER 2

LENSES

Nothing, not even the film or the camera body, has the ability to so dramatically affect your picture as the lenses you use. It is here, more than in any other area of photography, where creativity comes into play. Composition and exposure are vital keys to creating the impressions you want the viewer to receive, but it is the lenses you choose for various shots that have such a profound effect. Lenses are identified by their focal length (given in millimeters) and their maximum f-stop (widest opening or aperture), e.g., 200 mm f/4.

The differences between a wide-angle, a telephoto, and a normal lens for the same subject can be startling and often immensely pleasing or disastrous. A particular lens will allow you to photograph something inches or miles away; to increase the subject beyond its normal size so that the viewer gets an entirely different and more interesting look; to bring things

close from a long distance; to eliminate distracting subjects in the foreground or background; and in many other ways to "create" the photograph your mind's eye sees. The image size is determined by the focal length of the lens. The longer the lens, the larger the image, and the greater the distance between you and the subject. The ability to back away from your subject is often very helpful, especially in close-up work or when taking pictures of wildlife.

As mentioned above, lenses are categorized according to focal length; the lower the number assigned the lens, the wider the angle of view; thus a 21-mm lens will enable the photographer to show more of the subject than will a 35-mm lens. A telephoto will have a much higher number, such as 200 mm or 400 mm. Generally, wide-angle lenses are those grouped in a class with lengths running from 20 mm to about 40 mm. A normal lens (which gives a

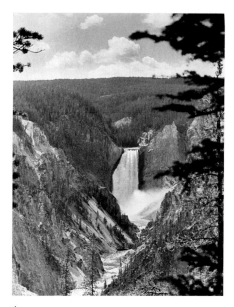
▲
Yellowstone Falls, taken with a 200-mm lens.

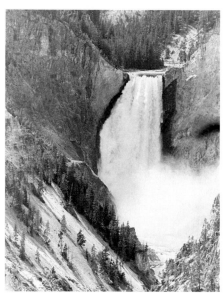
▲
The same falls taken with a 400-mm lens to show how a lens can affect a photo.

picture quite similar to what a person "normally" sees), is considered to be about 50 mm. Lenses longer than 90 mm are generally regarded as telephotos.

LENS FOCAL LENGTH	ANGLE OF VIEW (in degrees)
21 mm	90
24 mm	84
28 mm	75
35 mm	63
50 mm	45
90 mm	27
105 mm	23
135 mm	18
200 mm	12
300 mm	8
400 mm	6
500 mm	5
600 mm	4

Having available a number of lenses of different focal lengths allows you to take a variety of pictures, and in some cases to take photos that you couldn't if you didn't have a lens of the correct focal length. Therefore, your choice of lenses is dependent upon just what you want to do with them. If you are interested in flower photography, you obviously want to show detail, and since many flowers are tiny, you will need a lens than can move in close to magnify the subjects and show people how lovely they are. Conversely, if you are photographing dangerous animals, such as on a safari, or you have located a fox's den or a bird's nest and want to photograph the parents feeding the young, you will have to be well away from the site. This will require a long telephoto lens.

Weight is another factor to consider. Lenses with larger maximum f-stops allow more light into the camera so that you can see better to focus. But an increase in f-stop opening means an increase in weight. The difference between an f/4.5 400-mm telephoto and one with an f-stop of 2.8

could mean that the f/2.8 lens might weigh more than twice as much. If you have to lug this equipment long distances, you may choose the slower, lighter lenses, even though you'll sacrifice some focusing ability to correct exposure in lower light levels.

Another obvious consideration is price. Generally, the larger the maximum opening or f-stop, the more expensive the lens. And some telephoto lenses have special focusing devices, which can be handy, but you'll have to pay for them.

Much has been written about lens sharpness. Most modern lenses are sharp. Even moderately priced lenses are superior in sharpness to many fairly expensive ones manufactured in the recent past. The more expensive lenses of the top camera manufacturers can be depended upon to deliver better work than most of their owners. There are also a number of well-known manufacturers whose less expensive lenses deliver excellent results as well. Lenses are normally graded for sharpness by examining the center and edges of extremely enlarged photos. However, the human eye cannot usually recognize the difference between two normal-sized photos taken by two different lenses whose sharpnesses are technically graded at different levels.

A lens shade can reduce flare in your picture. It is a major method of improving the color saturation of your pictures. On the left is a collapsible rubber shade, and on the right is a metal one; both work well.

▼

It's important to understand that no lens is perfect. A number of factors affect lens quality, and there are compromises to obtain the best possible performance. For example, there are some lenses designed to give an overall soft focus. These are portrait lenses. A *macro lens* is designed for flat-field work at very close distances, in which the photographer wants the image razor-sharp. And so on.

I believe that too much has been made of lens sharpness and not enough of how well the lens handles *flare*. Flare occurs when light strikes the lens as it is pointed in the direction of the sun or another strong light source. As I hope you will see in the chapter on exposure, I believe the major difference between the photographer who takes well-exposed photos and truly outstanding ones is the increased use of light coming from the side or toward the camera. In general, the more this is used, the more outstanding will be the photos. When you shoot into the light, the contrast of the picture is lowered. You can often see in the camera viewfinder what flare is doing to spoil your picture. Look into the camera as you face the sun, and notice the bright glare, reduced contrast, and often increased haziness of portions of the photo. Then turn your back to the sun and see how the color contrast improves and how the haziness has disappeared. There is more flare when you photograph brightly lit scenes and where there is high contrast between the light and dark portions of the photo. This is also why you should always use lens shades or at least try not to let the sun strike the front glass head-on.

Quality lens manufacturers employ several methods to reduce the flare problem—all of which increase the price of a lens. Special glass is used, which reduces the amount of flare; the interior barrel of the lens is coated with a black substance to further reduce reflections; and each

manufacturer applies a special coating to the lens. That coating is subject to damage, and it's why extra precautions should be taken when cleaning the lens surface to prevent scratching. Since fingertips contain acid, you should never touch the lens with them.

One of the major causes of flare is a coating of dirt, film (such as wind-driven salt spray at the beach), or dust on the lens. Make it a rule to keep your lenses very clean. And whenever you are shooting directly into the sun or bright light source, be especially aware of this problem. Sunset shots, for example, are much improved if *all* dirt is removed from the lens prior to the shot.

It boils down to a number of personal considerations that ultimately determine which lenses you will choose for your work. But an understanding of the positive and negative features of various lenses will help you make a selection and end up with better pictures.

There are a few fundamentals that should be understood. A wide-angle lens "sees" more, but most things in the picture will be much smaller than they appear to the unaided eye when the photo is taken. Another important consideration with wide-angle lenses is that what is close to the lens looks larger, and things farther away proportionally smaller, than normal. Wide-angle lenses have a greater depth of field, with much more appearing to be in sharp focus. For example, you could photograph a person sitting on a bench with a playground behind him or her with a wide-angle lens and show the person dominating the scene. The playground would be completely in focus. Because a telephoto lens has a narrower depth of field and you took the picture of a person sitting on the bench, much less of the scene would be in focus in front and back of the subject. Telephotos tend to make subjects appear more normal than do wide angle lenses.

Wide-Angle Lenses

The ability of the wide-angle lens to make things close to the lens look larger than life can often be utilized to advantage. Study advertisements in magazines and you'll quickly see that what is important to the advertiser (i.e., the merchandise being sold) will be up front, and what's up front is immediately noticed. When you want to emphasize the subject, often you can get close with a wide-angle lens, and it will appear larger than normal.

But you have to be careful. The wide-angle lens tends to distort objects. It is often a bad lens for portraits. When you move the lens near the person, those features that are closer to the lens will appear abnormally large (nose, chin, eyes) and those features a little farther away (ears or top of the head) will appear abnormally small. The photo will show a person with enlarged eyes, nose, and chin, and a pin head. Of course, if you don't like the person, you may want to take his picture with a wide-angle lens (only kidding).

A common mistake made by photographers is to buy a long telephoto lens as a second choice after a normal lens. If there is a very special reason for that, it's okay— but most of the time a wide-angle lens is a better second lens. The average outdoor photographer is going to take many pictures of people as well as photos at home, in the boat, at the hunting camp, or along the trail. Far fewer shots will be taken of wildlife at a distance. Thus, the wide-angle lens will be used by the average photographer to take more of his pictures.

The question is, then, which focal length? A wide-angle lens of 28 to 35 mm gives you an almost "normal" lens photo if used with care, but allows you to utilize the attributes of these special lenses. The wider the angle of the lens, the more it will exhibit the characteristics discussed, and because of the increased possibility for

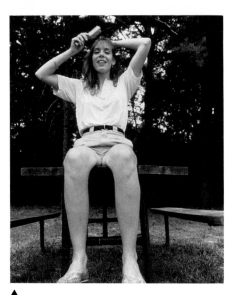

▲
A wide-angle lens tends to distort subjects—especially if a portion of the subject is closer to the camera, as is the case here with model Lauren Green's legs. This picture was taken with a 24-mm lens.

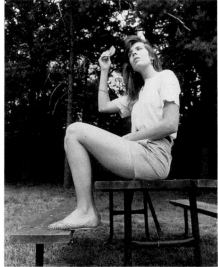

▲
Placing Lauren's legs in the same plane as the rest of her body makes her legs appear normal.

A vital point to remember when using wide-angle lenses, if you want to reduce distortion, is to keep the lens at the midpoint of, and parallel to, the subject. This is a picture of Lauren Green taken with a 24-mm lens at the midpoint of her body. Little distortion results.
▼

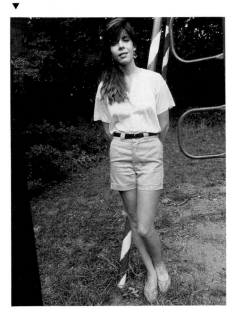

distortion, more care has to be taken with shots. There is a trick when shooting with wide-angle lenses that will generally give you the desired effects of such lenses, but not show distortion of perspective.

Let's first examine the problem. If you shoot a picture of something tall, such as a person or a building, from a low angle, this will make the lower part of the person or building larger and the upper part smaller. If you shoot from a higher angle, the results are the opposite. But you can photograph many things (including people) so that they look rather normal with lenses as wide as 24 mm. There are two rules you must follow to do this. First, *the lens must be near the midpoint of the subject.* Thus, if you were taking a picture of a six-foot person, the camera and lens should be three feet from the ground. Second, *the lens must be on the same parallel plane as the subject.* (This may be even more important than the first rule.) If you tilt the bottom of the

lens forward, the legs and feet will be enlarged, and if the upper portion of the lens is tilted toward the person, the head and upper torso will be larger.

Wide-angle lenses are terrific when shooting in confined areas, such as a room, a tent, or a boat—but try to use the above guidelines to make things appear normal. They are often superb when you want to photograph a scene and give the impression of vastness, such as a huge valley or a large expanse of water.

To summarize, with wide-angle lenses it is best to include something in the foreground. Foreground detail helps lead the eye to the other features and gives an increased emphasis on the vastness of the scene. Subjects such as trees or buildings, unless you can get to a midpoint, which is often impossible, are generally distorted when photographed with wide-angle lenses.

Normal and Macro Lenses

Normal lenses are those of 50 to 60 mm in length and have fallen from favor with most photographers, who seem to prefer zoom lenses. But I still like this length for many subjects, since it does deliver what a person would regard as a "natural" photo. Almost every working outdoor writer and active outdoor photographer I know, however, doesn't own a "normal" lens. Instead, they have purchased *macro lenses* of 50 to 60 mm, which serve as their normal lenses, and also for close-up work. Such a macro lens allows you to take all your normal photographs and then come in close and show things half as large as life-size on the film. You could, for example, take a picture of a person standing on a cliff and show the valley below, then move in very close and photograph a tiny flower the size of a penny at the person's feet, so that

Here the 24-mm lens has been held above Lauren; because her upper body is closer to the lens, it becomes larger and distorted.

▼

The same 24-mm lens, shooting from a low angle, makes Lauren's legs look much larger.

▼

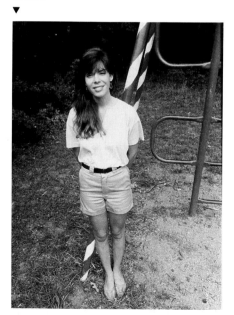

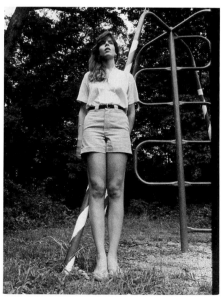

when you got your slides or negatives developed, the image on the film of the flower would be half-life-size.

One of the nicest features of 50-to-60-mm macro lenses is that they are usually among the less expensive lenses. If I had to own only one lens for my outdoor work, it would be this macro. There are other macro lenses having focal lengths of from 100 to 200 mm, which are special-purpose lenses. They do have the outstanding virtue of enabling the photographer to work farther away from the subject. For instance, this is especially helpful when taking insect shots, where getting too close often scares the subject. Longer macro lenses also give you more mobility in placing artificial lights (electronic flashes or floods). When using a 50-to-60-mm macro, you must get within inches of the subject, and that will often cause a shadow on the subject if you're not careful. Longer macro lenses allow plenty of clearance. With a true macro lens, you must move toward the subject and refocus when enlarging the image. It is not like a zoom lens, which allows you to push or turn the lens barrel to enlarge the subject, which stays in focus as it is enlarged.

Telephoto Lenses

Telephoto lenses are lenses of 90 mm or longer. The 90-mm lens isn't used much anymore, having given way to 105- and 135-mm lenses. The 105 is considered the absolute best lens for taking pictures of people, followed closely by the 135. Such lenses allow you to stay well away from a person, so that he or she doesn't feel intimidated and acts more natural. Such lenses are light, very sharp, and fairly inexpensive.

The 200-mm lens is really not very useful in wildlife photography. It's fairly heavy, expensive, and not long enough to get a sufficiently large image for most wild-

life situations. The 300-mm lens is well received by some wildlife photographers, but most experienced wildlife photographers feel that you have to get too close to the subject to obtain a large enough image.

The 400-mm lens is considered by most active wildlife photographers to be the best all-around choice. It is the workhorse for most. Lenses of 500 and 600 mm are also used frequently, but as lenses get longer they present unique advantages and problems.

Very long telephotos do several things for the photographer. Of course they make the image size larger; the longer the lens, the larger the final image. You have the ability to obtain a larger image while shooting at a greater distance from the subject. But they deliver results just the opposite of those obtained by the wide-angle; they have a shallow depth of field, and the longer the lens, the less of the photo is in focus. Thus your subject is more difficult to get in focus, especially if it is moving toward or away from you. Another concern is that they magnify not only the image, but also any movement on the part of the camera or the photographer. When using a telephoto lens, it's extremely important to stabilize the lens—and small, tabletop tripods are usually not enough; a firm support is required. More on that in another chapter.

With a longer telephoto lens, you need not get as close to the subject and you can often photograph wildlife in a natural setting. Because of the shallow depth of field, you are able to isolate the subject. This forces the viewer to look only at it, and if there is a distracting background it can be thrown so out of focus as not to be recognizable. Shallow depth of field allows you another advantage. If you are shooting a subject and you get the lens close to things in the foreground such as leaves, stems of grass, or small limbs, they will often be so out of focus that you simply can't see

them. This has the advantage sometimes of not showing on the film. On the other hand, there are shots I've taken with a long telephoto in which the background was in focus just enough to cause a distracting blur—and I never saw it when I was composing the picture. Another disadvantage of longer telephotos is that they usually have a small f-stop—most are from f/5.6 or f/8—which are so low that they allow little light to get to the viewfinder, making it difficult to focus in low-light situations. If you buy telephoto lenses with special light-gathering qualities and fairly large f-stops, such as f/3.5, you are going to have to pay a great deal more money. And they are heavy.

Still, there are reasons that the 400-mm lens is considered the most popular among all the wildlife long lenses. The 400 is about as long a lens as the average person can hold on a gunstock or monopod and still get sharp photos. Longer lenses are just too difficult to hold steady. When compared to longer lenses, 400-mm lenses are relatively light, and they can often be purchased for considerably less money. The image size of a telephoto is rarely as large as the photographer would like, but a 400 will do a good job.

There is a precaution that should be observed with certain long lenses. Many will actually focus past infinity, which means that *nothing* will be in focus. Not all lenses have this characteristic, but it pays to check yours.

Zoom Lenses

Basically, there are two kinds of lenses you can buy for your camera: *zoom* lenses or *prime* (or conventional) lenses. Prime lenses have one focal length, and they are almost always sharper than zoom lenses. With a prime lens, if you want your subject to be larger, you must move toward it and refocus.

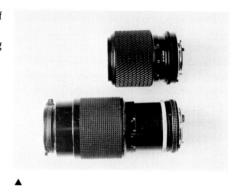

▲

Examples of two zoom lenses. The short one is a 35-70-mm model, while the longer one is a popular 70-210-mm.

A zoom lens is actually many focal lengths in a single unit. Thus, a 70-to-200-mm zoom lens is one with which you can shoot at any focal length between these extremes, e.g., 66 mm, 113 mm, or 130 mm. A zoom lens has several movable elements that, when moved, vary the focal length. There are often extra elements for additional corrections, too. Zoom lenses may have as few as a half-dozen to nearly two dozen elements inside to change the focal length and keep the subject in continuous focus.

The early zoom lenses were not very good, but these lenses have been vastly improved, and while very, very few will produce the same results at a given focal length as a prime lens, the final pictures are often pleasing to many photographers.

There are several obvious advantages to zooms. The most important, of course, is that you can carry a single lens with a multitude of focal lengths. It would be too costly and impractical to carry prime lenses of many lengths. And since prime lenses are made only in certain focal lengths, the zoom offers something that prime lenses can't. It allows the photographer to crop his photograph in order to put on the film exactly what he wants the viewer to see—an enormous advantage.

The ability to compose a shot while standing in one position is often a great boon. If you are inside a boat, standing on a cliff, or backed up against some object, your movement is so restricted that with a prime lens you might not be able to get the shot you want. With a zoom, you can simply move the lens barrel to compose. Incidentally, zoom lenses that are larger than 300 mm are generally very heavy and impractical for most outdoor use, and are also expensive.

But I feel that zoom lenses are not the key to superior photographs under many lighting conditions. If they were, no one would use prime lenses, and many professionals still insist on staying away from zooms and using only prime lenses.

A zoom lens is usually slightly heavier than a prime lens in a given focal length. A factor that is often not considered is that long lenses are harder to hold steady, so that a 200-mm lens is much more difficult to steady for a sharp photo than, say, a 50-mm lens. *If you are using a zoom lens that varies from 70 to 210 mm, you are really shooting all your pictures through a 210-mm telephoto, even though the focal length you are using may be much shorter.* This means that you must take much more care when using such a zoom. Many people blame their unsharp photos on the long zoom lens when it is their own fault for not realizing they are shooting with a longer lens that is simply more difficult to hold steady.

Another factor to consider, and one that is especially important outdoors, is that zoom lenses have many elements inside. As indicated earlier, many of the most outstanding pictures are those in which the camera is pointed toward the sun. When you use a zoom lens, serious flare and a degraded image often result as light bounces from one element to the other. I consider this to be the most serious fault of zoom lenses.

If you are, for instance, a backpacker,

and are concerned about carrying many lenses, and you know the limitations associated with zooms and are willing to put up with them, a wonderful outfit for taking all but wildlife photos would be a zoom in the 28- or 35- to 70-mm length, a 50-to-60-mm macro lens, and a 70- or 80- to about 200-mm zoom. With this outfit you can take almost all the photos you will encounter in the outdoors, with the exception of wildlife at a distance.

Mirror Lenses

There is a special type of telephoto lens that offers some outstanding advantages, but as with everything in photographic equipment, there are trade-offs. The conventional (also called *refracting*) lens is long and heavy. But the mirror lens is not. It is short and fat. This makes it much easier to transport and hold. Mirror lenses from 300 to 1,000 mm are half the length or less of a conventional lens of the same focal length.

In a mirror lens, light is folded or reflected off mirrors inside the barrel, which accounts for their shortness. And they weigh perhaps half as much as a conventional lens, or less. But the problem is that a mirror lens brings light to the film

It is readily apparent how much shorter is the 400-mm mirror lens than the 400-mm conventional or prime lens.
▼

▲

One objection that many photographers have to the mirror lens is shown here. Note the doughnut-shaped circles in the background. Such circles don't appear in shots taken with prime lenses.

through a hole in the mirror, and that is a fixed aperture. Most mirror lenses are f/8 or f/11, and only a few are f/5.6. This makes for tough focusing and exposing under poor light conditions.

The fixed aperture also results in two other liabilities. One is that you can only adjust exposure by adjusting the speed, which is often a severe disadvantage. Some mirror lenses allow you to adjust exposure with the use of filters, but you can never open up the aperture to get more light, since it's fixed. The other problem is that where there is water or a reflective surface in the background, a mirror lens will produce doughnut-shaped circles of glare where light sparkles off the reflective background. Many people feel that these doughnut-shaped images are very objectionable.

Both mirror and conventional lenses are capable of taking excellent photos. You simply have to make up your mind which is best suited to your needs.

Teleconverters

An accessory for lenses that outdoor photographers may want to consider is a *tele-*

converter. This is a magnifying element that is positioned between the camera body and the lens. Converters are designated by the factor ×. A 2× teleconverter will double the length of the lens used, so that a 50-mm lens becomes a 100-mm one. A 3× converter will triple the length, so that the same 50-mm lens is now a 150-mm lens. As with all such equipment, when you gain one thing you lose another. Teleconverters cause a reduction in the light that reaches the film, and you generally have to increase exposure by two or three stops, or decrease shutter speed, depending upon the individual converter.

Some teleconverters actually improve the quality of the lens—if they are designed specifically for that lens. But most teleconverters will not deliver as sharp a picture as a prime lens without it. Almost all converters should be closed down several f-stops to improve image quality. (Add that to the two or three f-stops of light lost to the elements, and things get sticky.)

If you are aware of the liabilities, you may still want to use teleconverters for some purposes. Certainly they can increase the focal length of a lens, and may get you a wildlife shot that would otherwise be impossible. I carry one and use it mainly for one type of shot, and for that situation the results are really striking. Generally, the larger the sun's image in a sunrise or sunset, the more dramatic the picture. A sunset taken with a 400-mm lens is beautiful, but a 2× converter will make it an 800-mm shot, and the same sunset can be awesome. Since sunrise and sunset pictures are rarely razor-sharp anyway, I don't find the teleconverter objectionable for these pictures.

Ultra-Wide Lenses

There is a group of lenses that is considered ultra-wide: 8 mm to 18 mm. These are special-purpose lenses that can create se-

vere distortion (and are sometimes used for that effect). While some very pleasant results can be obtained, it is my belief that for most outdoor photography a 24-mm lens is the widest you will need.

Among other disadvantages of ultra-wide lenses is that they are very expensive, they usually have a large front glass element that is difficult to protect, and some cannot be used in a conventional manner on some camera bodies.

Autofocus Lenses

While some autofocus camera bodies will accept (with an adapter) many lenses not specifically designed for the body, the best results are obtained when using the special autofocus lenses designed for these bodies. The latter can often be used on older, non-autofocusing camera bodies, but they must be manually focused. Designers sometimes make them difficult to focus manually or nearly impossible to work with some filters, such as a polarizer. If you plan to buy an autofocus camera body, plan on making the large outlay for the lenses designed for it, too.

Depth of Field

In every picture that is exposed properly, a portion of it is sharp and the rest is to some degree out of focus. Once the subject is brought into focus, only one factor affects *how much* of the entire picture will be sharp. That factor is *depth of field.* As you focus on the subject, some portion of the picture will appear sharp in front of and behind the subject. That zone is the depth of field, and it varies with different f-stops. Without getting complicated, all you need to understand is that the smaller the f-stop, the greater the amount of the image that will be sharp in front of and behind the subject (or point of focus). Thus, in a photo of a person standing in a garden of flowers, shot at f/2.8, only a few inches in front of and behind the person may be in focus, while the same subject shot at f/11 or f/22 would have considerably more in focus on either side. Depth of field decreases as you move the camera closer to the subject. Thus, in close-up photography there are only a few centimeters of sharpness, while at ten feet a subject may have as little as three feet or as much as 30 feet in focus by changing the f-stop.

In many prime lenses and some zoom lenses, there are coded lines on the lens barrel that tell you, when using a particular f-stop, just what is in focus in the photo. When the camera is focused on a subject, the lines on each side of the f-stop reveal how much is in sharp focus in front of and behind the subject.

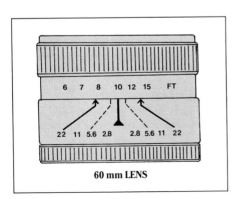

◀

Many lenses have lines on the barrel (often color-coded; see your camera's instruction manual) that show how much of the subject will be in focus. With this lens focused at ten feet at f/22, everything in the picture will be sharp from just under eight feet to about fourteen feet.

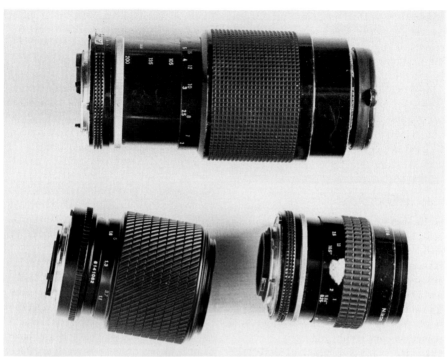

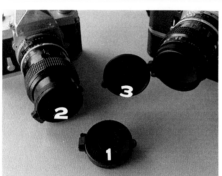

▲

If you want to carry a minimum of lenses in the field for all but long-range wildlife photography, this three-lens assortment will allow you to take most of the photos you might want to. Lower left is a 35-70-mm zoom, lower right is a 55-mm macro, and at top is a 70-210-mm zoom.

◀

Perhaps the best way to protect a lens in the field is to use the FasCap. This is a spring-operated, screw-on cap. No. 1 shows the unit itself; No. 2 shows it in place, protecting the lens; and No. 3 shows how it flips open for the picture and then snaps shut when finished. It's important to know that this unit works only on lenses that are 35 mm or longer. On wider-angle lenses, such as 28 and 24 mm, it will cause vignetting, creating a dark circle at the corners of the photo.

◀

A neat trick for carrying two short lenses together is to pop-rivet or glue two lens caps back to back, as shown.

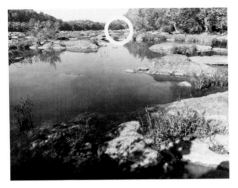

◀

This is a sequence of photos showing how different focal lengths of lenses affect the foreground and the background. The wider the lens, the farther away the subject (in the circle) appears from the camera and the background. Also, the wider the angle of the lens, the smaller the subject appears, and the more the foreground dominates the scene. The longer the lens, the less foreground is shown and the closer the background is brought to the subject. This photo was taken with a 24-mm lens.

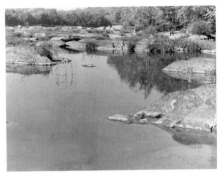

▶

With a 50-mm lens, the subject becomes a little larger and closer, and the background and foreground are reduced.

◀

With an 80-mm lens, there is a larger subject and less foreground and background; everything also seems closer.

▶

With a 200-mm lens, the foreground is almost gone, the subject is much larger and closer, and the background is brought nearer the subject.

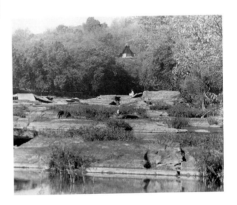

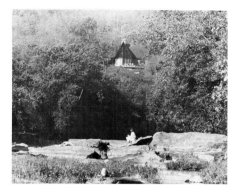

◄

With a 400-mm lens, the subject is easy to see, the foreground has nearly disappeared, and the background is larger and much closer to the subject.

▶

Lenses affect how close the background is to the subject, so that use of lenses allows you to eliminate background or put it so far away in the picture that it isn't noticed. In this series of pictures, the wheel of the cannon has been kept the same size as the etched circle in the camera viewfinder. As the photographer moves closer with wider-angle lenses and farther away with longer lenses, the wheel (the subject) remains the same, but observe how the background is affected by focal length of the lens.

◄

A 105-mm lens brings the woman and the wall closer.

▶

A 400-mm lens makes the woman appear to be very close to the cannon, when she is actually about 100 feet behind it.

CHAPTER 3

FILM AND EXPOSURE

The greatest hurdle for most people who take pictures is getting good exposures. With color slide film, underexposure results in dark pictures; overexposure means washed-out shots with no detail in brighter areas. In color print and black-and-white films, too much exposure will mean dark negatives that have a grainy appearance, and underexposed negatives will lack detail. But to get good exposures with modern films and cameras is not really difficult.

Film

Before we discuss how to expose film for a photograph, it would be wise to understand a little about the film we use. There are three basic types of film: black-and-white film and two kinds of color film, slide and print. Some people feel that because black-and-white film has no color to help

separate the subject from other parts of the photograph, it is much more difficult to work with. Others admit that this may be true, but feel that for many outdoor subjects it delivers a more powerful impact than color, as witness some of Ansel Adams's photos. With color films you must first decide whether you would rather show prints to your friends, or use slides for your presentations. Slides, properly projected, can be much more dramatic but require that you use more care during exposure. Print films are more forgiving, and slight overexposures do not radically affect the final print.

It should also be pointed out that you can have prints made from slides, and slides made from print film negatives, although it can be a little expensive. If you have an especially important slide that you would like to have a print made from, you will obtain better results if you have an in-

ternegative made. In this process, negative film is used by the processor to rephotograph your slide. This negative (instead of your slide) is then used to produce the print. The internegative is returned to you, and from it you can make as many prints as you like.

Some people new to photography don't know how to tell the difference between a slide and a print film. If the film is designed for making prints, the film's name will end with the word *-color;* if it is a slide film, the last portion of the film name will end in *-chrome.* Thus, Fujicolor would be a film that has been designed to deliver negatives from which you will make prints. If the film name is Kodachrome, that film will deliver slides.

Color print film gives you orange-colored negatives from which the final print is made. For someone unskilled in reading these strange-colored negatives, there is a trick I discovered that helps me evaluate whether I want to have a particular negative printed. If one holds a green filter in front of the eye, the negatives take on the appearance of black-and-white negatives, and most people can better assay them. This is the same green filter you use on your camera.

You can tell a color print film from a slide film by looking at the last portion of the name on the box. If it says "color," it is a film that is designed mainly for prints, although slides can be made from it. If it says "chrome," it is mainly designed for slides, though color prints can also be made from it.

▼

Films formerly had a numerical designation of either ASA or DIN, which indicated the film's sensitivity to light. The higher the number, the more sensitive the film is to light; therefore less exposure at higher numbers is needed to capture a photograph. Today, ISO (International Standards Organization) is the world-wide accepted numerical designation for film speed. (The numbers are actually the same as the older ASA numbers.)

The following lists the ISO numbers approved for current use:

SLOW FILMS	MEDIUM FILMS	FAST FILMS
10	64	200
12	80	250
16	100	320
20	125	400
25	160	500
32		650
40		800
50		1,000
		1,300
		1,600

The cassette, which is the lightproof container that holds the film, is coded with a special series of metallic bars called a DX code. The purpose of DX coding is to allow cameras that possess special contact points inside the casing to recognize the ISO of the film and automatically adjust the ISO controls on the camera.

As indicated in the preceding list, there

Modern films have special coding marks called DX that automatically set the correct ISO when the film is used in certain specially equipped cameras.

▼

▲
On an overcast day in Scotland, a film with a high-speed ISO was needed to capture the swift action of this fly caster.

are three basic categories or speeds of films: slow, medium, and fast. For most situations, the outdoor photographer is probably better off with a medium-speed film. In color an ISO of around 64 to 100 is ideal, and in black and white an ISO of about 125 is suggested.

Slow films have a finer grain, which can produce pictures that look clearer. Medium-speed films have slighly larger grain and are almost as clear. In faster films the grain is much more apparent and the final photo doesn't have as much clear detail. Many people prefer fast films, but experts feel that fast films should be used only when slower films won't do the job. The plain truth is that if fast films performed as well as medium or slow films, there would be no medium or slow films. It's a trade-off, and the choice is yours.

Slow films are less sensitive to light than are fast films. If you are going to be taking pictures in very low light, especially where the subject may be moving, or in normal light when the subject is moving at very high speed, you may be forced to use a fast film. But where you can use a tripod to photograph subjects (even in low light) that are not moving, you'll generally get sharper pictures that are richer in color with slower ISO films.

▲
High-speed film was needed in Iceland to capture the motion in this photo.

Even on a bright day, a high-speed film was helpful in freezing the action of this leaping tarpon.
▼

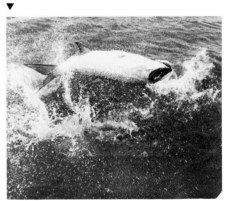

Light Meters

The device that measures light for an exposure is called a light meter. There are several types, each of which has its purpose, and for different situations one may be better than another. Basically, light meters are used in two different ways: *incident*

meters measure the light that is falling on the subject; *reflected meters* measure the light bouncing back from the subject. The meters inside camera bodies are reflected types. The light hits the subject and is reflected into the camera through the lens, where it is measured. Three kinds of these meters are used inside camera bodies: *interpreted, center-weighted,* and *spot.*

An interpreted meter measures the light across the entire picture. Fortunately, this meter is not in common use, as it can result in poor exposures because it measures light over the entire scene.

A center-weighted meter is one in which most of the reading comes from about 60 percent of the center of the scene (the percentage varies with different cameras), and this one is perhaps the most useful for the average photographer. When the camera is held for a horizontal picture, many center-weighted meters read a bit more at the bottom than above the center viewing spot. That's fine, so long as you are making horizontal pictures. But remember that when you take a vertical picture, a portion of the center-weighted meter reading will now be to one side or the other. Your camera manual usually explains this.

With a spot meter, only a very small beam or angle of light in the center of the photograph makes the reading. This allows precise measurements, but until a photographer has a good grasp of how to expose for pictures, the spot meter often results in poor photographs, though for many situations it is the best. Some cameras offer both a center-weighted and a spot meter.

Aside from through-the-lens meters contained in the camera body, there are hand-held types, which almost all professionals carry as backups. They work the same way, either incident (measuring light falling on the subject) or reflected. The hand-held reflected meter is the most popular type, and some of these can be quickly converted to incident meters.

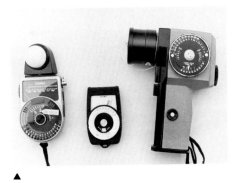

Three types of metering devices: from left to right, incident, reflective, and one-degree spot.

A special-purpose, hand-held, reflected spot meter has an extremely narrow reading zone of only one degree. You might wonder why you would use such a meter outdoors, but it has many excellent uses. Suppose you are sitting in a blind, trying to photograph a red fox pup lying on dark green grass just outside the den. A spot meter will allow you to take a reading off the fox's fur. Another example: if a tiny yellow flower is surrounded by dark green leaves, the spot meter will permit you to take the proper reading just on that tiny flower.

An incident meter is one that generally has a diffuser bulb or screen, and the meter reading is made *at the subject,* measuring the light that falls on the subject rather than that which is being reflected from it. The incident meter can result in poor exposure information if not handled properly. The light should fall at the same angle on the bulb as on the subject. Incident meters usually have to be close to the subject to take the reading.

To operate any meter, inside or outside of the camera, we must adjust the ISO setting correctly. Professionals realize that the meter's ISO scale may not be absolutely accurate, so they take some test shots as soon as they buy the meter or camera. You may find that you will have to

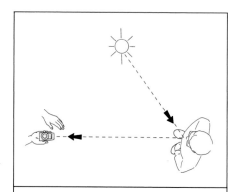

▶

With a reflected meter, the photographer measures the light
that is being reflected off the subject to get an exposure.

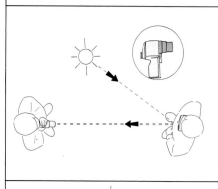

▶

Meters in cameras are the reflected type, although some are
averaging and can also be used as spot meters.

▶

The spot meter reads just like an averaging meter, but over
a much narrower field of view, so that precise metering of
a small object is possible.

▶

An incident meter reads the same light that falls on the
subject. It should be held at the same angle as the subject;
tilting its dome toward the sky will result in false readings.

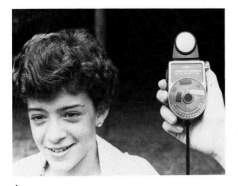

▲

When using an incident meter, try to place it as close to the subject as possible to get an accurate evaluation of the light actually falling on the subject.

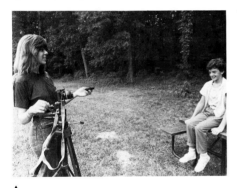

▲

When using a reflected meter, make sure that it is pointed at the subject. More accurate readings can be obtained by getting closer to the subject, thereby reducing the chance of metering on the background.

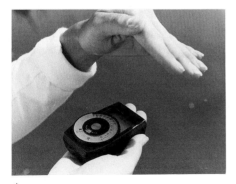

▲

On bright days, it's easy to get a false reading with a reflected meter unless the meter is shaded from the bright sky or sun. But keep the hand out of the metering area.

set the adjustment a little higher or lower in order to get the exposure you feel is correct. This is no reflection on the meter—just something we live with. In fact, many people who use center-weighted meters in their cameras will adjust the setting one step higher to obtain richer exposures. For example, when using ISO 64 film, they will establish a setting of ISO 80.

Exposure

Exposure simply means the amount of light that is allowed to strike the film. The exact exposure for a particular scene may vary according to the photographer's individual taste. One person may want to enhance a certain portion of the photograph, another may want it to be slightly over- or underexposed. In the case of a silhouette, it means that you have deliberately underexposed one portion of the shot, and in another situation you may deliberately underexpose to enrich the picture. (Sunsets are usually more appealing if a bit on the underexposed side.)

Light can be emitted into the camera in two ways: by increasing the amount of light in a quick burst, or by allowing less light to fall on the film for a longer period of time. It's much like draining a bucket of water. If you punch a big hole in the bucket, all the water will drain quickly. If you punch a smaller hole, the same water will eventually drain out, but it will take a longer time to do so.

What controls the amount of light falling on the film is a combination of the shutter speed and the lens aperture opening. If you open the aperture one stop, you have doubled the amount of light allowed to pass through the lens; if you close it one stop, you halve the amount of light that passes through. By changing the shutter speed ring to one setting lower, you will double the length of time that the light coming through the lens strikes the film;

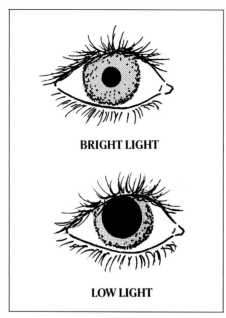

BRIGHT LIGHT

LOW LIGHT

▲
The camera reacts to light much like the human eye. The pupil (or lens) closes down in bright light and opens in dim light.

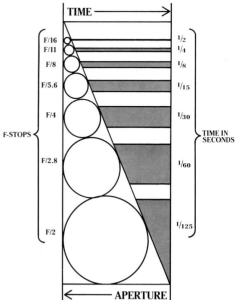

▲
Here is a chart that helps to explain exposure and the relationship between speed setting and lens aperture. The smaller the lens opening, the longer the aperture must remain open to get the exposure, and vice versa.

and, of course, if you adjust it to one setting higher, you halve the amount of time that the film is exposed to the light.

What this simply means is that by adjusting the speed ring and the lens aperture, you can control the amount of light falling on the film. On all lenses you can position the f-stop setting (lens aperture) between the established numbers; but only on some cameras can you set the speed ring between designated settings.

In this modern world, many photographers rely too much on the meter inside the camera; they simply adjust the controls and take the picture. But everyone seriously interested in obtaining good photographs should have a firm understanding of the relationship between light and exposure, and between the speed setting on the camera and the f-stop of the lens.

There is a simple trick to check meters

(inside cameras or hand-held) to be sure they are working properly. It's often called the "sunny sixteen" rule. For those of us who don't want to be technical, spout algebraic formulas, and do a lot of math, it means that if the sun is shining brightly from behind you, and you adjust the speed setting on the camera to the same number as the ISO and set the aperture at f/16, you get a proper exposure. Several examples may help you learn this important rule. If you are using a film with an ISO of 64, adjust the speed ring to the closest setting (1/60) and use f/16—*with the sun behind you*—you'll generally get a very good exposure. If the film is ISO 400, the closest number on the speed ring is 1/500; set it there, but open the lens a half stop—halfway between f/11 and f/16—and you'll get a near-correct exposure.

This is a very important rule to learn. Most cameras are operated by batteries. Should your batteries fail, you could still get good photographs by using the "sunny sixteen" rule. Another good reason for knowing this rule is that if you should bang or drop the camera and you are in doubt as to whether the meter is functioning properly, all you need do is use the "sunny sixteen" rule. Also, if you take a meter reading and for some reason doubt that it's right, you can use the "sunny sixteen" rule to mentally check it.

There are three tools usually available to you to check both the "sunny sixteen" exposure and other average-exposed subjects. The first is the Kodak 18 percent gray card. This is sold by Kodak (some others sell it, too), and is a sturdy eight-by-ten inch piece of cardboard that is gray on one side and white on the other. The gray side reflects 18 percent of the light that falls on it; the white side reflects about 90 percent. For most outdoor exposures we can forget the pure white side. If you do not use the automatic mode on your camera, but make manual readings on subjects and use a gray card, you will improve the success rate of your exposures dramati-

cally. I think it is the single most useful tool you can own for getting consistently good exposures, and I really urge you to use one frequently.

Here's how it works in principle. If you were to make light meter readings on ten different features with a picture from bright to dark, then average them up and divide by ten, it would usually be about the same exposure you would get from reading off a gray card. When you take a reading off the gray card (the light must be the same on the card as on the scene), it gives you the "average" for the scene. The gray card works perfectly if you are photographing an average scene. You should hold the gray card so that light strikes it as it does the subject. If you are going to photograph a person standing, the card should be held vertically; if the card is tilted toward the sky, it will reflect more light than the subject, and if it is tilted toward the ground, it will reflect less light. It's just using a little common sense.

To use the gray card properly, you have to use a little judgment—and if you do, you

A Kodak 18-percent gray card. It can be cut in half, as shown on the left, and, with a string attached, can be easily carried around the neck.
▼

On the left is the author's homemade aluminum camera case with its painted patch of flat gray that was matched to a Kodak gray card (short arrow), which allows quick readings in bad weather or when you don't have your gray card (long arrow). Many people use fiberglass or plastic boxes, which are often superb. Meter on the box and compare it to your gray card; you may be able to use it for quick readings, too.
▼

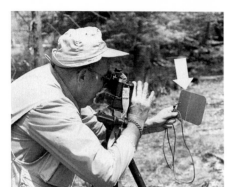

This is how you read from a gray card. Just make sure that the light falling on the card is the same type of light that is on the subject.

will rarely take a badly exposed picture. Let's use three examples to show how using the gray card will almost always deliver a satisfactory exposure. First, consider a subject that is about the same tone as a gray card, such as something medium green, blue, or red; since the color is reflecting about the same light as the gray card, your reading on the card is the correct exposure. Next, let's assume that you are photographing a person and you have taken a gray card reading, but you realize that the gray card is darker and reflecting less light than the face of the person—the most important part of the picture. You will need then to close down the aperture to let less light into the film. If you are using black-and-white film, close down one stop and you'll probably get a good picture. If you are using color, shoot one picture a half-stop toward underexposure, and then one more a half-stop further closed down. Let's take it one step further and assume that we are shooting a subject that is darker than the gray card. We take a card reading and we know it will be reflecting more light than the darker subject, so we do the reverse of what we did with the light subject, and open up the aperture.

Kodak's gray card is big (they can be cut in half), and is made of cardboard. The gray side is lightly lacquered, but won't take much exposure to water. There is an inexpensive commercial waterproof gray

card now offered for sale, which I use frequently. You can also do something else. I bought a small can of flat gray paint and some lampblack from a paint store (you could also use flat gray and flat black paint) and I mixed into the gray paint enough black so that when I finally got it right I had a paint that reflected about the same light as the Kodak gray card. Then I painted a large rectangular portion of my metal camera case with this adjusted paint. Now I need only to take a gray-card reading from the box—even in the rain. It works very well.

If you have no gray card or painted box handy, you can still get an average reading. A dry macadam road has about the same reflectance as a gray card. So does green grass. Thus, if you want to take a picture of a scenic valley, all you have to do is take a reading on a dry macadam road (not a dark blacktop one) or green grass (so long as the light fell at the same angle and intensity on both scenes) and shoot the shot, and you'll know you've gotten a good exposure.

Making the Meter Reading

Perhaps it's important to understand that film doesn't see the subject as the human eye does. We can see all the detail in a pale yellow flower set against dark green foliage, but film doesn't have this much latitude. It has to be exposed for one end of the range or the other. In other words, it can record well the light-colored flower, but not the detail in the very dark green leaves. Or it can do the reverse—but not both, as our eye can. There are many subjects that have such a range of light and darkness that it's simply impossible for

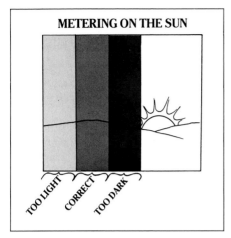

METERING ON THE SUN

TOO LIGHT CORRECT TOO DARK

◄

A simple trick and a little personal experimenting will allow you to get predictable exposures of sunrises and sunsets. With most in-the-camera meters, if you take a reading where the middle tone is, you'll probably get about what you see. If you move it to the panel area that is farther away, you will get an exposure that is lighter, and metering closer to the sun will result in an underexposure of all but the sun. Remember an important point when taking sunrise and sunset shots: so long as you can look at the sun without squinting, you can take a good photograph of it. Pointing the camera at a too-bright sun for an extended time can result in "poisoning" your meter for a brief period.

film to record all of them—even though our eye sees it perfectly.

If you use slide film, the secret in making good exposure is simple: *Take a meter reading on something important in the picture that is light in color.* Some professionals call this taking a meter reading of highlights. The meter is only an instrument that will read light reflected to it. It can make no judgments—that's up to the photographer.

Let's see how this works. Assume that you are photographing a pretty girl in a bathing suit who is standing against dark green foliage. If we use a center-weighted meter reading, the meter will take into account the skin, which is bright and reflecting a good bit of light, and also the dark green foliage surrounding the girl. Had you metered only on the girl's light skin, the reading may have said to shoot at f/11. If you stand back and make the meter reading, the meter will take into account the dark foliage, and it may suggest that you take the picture at f/8 (an average of the light and dark colors). What this means is that at f/11 the skin tones on the girl would have been one f-stop overexposed and the skin would have been chalky white—spoiling the photo.

Had we moved in close (or used a spot

meter) we would have been able to read only the light part of the picture that was important (the girl's skin), and it would have been properly exposed in the photo. The green would have been a little darker—and richer in color.

The secret of getting rich colors on slide film is to expose for a bright area that's important, then all areas that are darker (or reflecting less light) will be richer in tone.

Because color films are not perfectly stable, and two rolls of ISO 64 film may not be exactly 64 (as a result of where and how they were stored, as well as their age), the

Silhouette pictures are among the easiest to expose properly. Simply meter on the bright area immediately surrounding the subject, and use that reading for the exposure. Remember, if you have to squint to look at the bright area around the subject, your film won't be able to give you a good silhouette.

▼

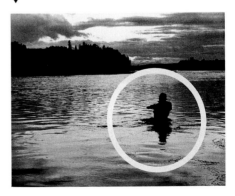

▲
The author simply metered on the bright sky to make this silhouette.

After you have exposed a roll of film, never place it in an exposed mailbox in warmer climates, if you are mailing it to the processor. The temperature in the box becomes elevated under the heat of the sun and can damage the film. Take the film to a post office or put it in a mailbox in the shade.

▼

professional covers himself to be sure he gets a good exposure. Any shot that is felt to be important when using color film should be bracket-exposed. Take a shot at the suggested exposure, say f/8. Then take another a half-stop between f/8 and f/5.6, and another halfway between f/8 and f/11. What you will get if you used care in making the exposure reading is one shot that is right on the money, one that is pretty good, which you'll want to keep, and one that you'll probably discard.

With black-and-white and color print films, the exposure is made in a directly opposite manner. Make a reading on something important in the picture that is dark in color. When you make an exposure with black-and-white or color print film, you are recording on a negative the image that you will later want to print. Imagine it this way: if you don't allow enough light to the darker areas that are important, so that they record on the negative, you will never be able to make the print.

To summarize, with color slide film you meter on something important that's bright in color—and that doesn't mean the brightest part of the picture, but what is *important* and is bright in color. With black-and-white or color print film you do the opposite. Follow these two simple rules and you will rarely make bad exposures.

▶

These two pictures show the effects of exposure on a waterfall. By controlling how long the film is exposed, you can stop or blur the motion of the moving water. The photo at the top (opposite) was shot at 1/250, and the one below it at 1/2. The speed of the moving water determines to some extent what exposure you must use to get the desired effect.

LIGHT

Without light, we cannot take ordinary outdoor pictures. But there are many kinds of light: overcast, strong low shafts, the bluish color caused by a rainstorm, and so on. This offers disadvantages and advantages—if we know enough about light to capitalize on it. I believe that outdoor photography is one of the most difficult forms of the art, simply because the light is constantly changing and we have no control over it. However, light is also often predictable (we can tell when it's going to storm, or the sun is going to set), and if we understand how it will affect the subject, we can prepare for a great photograph.

With the exception of flash, the sun is the source of light for all outdoor pictures. There are five major types of outdoor light that photographers can work with:

Frontlight—The light falls on the front of the subject; this means the sun is behind the photographer.

Sidelight—The light is at a strong angle to one side of the subject.

Backlight—The light is in back of or behind the subject and usually shining toward the camera lens.

Overhead light—The light is directly above the subject.

Overcast light—The sun could be at a variety of angles, but because of cloud cover or other weather factors, the light is diffused and there is no strong light. Light or thin overcast usually creates the best of this type of light.

Exposure for frontlight, or sidelight, and backlight is confusing to many people, but it's really pretty easy. If you take a meter reading for a frontlit subject, you'll have to open the lens aperture about one full stop for a sidelit photo (if a frontlit subject is f/11, you'll need to open to about f/8). For backlighting, you should open about two stops. Remember to bracket your expo-

▲

Backlight creates a halo around the girl's hair and body and causes the fishing line to glow as light comes through it. Backlight tends to separate the subject from the background, too.

▲

Frontlight falling on the tree bark gives few shadows and makes it look relatively smooth.

Sidelight falling on the bark on the same tree creates shadows on one side (textured lighting) and clearly shows the ridges in the bark.

▼

sure, not only for insurance, but because often a slight under- or overexposure results in a more pleasing picture.

A firm rule in photography for years was "Keep the sun at your back." This certainly results in fairly good exposures, but most of the time it does not produce the most attractive pictures.

I think an example may prove this. In many photography seminars I conduct, I hand out four *National Geographic* magazines to students. I ask them to select the ten photographs in each magazine that they feel are the most outstanding. The only stipulation is that they must select pictures made after the sun rises and before it goes down—in other words, during normal daylight hours. The photos in the magazine show rainstorms, hot, windy deserts, the jungle, and all sorts of normal daylight situations. After the students have marked their selections and returned the magazines and before I look at them, I make a statement that often startles the students:

"Of the forty photographs you have chosen that were taken with normal daylight, I would bet that at least thirty have been made using side- or backlight, and that most of the rest will have been taken in overcast light. Almost none of those that you have chosen will have been taken with front lighting."

It is a rare occasion when that is not exactly what the students have done. I believe that the major difference between superior outdoor photographs and most others is the photographer's use of side-

light, backlight, or overcast light. I once asked Larry Madison, award-winning filmmaker and still photographer, if he had his choice of the different lights to make most of his pictures, what percentage of each would he choose. "I'd take 80 percent side- and backlight," he answered very quickly.

One of the major reasons for not using frontlighting is that it presents the subject flat, without form. A building, a sand dune, a person, or a mountain that is frontlit will seem flat. The use of sidelight or backlight will often transform the subject into something outstanding.

There is another reason why sidelight and backlight are so effective. *Anything that allows light to pass through it, or transmits it, will almost always be more attractive if the photographer uses sidelighting or backlighting.* To explain this, let's use two examples that most people are familiar with. If you walk into a brightly lit room and observe a

table lamp that is not lit, the shade looks flat and dull. But once the lamp is turned on, the light inside the shade causes it to glow and come alive. Look at a church that has stained-glass windows, with the sun shining on the windows; they look okay, but dull. Now walk inside and look at the same windows as the light passes through them. They actually glow.

There is little logic in shooting a backlit or sidelit subject where light doesn't come through any portion of it (such as a solid wall). But almost all subjects that will transmit light will be enhanced in a photograph if backlighting is used.

Many people are disappointed with their fall foliage pictures, but if we will remember that leaves do allow light to pass through them, we can get some outstanding photos. Shooting a maple tree with sidelight or backlight will cause the leaves to glow a beautiful rich yellow, orange, and red.

The direction that the light falls on a subject can have a lot of impact, especially when the subject is a person. Here the light falls on the back of the model, whose face shows poorly as a result.

▼

Turning the model around so that the light falls on her face makes a great difference. Many people are not aware of this.

▼

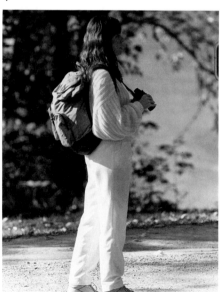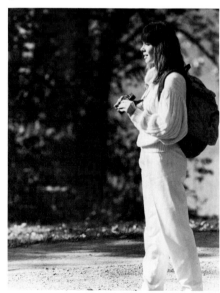

▲

Backlight pouring through the steam from this plant makes it stand out against the dark background.

Sidelight and backlight also help to separate the subject from the background. Front and overhead light tend to add little three-dimensional effect to the picture, and only the diminishing size of things in the background helps separate the subject from it. But with sidelighting and backlighting, shadows, plus light reflected from, or transmitted through, different parts of the scene, separate things.

Sidelight can be soft or hard. The most startling or deepest shadows come with strong, harsh sidelight. This can create dramatic pictures, but for many subjects it is often unsuitable. A pretty lady or a delicate flower taken with soft sidelight will make a more pleasing photograph. The rolling dunes or craggy rocks of a cliff, however, have more dramatic form and shape if the light is strong and harsh, creating darker shadows. Strong sidelight is referred to as *textured lighting* when the sun's rays strike the subject from a low angle, which occurs early and late in the day. When the subject has a geometric shape, or when you want to separate parts of the subject, such as the paddles on a waterwheel, gear teeth on an old abandoned tractor, sand dunes, craggy shoreline, or mountains, textured lighting produces very pleasing results. Generally, for the best effects, the light should be both at a low angle and strong.

Backlighting is often the best source to use in the outdoors. One of the facets of backlighting that makes it so attractive is that the subject, when properly exposed, is evenly lit, but light is transmitted around the edges of the subject, causing a "halo effect." A pretty girl doesn't have to squint if the sun is behind her, but every strand of

hair will glow. A deer standing in the forest, with strong backlighting, will have a halo of light around its body that separates it from the woodland background.

Flowers are often best photographed with backlight, allowing it to come through the petals. Backlight coming through mist rising from a waterfall will illuminate every water droplet. Icicles hanging from a cabin roof or rock ledge, taken with backlight, will look more alive than with frontlighting. Ice is particularly enhanced when shot with backlight or sidelight. Snow crystals will glow as a skier moves across the landscape if the photograph is backlit.

An important point: When shooting backlit subjects that are light in color or transparent, you must have a dark background. For example, in a shot of a fisherman casting with spinning tackle, the monofilament line transmitting light through it appears brilliant against a dark background, but you wouldn't be able to see it against a light background.

Overcast light is one of the most beautiful lights to use when delicate shades of color are to be shown. Just about anyone who loves the outdoors has looked at and

Overcast light has no glare (results are somewhat like using a polarizing filter); lightly colored subjects, such as many flowers or these New Zealand rainbow trout, will show all of their subtle details under these conditions. But in bright sun all of the lighter areas would have been simply white.

▼

▲

The thin material of this Alaskan tent creates a diffused light, which means there are no strong shadows and the three people's features show well.

admired the calendars of the Sierra Club and the Audubon Society. But if you study the photos closely, you will see that in almost all of the photographs there are no shadows. This means the pictures were made with overcast or diffused light. With diffused light there is no strong sunlight. Such a light could be found deep in the Grand Canyon, in the shade of a cliff in New England, or anywhere there is cloud cover. Light or thin overcast is the best for photography. When light becomes darkly overcast, such as during a storm, or too early or late in the day, the resultant photograph often takes on a blue cast that many people find unattractive. But, light overcast light is dynamite for many great outdoor pictures.

Bright sunshine creates glare off of almost everything it shines on, including rocks, clothing, and water. This glare is actually white light (the film sees it that way), and it reduces the intensity of the colors in a picture. The major reason why photographs taken with overcast light are so pleasing is that there is almost no glare. In effect, these pictures often appear as if a polarizing filter has been used. This lack of glare allows the rich tonal qualities of the subjects to come through, and that's one

reason why those calendar pictures are so beautiful.

For example, it is impossible in bright sunlight to photograph a wildflower that is light in color, with delicate shadings of pink or yellow. There is so much glare bouncing off the lighter portion of the blossom that all you see is a white flower; the delicate shadings are gone. Certainly, bright light can be used to enhance subjects, but often overcast light will produce almost overwhelmingly rich colors.

Overcast light has another advantage, too. If you are trying to photograph a subject that is light and the background is dark, or vice versa, the brightness range between the two is radically reduced and you can often record well on film both the dark and light features. This would be nearly impossible in bright or direct sunlight.

When shooting in overcast light, it often helps if the subject has a small amount of bright color. A red or yellow shirt or hat on a backpacker making his or her way through the woods on an overcast morning will not only draw attention to the subject, but that splash of color seems to set off the picture.

There is another kind of light that is actually overcast, but so different that I feel it deserves special mention. It is perhaps the most ignored of all natural lights used by photographers: twilight. For many years I took pictures of sunsets, then put away the camera. But no longer. I feel that some of the most interesting pictures I take are made before the sun has reached the horizon or after the sun has gone below it. This is especially true if there is water in the foreground that reflects the sky's colors, or if there is a subject that is in some way artificially illuminated, such as a lighthouse.

Gone are the strong reds, oranges, and yellows, but they are replaced by deep blues, rich lavenders, and sometimes a glow of red. It goes without saying that these are long exposures, usually more than a second, and they require the use of a tripod for sharp pictures. But once you have photographed a series of waves cresting at slow speed toward the beach (they will appear as if they were brushed on by a painter) with twilight blue and lavender coloring the scene, you will fall in love with twilight. It means getting up early or staying late—but that's a small sacrifice. One of the things that makes a professional photographer is the ability to get a different kind of picture. Few people take twilight photos, and those who do leave a strong impression on their viewers.

Overhead light occurs near midday, when the sun is as high overhead as it will get at that time of the year (this is usually the very best time to utilize thin overcast light for pictures). But it is perhaps the most uninteresting light of all. Generally the light is a bit diffused, shadows are nearly underneath subjects, and the lighting is rather flat. Time and again, great photographers have urged people to take their pictures early or late in the day, and avoid the midday times. You can take some nice pictures during the midday period, but generally, overhead light offers the poorest of all kinds of natural light for most subjects.

While you can move a person around to get the light you need, and for many other subjects you can change your camera angles to obtain the direction of light, that is not true of landscapes. You're stuck with what you have. If the light is not what you want, you have no choice but to wait. However, knowing what different kinds of light will do, you can often decide which time of day will be best for your picture (low sidelight, backlight, frontlight or overcast light). As they drive through an area, most good photographers will mentally take notes. They may think to themselves,"Gee, that old red barn would look great framed

▲

Joe Dorsey stands in what the author calls stagelight. A shaft of light comes through the woods and falls on the subject, isolating it, much like a ballet dancer on a dark stage under a spotlight.

by the maple tree and stone wall, if I come back in the fall." Or they may note that a number of sailboats at an old dock, enhanced by a rising sun penetrating the fog, would be a wonderful picture. The point is that landscapes can be pretty boring if shot under certain light conditions, but terrific under others. Try to visualize when the scene would be best shown, in which light and at what time of day or season, and then make it a point to return. On several occasions I have made a mental note to take a certain picture during a particular season or time of day; it may be several years before I'm in that area and able to do it.

During the day, the light changes color.

The human eye usually doesn't see these subtle differences, but film certainly does. Recognizing this and utilizing it to advantage is important. As daylight begins, the film sees the light as very blue. This is great for some mood pictures, and if there is water in the scene, especially in the foreground, it tends to make the water actually look wet on slides. Then the sky usually turns reddish, followed by orange. This is the time to take those great sunrises. Just after the sun gets above the horizon, the light is yellow in tint for a brief period. This can actually be noted by the human eye if you are aware of it. Never take close-ups of people at this time. They will look as if they have jaundice. On the other hand, a yellow wheat field will show brilliantly at this time of day.

Following the yellow phase, the sky becomes diffused and the colors are rather drab—normal daylight. In late afternoon the whole process repeats itself; first comes the yellow as the sun sinks low, followed by orange, red, and finally blue. If you know the characteristics of each color phase and time period, you can predictably use that color to enhance your subject, or make it different from a normal scene.

One of the best ways to learn about the kinds of light and the effects of different times of day on color film is to select a subject near you where you can take pictures of it at different seasons and different times of day for a full year. A white church is often excellent for this experiment. Shoot all the pictures from the same position and then study them carefully. It can be an impressive lesson in the effects of light.

Sunrises, Sunsets, and Afterglow

Perhaps nothing in nature is so colorful as some sunsets; every photographer's finger itches when he sees the sky filled with those gorgeous colors. Many people who

take these pictures are unhappy with the results, yet by following a few simple rules you can consistently get what you expected, and make your sunsets really interesting to your viewers. (Be aware that looking directly at the sun can be very dangerous to the eyes, so avoid doing so whenever the sun is bright.)

Film doesn't see nearly as much as we do in a scene, and while many subtle tones may be visible to us, they often are not recorded by the film. *To get a good photo of a sunrise or sunset, you have to be able to look at the sun for a brief period without squinting.* If you have to squint, the light is still too intense and some of the photo will be white or lacking in color intensity. Because you will be shooting directly into the sun, you need to have the lens as clean as it will ever be. A single dust speck can refract the light and either create flare or a degrading of the photo. Just before taking any sunrise or sunset, clean the lens— make this a habit.

Something you will learn quickly if you haven't taken many sunrise or sunset photos is that the sun comes up and goes down very rapidly. One moment it's on the horizon and the next moment it seems to have leaped into the sky—or disappeared from view. So you must be prepared. If you intend to bracket, or use several lenses to capture the glory of it all, have everything at hand. For an especially good sunset, I have several times set up two tripods with color film in each camera, and used two different lenses.

Which lens you take the shot with can make a considerable difference. Most of the time a wide-angle lens is the least desirable. If the entire sky is aflame, maybe the wide-angle lens is best. But generally the area of the sky close to the sun is the portion that is really awesome, and longer lenses can magnify this. Also, the longer the lens used, the bigger the sun will be in the photo. For example, with a 400-mm lens, the sun will still be only 4 mm wide on the slide. A good lens for this picture that is still small enough to carry with you is one of the zooms in a focal length from 70 to 200 mm. In general, I have not been impressed with most teleconverters or telextenders. The problem with most telextenders is that they don't produce a crisp, sharp image. But the one place I do use them is for taking sunrise and sunset photographs. Nothing ever appears razor-sharp in this situation anyway, so the drawback of the extender can be ignored. And a sunset shot with a 2× extender on a 400-mm lens is dramatic and eye-catching.

Filters can help or hinder. They may cause additional flare, since you are shooting directly into the sun and the rays can bounce around on the extra glass before striking the film. The more expensive filters do a much better job in such situations. If you remember that colored filters add that color to a color side or print film, then filters can sometimes be used to "dress up" a sunrise or sunset. For example, if the sunset has some clouds, but it appears that a weak, pale sunset is going to result—lacking deep colors—you can use an orange filter. What this filter will do is turn any orange in the sky into red, any yellow into orange, and any white into pale orange or yellow. What you have done in effect is to replace some of the existing weak colors with more brilliant ones. Some people will use a red filter for this purpose. I and many others who have seen this type of photograph feel that a red filter so overwhelms the photograph as to be displeasing to many viewers.

Sunsets are always more dramatic when there are clouds in the sky. The best situation is one in which some clouds are low on the horizon near the sun, and graduated layers of clouds rise above that. Then, as the sun rises or drops low, the angle is such that each bank of clouds receives a different coloring of light. Clouds that have

"bumps" and contours create more interesting color patterns than flatter formations.

Pollution can make the sun glow fiery red. Photos made near cities, especially those with industrial areas that put a lot of dust into the air, can result in a spectacular fireball of the sun as it sinks to the horizon.

Just like moon shots, the sun by itself, or even a sunset with nothing but sky showing in the slide or print, usually lacks impact. If something can be put in the foreground, such as a person, a tree, a rock formation, or a building—anything to add impact—the photo will be more pleasing. Sometimes a tree, rock, or other object can be used as a frame for the sun and still show off the lovely sky around it.

Kodachrome film lends itself especially to red and brown colors, making them much richer in tone. Many people feel that this is the best film choice for most sunrises or sunsets.

How to expose for the sunrise or sunset is easy. With the sun positioned in the middle of the photograph, take a meter reading at what would be one-third of the way toward one edge of the picture with about a 50-mm lens. After you take the photo and have the film developed, examine it. The photo should look about the same as you saw the scene. If you want the picture to be a little darker and richer, the next time meter a little closer to the sun. If you get only a bright fireball of color and everything else in the slide or print is dark, then you metered too close to the sun. With a few practice shots under your belt, you can soon make readings that will predict what you are going to get. A note of caution: holding the meter directly on the sun can "poison" it for a brief time and result in inaccurate readings. Avoid metering directly on the sun, unless you can easily stare at it without squinting. Generally, slightly underexposed pictures are more pleasing—all colors in the sky will be darker and richer—so you should adjust the ISO setting higher. If you have a camera that only has an automatic mode, you can sometimes still get nice underexposures. If there is an ISO setting, simply move it one or two stops higher than the film being used. For example, if you are using ISO 64 film, take one photo with the camera set on ISO 125 and another on 250. It's another way you can bracket exposures.

If the sun is below the horizon, it still casts its rays on the clouds. If there are a number of clouds in the sky, what often results is a colorful picture far more spectacular than the sunrise or sunset itself. This is often referred to as *afterglow*. Both the color and intensity of the light change continuously during this afterglow period. A tripod is needed for this, because the exposures are frequently long. Many necessary shutter speeds are from one to four minutes in length. Bracketing is a must here, for not only is the exact exposure difficult to determine, but often several exposures give completely different—and very pleasing—results. Many times, a normal or wide-angle lens works well, since you want to capture the soft, moody, pastel colors that permeate the entire sky. Afterglow pictures are especially beautiful if there is water in the foreground, reflecting all the sky's colors. I am finding that I prefer to shoot more afterglow pictures than sunrises or sunsets.

Night Pictures

To take night shots you must have a light source, and in most cases you will be making long exposures. This requires the use of a tripod for sharp photos. The only natural light sources at night are lightning and the moon and stars. Lightning is so bright that it will clearly imprint itself on the film. To get lightning pictures, you should first

be very careful and photograph storms from a distance. There's too much danger in setting up a metal tripod in a storm; it may be a high point and attract lightning. Try photographing lightning from a distance, with longer lenses. The exposure for the scene is tough. Some very successful lightning shots have been made after dark by placing the camera on a tripod and using a lock-type cable release. Set the lens for infinity and at the largest f-stop to get the greatest amount of light to the film, and adjust the camera speed ring to bulb (B) or time (T). When you feel that lightning may strike, press down the plunger on the cable release to open the shutter. So long as you depress the plunger while the speed ring is on time or bulb, the lens will remain open. As soon as the lightning has struck, release the plunger, and then hope you got the picture.

Stars are more predictable, and you can get a very interesting picture if you have a cable release and bulb or time on your camera speed ring. You also need a tripod, or at least a firm support for your camera. While we learned in school that stars move across the sky as the earth rotates, we probably haven't thought about it in a long time. But you can really prove this with your camera.

Set the camera f-stop at its widest opening and focus it on infinity, with the speed ring on either bulb or time. Screw the cable release in the shutter release port. Then position the camera on a tripod so that it faces upward into the sky. A normal lens (50 mm to 135 mm) works best for this. When all is ready, push in the cable release plunger and lock it so that the lens is held open for at least two or three hours. Obviously, you need a clear sky, and no fog. Cool nights with no humidity are always best for these pictures.

When the film is developed it will show many bright, circular streaks where each star or satellite has orbited around the earth. Naturally, the longer you keep the lens open, the more distance each star will track in the film. What is very important for good results is that you must do this away from bright lights, such as those of a city. These lights illuminate the sky too much, and the star tracks often don't show well. Also, if the moon rises while the shot is in progress, the added light will spoil it. This is a neat photograph to get when backpacking in the mountains or desert on a clear, dark night. A word of caution: the night can't be a cloudy one, and watch for rain while the camera is being used for the shot.

▲
By placing the camera on a tripod, with the shutter wide open (best lenses are 50 to 105 mm) on a dark night, and keeping the shutter open for long periods of time, you can use the light of the stars to photograph their nightly circle around the North Star.

Moon pictures are not too difficult to take, and the light of the moon is fairly consistent, if the sky is clear. Obviously, it pays to take pictures when there is a full moon if you want maximum light from it. Some photographers use a double-exposure technique for moon shots. They load a roll of film, making a mark on the inside of the camera that coincides with a mark on the film, and then take a number of

photographs of the moon with a very long lens. This allows them to magnify the moon's image. Then they roll the film back into the cassette and store it away until the right opportunity arrives. At that point they reload the film into the camera, making sure that the two marks are carefully positioned so that the photographer can now make accurate double exposures. All of this can get complicated and is fun, but is not too practical when on the trail. There are a number of books that describe this method in detail if you'd like to try it.

Fast films work better for moon shots. I'd suggest using an ISO of at least 400 for this effort. If your exposure is more than two seconds, the moon may appear a bit blurred. For shots of a full moon where the sky is clear, a good technique is to remember the "sunny sixteen" rule as explained in the chapter on exposure (place the equivalent of the ISO of the film on the speed ring and the f-stop at 16)—*but open one stop more than the "sunny sixteen" rule dictates.* For example, with an ISO of 125, you would use 1/125 on the speed ring and set the lens aperture at f/11.

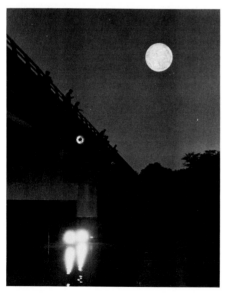

Flash

The use of flash outdoors will help in many photographic situations. Sometimes there simply isn't enough light, or it is so dim that you can't take the picture at a reasonable shutter speed. Of course, night pictures almost always have to be artificially lit, and flash is one answer. In bright sunlight, many outdoors people wear a hat, which means their faces are shaded. Fill-in flash can put just enough light under the hat to retain a suggestion of shadow and yet show detail in the features. Fill-in flash can also be used for many outdoor subjects, including flowers, insects, and birds. In some wildlife and bird situations, a flash can be set up and either triggered on command or when a creature trips a light beam or mechanical device. The light waits patiently until it is commanded to fire. With such techniques, some rare and elusive animals and birds have been photographed that would otherwise be nearly impossible to capture on film.

For many years, flashbulbs were used universally to take flash pictures, and while there are situations where they are still very useful, almost all active outdoorsmen today use electronic flashes. Flash units are plugged into the camera body, and if you use bulbs, you need to insert the flash unit's plug into the receptacle marked B, for "bulb." For an electronic flash, you need to insert it in the receptacle marked X.

Electronic flashes (often improperly called strobes) have many virtues for the person taking pictures outdoors. They are lightweight; most are very portable; they can be purchased at a variety of prices; many can tolerate tough treatment on the

◄

Lanterns suspended from a bridge lure minnows to the lights, which in turn lure crappies, and anglers can catch them. A long exposure on a tripod, using the light of the lanterns, made possible a photo of the scene.

▲

Many SLR cameras must be set at a specific speed setting to make a proper flash picture. If they are not, a portion of the picture will show black, as in the left side of this photo.

trail; for their size they have a great light output; and the duration of the flash is very brief—an outstanding advantage.

There are also some disadvantages to electronic flash that need to be recognized. The flash must synchronize with the shutter speed of an SLR. Generally, this requires that the shutter speed be set at 1/60 or 1/125, although there are models on the market that operate at faster speeds, or at all speeds. You need to check your owner's manual. Photographs taken at too fast a speed setting will show a portion of the picture black.

Another problem is that the number of flashes you can get out of a battery is often limited or insufficient. This requires carrying extra batteries. Many electronic flashes operate on AA batteries. I suggest that the motor drive on your camera, the emer-

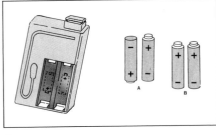

▲

Conserve your batteries by storing one of them in the wrong position. A shows proper installation; B shows that storing one battery improperly will prevent battery burndown if the switch is inadvertently turned on. Just reposition the battery correctly before use.

gency flashlight that you carry, and your electronic flash all use the same size batteries. That way you always have with you a number of them to draw on. A trick that I have used for years is to carry one battery in reverse inside the flash. On several occasions I wanted to use my flash, only to discover that the switch had inadvertently been turned on, burning down the batteries. I began placing one battery in the reverse of the proper position inside. If the switch did get turned on, the batteries failed to burn down. So far as I know, this causes no trouble and I've used this trick in at least a half-dozen electronic flashes, as well as in the emergency flashlights in my camera bag and my car.

Many electronic flashes come with a rechargeable nickel-cadmium battery. If you are going to use these, I'd suggest buying at least one spare battery. A major mistake made by many people who use rechargeable batteries is not to realize that they should be recharged about once a month. Many people charge the batteries, use a portion of the charge, then store them on the shelf. Several months later they try to use them again, only to find that they're dead. Nickel-cadmium batteries should be recharged routinely at least once a month. It pays to keep a log of charging dates for each battery. Unfortunately, most photog-

▲

Number rechargeable batteries so that you know which ones are exhausted. Labeling flash cords will let you remember which cord is giving you trouble.

raphers won't do this, and they have problems with the batteries. If you fail to do this and find that the batteries still have some life—but not much—there is often a way to revive them. What you need to do is fully charge the battery, then completely discharge it. Then immediately recharge it and repeat the operation with three charges and discharges. Many times, an apparently dead battery can be revitalized. Don't worry that you'll be recharging your nickel-cadmiums too much; most are good for 5,000 or more recharges. Unless you are willing to follow the charging program, it's best not to use nickel-cadmiums.

Those who don't want to be bothered with constantly charging batteries can buy "throwaways." The least expensive of these are carbon-zinc batteries, but they will not deliver as much power, and in the long run are more expensive if you take many flash pictures. A better type of battery is the manganese-alkaline type. These cost more, but give greater power output and last longer. Another kind that is even more expensive, but is supposed to deliver longer life and better service, is the lithium battery (these are used in cameras as well). With throwaways or rechargeable batteries, you can tell when they are low

on power because the recycling time is much longer to get the flash ready to fire.

Another disadvantage of electronic flash units is that some of the PC cords used to connect them to the camera are poorly made, won't stand much abuse, and fail at a critical time. I strongly suggest carrying at least one spare PC cord in your camera bag or box. I also suggest having a PC extension cord that allows you to move the flash unit at least four or five feet from the camera. This will come in especially handy when you are making close-up photographs. It allows you to manipulate the light and rid yourself of background shadows. The best PC extension cords have a lock that keeps the connections tight, but if yours doesn't, use a rubber band, or you may fire a shot only to find the light not going off.

Almost all flashes today come with some automatic features. That is, for at least certain f-stops they will deliver a proper exposure. And almost all flashes also have a manual function, which means that the unit puts out the same amount of light at each discharge. This requires that adjustments be made in lens aperture as the distance changes from the subject to the camera. It is important that the photographer understand how to use the manual function; there are times when it will do a better job than an automatic exposure.

Because you must make adjustments in the aperture as the camera-to-subject distance changes, you need to know the correct f-stops for those distances. There is a simple way to establish this guide number, and it varies with different flashes, so you need to make a personal check of your equipment. Have someone sit or stand ten feet from a camera and flash that are mounted on a tripod. During the test the person and the camera should remain at the ten-foot mark. It helps if the person wears clothes that have different colors, or holds something yellow, blue, red, or

▲

On the right is a typical short PC cord that connects your flash to your camera. On the left is an extension that allows you to move the flash well away from the camera.

When using an extension PC cord, make sure that the connections don't loosen. Two simple remedies are the rubber band (left) or a cord that has a metal retaining clip.

▼

green. If you have no idea what the approximate f-stop should be for ten feet with the ISO film you are using, you will have to shoot a few additional photos. But once this procedure is followed, you will always know what guide number is right for your flash and a specific film. Make a series of four-to-six-inch square cards and mark an individual f-stop on each of the cards, for example, f/4.5, f/5.6, f/8, f/11, and f/16.

Have the subject hold a card against his or her chest and shoot a picture using the indicated f-stop at exactly ten feet from the flash. Make an exposure at each f-stop, while the person holds the corresponding card. When the film has been developed, study the photographs. Let's assume that f/8 was the best exposure. Since the subject was ten feet away, multiply f/8 by ten feet, and the guide number for your flash on the manual with that film is 80.

How do you use the guide number? When taking a picture, focus on the subject and note the distance from the flash to the subject. Let's assume that it's four feet. Divide four feet into the guide number, and you will get an f-stop of 20, which should give you the correct exposure. Once you have established the guide number for your flash and film, all you need do is divide the distance from the subject to the flash into your guide number. Many people make the mistake of dividing the distance from the camera to the subject. *But it is the distance from the flash to the subject that is necessary to determine the f-stop setting.* Very often in close-up photography, the flash is set at a certain distance and the photographer moves the camera in and out. *Always be aware that the exposure is from flash to subject.*

Electronic flashes almost always have a guide on the side of the unit that indicates the proper exposures (what f-stop to use at the currently focused distance). By looking at the guide and knowing the distance to the subject, the photographer can determine the correct f-stop. However, these flash units almost always suggest that they are more powerful than they really are; if the guide is followed exactly, the photo will usually be underexposed.

One word of caution. Either with an established guide number or when the flash is in the automatic exposure mode, it will deliver the correct exposure under normal conditions. But when you are using flash outdoors on a manual setting, there is usually nothing that will bounce stray light

▲
The small Pelican carrying case makes a superb waterproof box in which to carry a flash or many other small photo items where water or dust may be a hazard.

▲
Many flashes have several automatic modes that require some adjustments by the photographer. It will save you time if you place a label with the information on the camera.

back toward the subject. Unless your guide number was established outdoors, you will probably have to open up at least one and a half stops to get a good exposure. This is all the more reason why you should bracket all shots if the situation permits. There are very few flash units that will allow you to get proper exposures outdoors beyond 25 feet.

More and more photographers are using what is called a *dedicated flash*. This is an electronic unit that is designed to work specifically with your camera model. Many dedicated flashes made by one company for a particular camera won't work on another of the same company's models—so be sure, when buying a dedicated flash, that you get the one that is right for your camera. Such flashes resemble regular flashes, but they cost about one-third more. With a dedicated flash, its sensor

reads the light that comes through the lens, and when it determines that the correct amount has been delivered to the film, the flash is shut off. So, if your flash happens to be aimed slightly off target, the sensor in the dedicated flash will allow the light to continue pouring through the lens until the correct amount is delivered.

Through a set of contacts that join the shoe of the dedicated flash to the camera (or through a special extension cord), the dedicated unit electronically takes over flash operation of the camera to a large degree. Most models will automatically set the camera to the correct synchronization speed. With many units, you must set the lens aperture at one of several options, so that it may only give correct exposures at, say, f/2.8, f/5.6, and f/11. The more expensive flashes will monitor the light coming through the lens and cut it off after the proper exposure, regardless of what lens aperture setting is used. The latter is certainly the most desirable type. However, the more closed down the lens, the more flash power is needed for proper exposure. To avoid using too much battery power, consider using the widest f-stop you can.

Many pictures are improved if the flash is not attached to the camera, but is held at an angle. This allows you to backlight or

sidelight a subject—giving you control of the lighting you want. In some cases there are extension cords that allow you to add two or more flashes—all of which may be held off the camera—so that you can get back, side, or fill light. A major reason for taking the flash off the camera when photographing people is that it eliminates what is called "red-eye." You must have seen color photos where the subject's eyes glow a bright red. This is caused by leaving the flash on the camera, so that the beam is aimed in the same direction as the lens. The light enters the subject's eyes and reflects back to the film the blood vessels deep within the eyes. Thus we are looking at the blood vessels of the subject's eyes—not very flattering. Also, a flash attached to the camera will often produce a distracting deep shadow directly behind the subject.

You can buy for most dedicated electronic flashes a remote sensor cord. This is a cord that has a sensor mounted in the "hot shoe" on your camera (and is aimed in the same direction as the lens) and the other end is attached to the flash. Usually, remote sensors with cords in excess of six feet in length are the most useful. This remote sensor cord allows you to move the flash off the camera and vary the light distance and angle. But the sensor is seeing what the lens sees—and so you should get consistently good exposures. However, even with automatic flashes, you should always bracket. Remember that adjusting the f-stop won't do it, for the flash will adjust, too. This means that if you set the f-stop on three different settings, any automatic flash will deliver you three photographs exposed the same way. To bracket an automatic flash, you have to adjust the exposure compensating ring, or you can use the ISO adjustment on your camera. But don't forget that you must put that adjustment ring back to zero for the correct ISO for future pictures.

▲
Sometimes outdoors a flash is the only way you can get the picture, and the brevity of the flash can freeze the action.

When buying an automatic flash for the outdoors, try to get one on which the head can be adjusted to different vertical angles; an even better type is one on which the head can be moved sideways as well. Remember that a flash mounted on the camera body will be six to eight inches above the lens. It will direct much of the light above the target in close-up photography. A light that allows the flash head to be tilted slightly toward the lens would mean you could point the beam directly at the target in close-up photography, when the flash is mounted on the camera body. Flashes that tilt can also be used for bounce lighting. A straight-on flash often creates harsh shadows, but you can soften them by bouncing the flash off something—in close-up photography, that may be simply a piece of white cardboard. Indoors, it may be a light-colored ceiling. Remember, whenever you bounce light off a surface, the color of that surface will be carried to the subject. For example, if a person stands close to a red wall and you

bounce the light off the wall, the light will have a reddish tint that will affect the coloring of the subject. That's why a white surface is preferred for bounce lighting. You can point the flash head vertically at a slight angle above the subject, and then hold a white cardboard at an angle so that, when fired, the light bounces from the card down to the subject, giving you relatively shadowless, soft lighting. Flashes that read the exposure off the film and automatically shut the light off when the correct amount has entered the lens are best for bounce-lighted pictures.

An important feature of flash photography that should be remembered is that when a flash is brought very close to any subject, especially if it is to one side, the side nearest the light will receive considerably more light than the far side. This will often result in one side being overexposed or burnt out, and the other side being slightly or deeply underexposed. To eliminate this problem, simply move the light back farther; then the ratio between one side and the other is diminished and the entire subject is more evenly lit. An alternative is to bounce the light off something, such as a white card.

A handy device on some automatic flashes is a variable power adjustment. This allows you to vary the output, and in many cases just a little "splash" of light is all that is required—such as in flash fill.

There is one flash that is very much dif-ferent from all others, and that is the *ring flash.* This is a circular flash that fits *around* the lens and delivers light to the subject from 360 degrees. Such a light is excellent for some purposes, such as very close macro photography. This type of light eliminates almost all shadows and allows you to get a clinically good look at the subject. The ring flash is also very good for taking close-ups of insects and small creatures. Flat flowers, such as daisies, are often beautifully photographed with a ring light. However, because they do produce almost no shadows in most cases, many photographers do not like ring flashes. There are now on the market several ring flashes that have separate lights around the rim. This means that you can adjust the intensity of each of these little units and get some controlled shadowing.

Electronic flashes allow us to take many photographs we could not otherwise get. And modern electronics have given us instruments that, when used with good sense, help us to produce beautiful photographs.

▲
Norman Bartlett has developed a very easy-to-make flash unit for close-up pictures that results in shadowless pictures. A small flash is positioned against the inside of a white plastic bowl. A hole is made in the center of the bowl and a bracket attached to hold the camera in position. This unit is extremely effective.

◄
A photo made with Bartlett's bowl.

CHAPTER 5

COMPOSITION

Defining composition is difficult, but when a photograph is poorly composed, most viewers quickly recognize it. When someone looks at a potential photograph, there are two decisions to be made: what to put in the picture, and what to leave out. That's the first step in composition. A number of factors must be evaluated to make the photo successful. There should be a main subject or point of interest. How to use various forms and shapes to enhance the picture is a major consideration. Just as important is what kind of light we use. Whether we are using color or black-and-white film, we need to determine how the colors or shades in the scene will help or hinder the final image. The best lens and aperture for the picture must be evaluated. How we position each part of the scene, where we stand, whether we take a high or low position, and the way we use the light that falls on the scene are all part of composition.

No matter how well exposed the picture, or how interesting the subject, if the composition is poor, the picture will probably not please viewers. Much of how you expose the picture, and whether it is properly focused, are mechanical decisions. But composition is a creative thing. Some people instinctively have the ability to compose a picture so that all elements within it are pleasing to the viewer. Three people asked to look at a scene, and then record what they think is important in it, will probably make three different lists. This emphasizes the point that we all see things differently, and that any scene may be pleasantly composed in many ways. The final composition is determined to a large degree by what the photographer thought was important and wanted to convey to the viewer. Fortunately, there are a few simple guidelines that can help us to compose better pictures. It is not always wise to follow the guidelines, and an occasional vio-

lation of the rules will produce an out-standing photograph. But most of the time, adhering to these rules will improve your outdoor pictures.

I believe that one rule applies to every photograph you take, regardless of whether it is a ship at sea, a nude, a child at play, a deer leaping over a log, or any subject. *Put only in a photograph what you want the viewer to see—nothing else—and compose to make the viewer look at the main subject or point of interest!* It's amazing what people will see in a picture that you thought was just right. They may notice in a close-up picture that there is a small wart on the finger of a person plucking a morel mushroom. And once they mention it, the picture will never again quite satisfy you. I try to avoid having watches in photographs if possible. In slide shows, in a picture in which someone is holding an object and there is a watch on the person's wrist, I've seen people cant their heads just to determine what time the picture was taken. Backgrounds can be terribly distracting. We've all seen pictures in which a telephone pole is positioned behind a person so that it appears to be growing out of his or her head. Or pictures in which people hold fishing rods, shotguns, rifles, and other objects so that they cross a person's face. What this primary rule really means to someone interested in taking better pictures is to take your time and look around a photograph; don't just hold up the camera, take a meter reading, focus, and click the shutter.

One of the most useful tools for improving your compositions is a tripod. I suppose all photographers recognize that a tripod will allow them to take sharper pictures because the tripod stabilizes the camera. But the tripod forces us to do something unconsciously that I feel is even more important. When we put a camera on a tripod, *we slow down.* There is a tendency, when hand-holding a camera, to focus, look quickly, and shoot. With a tripod we tend to observe many more composition factors, and we do more thinking about the picture before we touch the shutter release. Better photographs are the result. I urge you to use a tripod whenever possible.

No matter what you are photographing, the picture will usually make a stronger statement if there is a main point of interest. Before you click that shutter, try to identify the point of interest—what you want the viewer's eye to go to immediately. Naturally, if you are taking a person's portrait, the face will be the point of interest. While looking through the viewfinder, try to recall just what stimulated you to make this photograph in the first place; that is probably the point of interest. Once you recognize it, you can then determine the best way to show it off. This could include how you allow the light to fall on it, how it's framed, and from what position you will take the picture.

Some of the best outdoor photography that you'll ever see is in advertisements in magazines. These shots are almost always taken by professionals. Even more important, each photograph was usually planned and laid out long before the picture was taken. Every element in the photo was considered before the photographer went into the field. Take advantage of this, and study outdoor advertising pictures that are pleasing to you. It's one of the best short courses in good photography that you can take.

In many of these advertisements, the photographer is trying to force you to notice the manufacturer's product—the point of interest. They almost always do that by placing the subject up front in the photo. To give more impact to the subject, a wide-angle lens is used. Wide-angles make things close to the lens look bigger than other features farther away.

In the outdoors, this trick of putting up

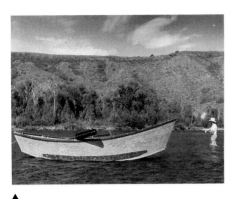

▲

This angler is using a drift boat to get from pool to pool on a western river. Placing the boat up front makes it dominate the picture.

▲

This is a fine catch by the angler. To emphasize the channel bass and force the viewer to look at it, the fish was placed in the foreground.

front what you want to emphasize, and using a wide-angle lens, can be used in many cases. Here are a few examples. You could photograph a single wildflower close-up, but have others in the background. This allows you to see the entire group of flowers, but also to note the detail in a single blossom. You could have a canoe beached on the shoreline, and in the background show two campers eating their dinner by the fire. A box containing fishing lures or flies close-up in the foreground, with the angler casting in the background, tells where the angler is fishing and what the fish may be caught with.

There are several reasons why you may want things in the foreground if you are trying to emphasize them. Optically, the camera is going to make the closer things dominate the photograph. Because the near things take up so much of the photograph, they tend to block out less important features. Further, if the emphasized subject is large in the foreground, it gives the viewer the ability to study it in detail.

How we use light to compose the photograph is extremely important. Consider how different each photograph of a farm scene would be if pictures were taken under the following light conditions: a

foggy day, an early-morning sunrise, during a thunderstorm, at twilight with lights on in the farm buildings, or with a shaft of light coming through the clouds and illuminating just the barn. You can quickly understand that light has a major affect on both mood and composition. Strong sunlight also produces deep shadows. These shadows can be used to show the texture of sand dunes, rough tree bark, or snow-covered rocks. Those same dark shadows can be used to eliminate items from the scene that may be distracting. And those shadows can be highways for the mind that lead the eye to the point of interest.

Using morning fog, with the sunlight streaming through it and a ray of it shining on the subject, is composing with light. Fog can also be used to eliminate features you don't want to see, or to create moodiness. A single shaft of light coming down through the trees can be used to isolate a subject or point of interest. Brilliant light falling on pale flowers will usually mean washed-out tones, and you may want to wait for a cloud to diffuse the light so that you get enhanced colors, or come back another day when the light is less brilliant. Sometimes such light can be used to make an attractive picture. For example, a group

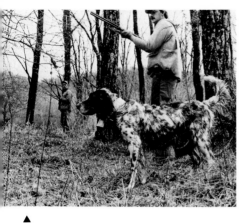

▲

Three composition factors are at play here as the hunters and dog are on the right moving into the picture; keeping the angle low and placing the dog in the foreground makes it the most important part of the picture.

of light-tinted flowers taken in bright light with a slight overexposure will render them in subtle wash tones that may resemble a painting. Deliberately underexposing a picture, so that distracting details in the shadows are turned so dark that they disappear, is often effective. By underexposing, we also enrich the colors and can make a different statement—a factor in

composition. The point to remember is that light is one of the tools you can use to compose your picture.

Another major factor in composition is how the action flows into a photograph. I think that this rule is generally important to good composition: *Have the action move into a photograph, not out of it.* What does this mean? If there is someone canoeing across a placid lake, the usual tendency is to place the subject in the middle of the photograph. For our purposes, let's say the canoe is moving from left to right. With the canoe moving from the center to the right, the viewer gets the impression that the subject is paddling *out of* the photograph. I feel that it makes for a much better balanced picture if the canoe and paddler are to the left of center, paddling *into* the photograph.

The man who is shooting at an escaping grouse should be to one side, shooting into the picture. The backpacker walking through a beautiful forest should be coming into the photograph. To really appreciate the impact of this, try shooting a photograph with the subject coming into the picture, and then another with the subject placed at the other edge, seemingly going

▲

Having the angler fishing out of the picture leaves the viewer with an uneasy feeling.

▲

With a slight shift of the camera, the angler is fishing into the picture—a considerable difference in impact.

► *When a number of people are being photographed doing something, all of them should be looking at a central point, or point of interest, like these conservationists examining the contents of a net.*

out of the photograph. Then ask friends which picture they like best. It is soon obvious that a skier should be coming to the picture, or a deer leaping over a log with the rest of the photograph to run through. This applies whether the photograph is in vertical or horizontal format.

Sometimes the movement or action is subtle. For example, a person looking through field glasses isn't moving, but the implication should be that he or she is looking *into* the photo, not out of it. Thus we should position people off to one side. Especially in vertical photographs, most photographers tend to place the subject directly in the middle.

Closely related to this idea is the "rule of thirds," often discussed in photography. Actually, I think it's easier to understand and apply if we say that when there is a horizon in a photograph, it should be near

Putting too much sky in a photo is a common fault of photographers. Whatever is most interesting or attractive should take up most of the upper and lower portions of the scene. Decide on what is the most important part of the scene, then eliminate the least interesting part—in this case, the all-white sky.

▼

the top or near the bottom. The only time a horizon should be dead center is in a good reflection shot.

I believe that this is one of the most violated of all composition rules. How many times have you looked at a picture in which there is a totally bald or white sky in the upper half of the photograph? The photograph would actually be improved if the upper half were cut away. How you determine whether the sky should be in the very upper portion or the lower portion is simple. Make it a rule that the sky dominates the photograph only when it is justified; if the sky doesn't enhance the picture,

Taking away almost all of the sky gives the photo much that is interesting for the viewer to look at.

▼

then chances are it's best to leave only a suggestion of it or, often, none at all. The key to where the horizon goes is to look at the photo and ask yourself, "Is the foreground or the upper portion of the photograph more important?"

There is another advantage to eliminating the sky from many pictures—especially if you are taking slides. When looking at your slides, viewers are seeing *reflected* light from a bright screen. If there is a white sky in the photograph, it is actually a form of glare, making it difficult for the viewer to see the darker images on the screen.

There is one time when you should have the water line or skyline dead center, and that's when you are taking a reflection picture. The more nearly the horizon is centered, the more pleasing this type of photograph usually is. A good check with a slide is to look at it, and if you are not sure whether it's upside down or right side up, then you have taken a good reflection shot.

A very "illuminating" test is to project on the screen a slide with a portion of the photo containing white sky. Then take a piece of cardboard and mask out the white sky while you are looking at the darker subjects in the foreground. With the brilliant glare removed, considerably more de-

A reflection shot is the only kind in which you want the waterline or skyline to run directly across the middle of a photo.

▼

tail will be instantly noticeable in the darker areas. With this same slide projected on the screen, move in close and meter the sky, then the darker foreground. Chances are there will be three or four f-stops of difference between the two. In such a case, the sky will be a bright glare and detract from your picture.

The ability to make a photograph so that *only* what you want the viewer to see is in sharp focus and all other elements of the picture are fuzzy is another composition control at your command. The aperture on your lens allows you to do this. By controlling depth of field, you can control what the viewer sees. To increase the depth of field, stop down (for instance, from f/5.6 to f/8, f/11, or f/16). To reduce depth of field, open up. As a general guide, you can figure that opening up two stops will halve the amount of the picture that will be in sharp focus. Also, the farther you are from the subject, the more details appear in focus; moving in closer will often allow you to reduce what will be sharp in the final shot. Many times, getting very close to something peripheral to the subject, such as flowers or fall foliage, will make them so out of focus that they become soft blobs of color that enhance the picture and force the viewer to look at your point of interest. Of course, there are some situations in which you want a great deal of the scene to be in focus, and so you would select a small f-stop. The point is, controlling depth of field has a great deal to do with composition.

Framing is another device that has been used to improve composition. A picture hung on the wall without benefit of a frame usually isn't as attractive as one with a frame. There can be a considerable difference between two of your pictures in which a frame is used in one and not in the other. A frame is something in the scene that either surrounds or is to one edge of the photograph, and leads the eye

to the point of interest. It could be a rock leaning from one side into the picture, a colorful tree limb in fall foliage, or a stump in the foreground. It often helps give a third dimension to a photo. Most often, a frame is positioned at the top or to one side of the scene—but not always. Frames are all around us, but unfortunately, we outdoor photographers don't use them often enough.

A fisherman casting toward the camera from open water can make for a pretty drab photo. But if there is a series of mangrove roots in the foreground, standing on spiderlike legs, a knowledgeable angler viewing this scene instantly recognizes it as a saltwater flat where the fisherman is probably seeking bonefish. And the photograph is so much more meaningful and pleasant to look at with the mangrove roots in the foreground as a frame.

A picture of someone cross-country skiing over a wide-open field covered with snow can often be improved if a tree shrouded in snow is used as a frame, leading the eye to the skier. A jagged, twisted pine tree in the foreground, tortured by wind and weather, with hunters and a pack train coming up the ridge below, lets the viewer know this is probably a photograph made in the Rocky Mountains.

Frames don't always have to be in sharp focus. Indeed, sometimes a fuzzy, out-of-focus frame can enliven a photograph. For example, one of the most pleasant frames is created by placing the camera near a cluster of colorful flowers, or bright autumn leaves in full fall colors, using them as a frame. Remember, though, that if they are in sharp focus they often lead the eye away from the subject. The trick here, often not recognized, is to open the lens aperture very wide, throwing the entire close foreground completely into soft focus.

Often, if the frame is totally black but is filled with strong lines that force the eye to

▲
Many times, frames help make an outdoor photograph. All sorts of frames exist if you look for them—in this case a railroad tunnel.

▲
A mangrove tree on one of the Florida Keys serves as a frame for this shot.

▲
Note that the tree follows the contour of the subject (even to the stub on the tree limb and the soda can the person is holding). If the subject and the frame repeat each other, viewers often find the photo more pleasing.

▲

Two different compositional techniques were used to take this picture of an airboat ride advertisement. The first picture shows a reflection, but there is an uninteresting sky.

▲

Moving to a nearby chikee and using the thatched hut for a frame results in a more pleasing photo.

Another way of composing the picture is to use a long lens and show only what you want the viewer to see. Splitting the skyline (this is a reflection shot) helps add interest.

▼

look at the subject, you will have an outstanding photograph.

Another use of a frame is to eliminate something that you simply don't want in the photograph. It could be a distraction, something ugly, or something that would simply spoil your picture. For example, remember the bald sky that can ruin your picture? One way to get rid of it is to use a frame. Perhaps it's a bridge overhead, or it could be a projecting rock, a stout tree limb, branches filled with bright leaves, or a host of other things. If no frame is available, you can often make your own. One old trick is to hold a few branches of bright fall leaves in front of the camera so that they make a pleasant frame. The leaves can be adjusted to the desired height. When using leaves for frames, I often resort to a pair of garden clippers I carry in my backpack. By trimming away certain leaves or tiny twigs, I can "arrange" my frame to suit me.

I believe that frames which conform to the same outline as the subject are more appreciated by viewers, and I look for such situations. Let me give an example. If there is a church that runs from left to right and at the right end there is a steeple, I'll look for an opening in the tree leaves that runs along the shape of the roof, with an open-

ing that will frame the vertical steeple.

When you begin composing a picture, evaluate all the factors just discussed—but don't be in a hurry, for choosing the right moment might make the difference between a drab photograph and a vital one. This is especially true if you are photo-

graphing action, such as a canoe race, an angler fighting a fish, a dog on point (wait until the bird is flushed into the air), or a boy swinging on a rope over his swimming hole. Take the last example: if the boy is just swinging, the picture is a little static. But if you click the shutter just as he releases the rope, or maybe just as he starts his plunge into the water, more action is conveyed. A hunting dog on point is a nice photo, but if the grouse or pheasant suddenly leaps into the air, the hunter crouches and goes into action, and the dog's whole demeanor changes. Taking the picture at the right time is a tool of composition that can make an enormous difference in the photograph's impact on the viewer.

▲

Light subjects shouldn't be placed against a light background.

When the light subject is placed against a dark background, it stands out. Always use a contrasting background behind your subject.

▼

▲

If the two fishing lures were laid by themselves on the dark background, there would be no way the viewer could tell their size. But placing something that is recognizable—such as this standard spinning reel—beside an object gives the viewer a basis for comparison.

The background in a photograph is extremely important, and can ruin or make a composition. If the background is "busy" or full of distractions, it will usually spoil the picture and can often become the center of interest—something you don't want. The best backgrounds are usually very plain, almost monotone. Mottled light or blobs of light and dark in the background are usually disastrous; this is especially

true with black-and-white film. *A good rule for backgrounds is to place a dark subject against a light background and a light subject against a dark background.* Sometimes backgrounds can add to a picture, but you have to be sure it doesn't dominate it. A backpacker in the foreground, striding toward the camera, dominating the scene, with a snow-capped mountain in the background, tells you where he just came from. Among all the considerations for composition, background is always a key one.

Sometimes we must handle a composition a little differently when we are using black-and-white instead of color film. The different colors in a photograph can be used dramatically in a scene, but when we have to use black-and-white film, we are really dealing in shades of gray, from white to black. In some instances, color can be distracting in a photograph, and a black-and-white print may be even more effective. Many photographers who have used little black-and-white film find, when they switch to it from color, that it is much more difficult. But if you realize that the shades of gray can either enhance or spoil a photograph, depending upon how they are used, you'll soon get the hang of it.

▲

When composing a silhouette photo, you must be careful to keep all of the subject surrounded by the bright area. In this photo, even though the photographer could clearly see the person, the camera saw only a dark head against a dark background.

Changing the camera angle slightly to position the subject so that there is a bright area all around it makes the silhouette work.

▼

One way to compose this picture is to use a relatively short lens and have the person come from right to left. The subject is light, the background dark.

▼

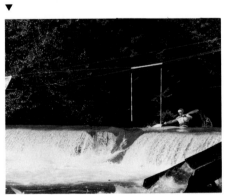

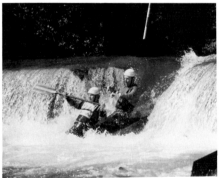

▲

Two strong compositional techniques are used to show these people on an Icelandic river. The photo was exposed to make a silhouette and the river made an S-curve, which almost all viewers find a pleasing form.

◄

Another way to compose the photograph is to use a longer lens, come in close, and shoot at a slightly slower speed, which causes a slight blurring of the figures diving over the falls and gives the viewer a feeling that the action is fast.

TRIPODS AND OTHER STABILIZING DEVICES

Perhaps the most underestimated piece of camera equipment is the tripod or one of the other steadying devices. I recall traveling through the western United States many years ago with Walter Heun, a close friend and one of the world's best photographers. Both of us were using Leica SLRs, and we swapped lenses for various shots. We also used the same kind of film. When I returned home and looked at my slides, I though they were pretty good. A few months later I was able to look at Walter's slides on an eight-foot screen. I was stunned. His slides had so much more of the picture in focus than mine did, and were sharper as well. I couldn't understand it. We had used the same type of camera bodies, often the same lenses, and comparable films. I wondered out loud why his pictures appeared so much more detailed and sharper. "You didn't use a tripod,"

Walter said, almost offhandedly. The way he said it made me feel that I really should have known better. I do now.

Since that day I have carried a tripod whenever I can. There have been times when I was aggravated by the inconvenience it caused me, but it's been worth all the tribulations. There is nothing I know of that can improve a photographer's pictures more than the consistent use of a tripod. It will also allow you to take pictures that would be impossible to get without one. Long exposures, close-up work with a macro lens, or long telephoto pictures are simply impossible without the rock-steady support of a tripod or some other steadying device.

To obtain clear, sharp pictures, more than half of the speed settings on your camera cannot safely be used in a hand-held position by the average person. This

means that many pictures are unobtainable unless some sort of device is used to steady the camera.

Many people refer to a tripod as an accessory. I don't. I think it's a necessity. This is especially true with modern cameras and lenses. The trend is to use zoom lenses, rather than a number of different lengths of prime lenses. The longer a lens is, the more difficult it is to hold steady enough to get a sharp picture. There is a much-repeated rule in photography that when one is using a hand-held telephoto lens, whatever the focal length of the lens, a comparable number should be used on the speed ring of the camera body. Thus, a 500-mm lens should be shot at a speed of 1/500 and never slower. I believe that rule applies to people under the age of eighteen in superb condition. Unless you fit this description, double that figure and you might be safe.

People often complain that their zoom lenses don't give them pictures as sharp as those they get with some of their prime lenses. The poor results don't always lie with the lens. To examine why many people are disappointed with the quality of their zoom lens pictures, let's look at one of the most popular of all zooms, the 80–200 mm or 70–210 mm. As far as being able to hold the lens steady is concerned, it has to be considered a 200-mm lens. Regardless of what focal length you have zoomed to internally, you are shooting everything through a 200-mm lens barrel. If you were shooting a true 200-mm lens and obeyed the rule, you would need at least a 1/200 exposure (or maybe double that) for a sharp, hand-held shot. But we frequently shoot pictures at speeds considerably lower than that—and often they simply aren't sharp. The problem lies not in the lens, but in our failure to realize that we have to be much more steady when we hand-hold a longer zoom. That's where the tripod comes into play.

Before examining tripods and other steadying devices, let's look at some outdoor situations that demand a tripod, or in which at the very least they can radically improve your picture.

Low-light photography requires long exposures at slow speeds, and that demands a tripod. One such situation is in the morning before the sun has risen above the horizon, or after it has descended below the horizon in the evening. Usually, evening photos produce more colors, since dust has been stirred all day into the atmosphere, and light penetrating that dust produces the richer colors. But to bring out these rich tonal qualities requires long exposures of as much as a full minute or more. Only a stable tripod can give you sharp pictures with such long shutter opening times.

Light is often very low when one is shooting wildlife. Many creatures are abroad only during the night or very early or late in the day, or when there are very low light situations, such as foggy days. These conditions require the use of a tripod to stabilize the camera.

Many close-up pictures are taken with a small f-stop to obtain maximum depth of field. This means extended exposure times, and the tripod or a flash are the only two answers for sharp photos. The common tendency is to shoot many outdoor scenes and other photos at an f-stop of about 5.6 or 8. This gives a fair amount of depth of field on distant subjects. One reason many people select a wide-angle lens to take a scenic shot is that they can get more apparent depth of field and sharpness. The reason for shooting the average scene at f/5.6 or f/8 is that it gives the greatest depth of field with a shutter speed that we can successfully hand-hold. But if we used a tripod, shutter speed could be pretty much ignored, except for subjects in motion. A scenic shot made at f/8 and another at f/22, provided each is exposed properly,

will look entirely different. The picture made at f/22 will look much sharper, since considerably more of the picture is in sharp focus because the depth of field has been drastically increased. This can be especially noticeable when making enlargements of black-and-white photographs.

Surprising as it may sound, a tripod will improve almost anyone's composition. When we hand-hold a camera, we tend to look mainly at the subject and how it is lit, then click the shutter. But when we put a camera on a tripod, almost everyone slows down and looks much more closely at all elements of the picture. We notice features that can be distracting or could improve the photo. There are often positions that we must get into to take a photo that make it nearly impossible to hand-hold properly. This is especially true of many low-angle shots. For example, taking a hand-held photograph in a swamp with the camera near water level would be extremely difficult, yet with the right kind of tripod it could be accomplished easily.

While almost every discussion about tripods revolves around their ability to hold the camera steady, I think their major benefit is that they allow us to take pictures with a greater depth of field—thus providing the additional bonus of getting clearer details throughout the picture.

What Makes a Good Tripod

A bad tripod is worse than no tripod at all. The little, flimsy models that are often advertised for a low price are almost always worthless. Perhaps 80 percent of the people currently buying tripods are buying another one because they are dissatisfied with the one they now own. Too many people want something that is light and that they can conveniently carry with them all the time. There's nothing wrong with that; everyone else would like the same thing. The problem is that all tripods are really a

compromise. The big, heavy models are entirely too much to lug into the field, but they are usually the best ones for a rock-steady support. With few exceptions, the heavier the tripod, the steadier it will hold your camera. Regardless of the tripod you select, it has to fit your needs. If you enjoy scenics and work from your car, you may not mind lugging a heavy model a short distance to take a photo. If you enjoy flower photography, you want something portable, but you need to be able to get the camera very low to the ground. If you backpack, lightness, combined with the ability of the device to hold the camera steady, is your need. For someone who works around water, a tripod with waterproof legs may be very helpful.

When buying a tripod, keep in mind that it must hold steady the heaviest lens-and-camera combination you'll be using. There is no tripod that is right for everyone. One of my special needs is that I shoot most subjects with both black-and-white and color film. Therefore, one of the features that I'm attracted to is the ability to quick-change one camera body for another on the tripod. Don't be in a hurry to buy a tripod, and talk to others who take the same kinds of pictures you do. But be aware that a good tripod, tailored to your needs, will be the best investment, outside of camera lenses and film, that you make in the photographic field.

There are a number of factors that will help you to evaluate a tripod. First, the number of leg extensions is to be considered. The more leg segments, the more joints that have to be tightened—or can slip. Each successive extension is smaller, too, contributing to a loss of stability. Most women and many men simply don't have the strength to securely tighten the friction-locking collars that are popular on many tripods. For these photographers, one of the lever-locking devices may be helpful. But be sure that the levers don't

extend too far from the legs. If they do and you have to carry the tripod through brush or woods, you may find that the levers constantly snag vines and small limbs.

A mistake often made by photographers when setting up their tripods and needing extra height is to extend the smallest or lower leg segments. Since the upper extension legs are always heavier (and sturdier), you should use the thinnest legs on your tripod only when there is no other option.

Check the tripod's stability in the store. Set the device up with all legs fully extended. Then push down on the mounting platform. If the legs flex, the tripod will probably deliver poor performance. While the unit is set up, check to be sure that it comes to a comfortable eye-level height. Working with one that is too short can be very aggravating. Don't be too concerned about the centerpost in the tripod. The

general feeling among most professional photographers, who have to make good pictures to keep their jobs, is that the centerpost should rarely be elevated more than a few inches. If the centerpost is raised too high, it really becomes a monopod and is not nearly as stable as a three-legged tripod. If you need more height, increase the lengths of the three legs, but resolve not to elevate the centerpost unless there is no other choice. Many of the sturdiest tripods are those that have a movable bracket extending from the centerpost. This adds rigidity. Sometimes you can also make your tripod steadier by hanging a heavy camera bag, backpack, or similar weight on it.

A feature that I find very helpful with tripods used in the outdoors is the ability to open the legs to more than one angle. Older tripods opened to a single angle, and then the legs were extended. This restricted one's ability to put the upper portion of the tripod lower to the ground, or to adjust the legs easily on uneven sur-

Three types of heads for tripods. Clockwise from top left: ball head, pan-and-tilt, and ball and socket.
▼

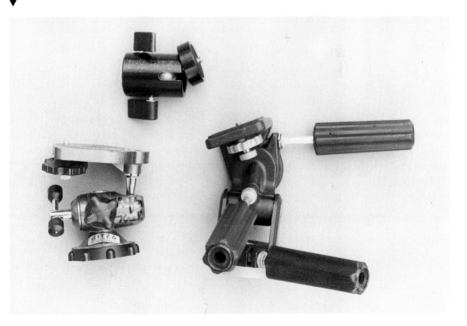

faces. A number of modern models allow you to adjust the legs to two or three positions, so that at the widest angle the legs extend almost at right angles to the centerpost. With such tripods, it's desirable to have a very short centerpost. Some models have a centerpost that is constructed of two sections, the lower of which can be removed, so that the post doesn't push against the ground when the whole unit is low to the earth. A few manufacturers actually market centerposts of different lengths, so that you can buy one tailored to your needs. Since I rarely use the centerpost to gain height, I have used a hacksaw on several of my tripods to shorten the centerposts.

When trying to sell you a tripod, salesmen make a great deal of the feature that allows you to invert the centerpost, so that the camera can be suspended between the tripod's legs and low to the ground. I have tried using a camera in this position. First, the tripod legs always seem to be in the way. More important, the camera, the controls, and everything else are upside down. Working this way in a swampy area is impossible. Frankly, everyone I have met who has tested this idea has rejected it as being impractical. There are better, easier ways to accomplish low-level photography that will be discussed shortly.

The camera is attached to a tripod through one of three types of heads: pan-and-tilt, ball head, or ball-and-socket head. The most common is probably the pan-and-tilt head. This usually has two handles that are used to tilt the camera to almost any desirable angle. One handle controls certain movements, while the other allows other movements—thus you can rotate the camera or swing it to a horizontal or vertical position. One has to be careful to make sure that the handles are well locked, or the camera may slip out of position. One problem with the pan-and-tilt head is that the handles constantly get in the way for

some outdoor activities (they also seem to grab every bush when packing the tripod through the woods), and they do take up quite a bit of room.

Check the position of your camera on a pan-and-tilt head; if it's mounted in the wrong direction, all adjustments will be cumbersome. The handle that gives you vertical adjustments should be pointing back toward the photographer, while the handle for left-to-right adjustments should be to your right.

The ball head type usually has one locking lever, although sometimes another at the base allows the entire top to rotate in a circular motion. When the upper lever is loosened, the attached camera can be rotated 360 degrees and tilted to virtually any position. Many photographers who have tried ball heads don't like them. The inexpensive ones slip easily and tend not to hold the camera in position. But if you get one of really good quality (they can be fairly expensive), they are, for me, the most desirable. A good store test before buying a ball head is to mount a camera with a motor drive and the heaviest lens that you'll be using on the head and adjust the camera for a vertical shot. If the head allows the camera to slip at all, buy another head. These heads take up little room in a pack and allow you to adjust to virtually any desirable camera angle. One feature I like about a good ball head is that when I travel by air, I can detach the head and wrap it in clothing in my duffle bag. I ship the remainder of the tripod as baggage. A pan-and-tilt head, with its longer arms, is more difficult to transport.

The ball-and-socket head has two levers. One works somewhat like a ball head, allowing the base attached to the camera to move at all angles. The other lever allows the head to rotate on the tripod. This is generally more expensive than a ball head and will usually better support a heavier camera. It will also allow you to get to diffi-

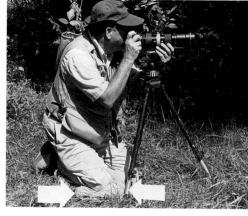

▲

The author kneels on a boat cushion, which greatly aids in comfort when kneeling to take photos.

Use a short piece of rope or strapping and attach it with two stainless steel adjustable clamps to make a handy tripod carrying strap.

▼

▲

Ned Segar uses a tripod properly—by positioning one leg toward the subject. This prevents the photographer from tripping over a leg.

cult camera angles with greater flexibility.

In many camera stores and through photographic supply house catalogs, you can buy the tripod and then select the type of head that suits you best. This is really the most practical method of assuring that you get exactly what you need.

When using a tripod, always station one of the legs *toward* the subject. Many people set up the tripod with one leg pointing toward the photographer. This means stumbling over the legs, or at least having one leg always in the way. With the leg pointing toward the subject, the photographer has greater mobility.

There are two tricks that may help you when carrying a tripod. Since they never have a handle, you can easily install one. Use two stainless-steel adjustable clamps that hold a small strap or wide rope to one leg. It's amazing how easily you can carry the tripod this way. Another good idea I

got from Pauline Theriault, who said someone else had showed her this one. Especially when we have a camera attached, we tend to place the tripod legs on our shoulder to move from one location to another. The legs, with the added weight of the camera, can be uncomfortable. Using a section of tubular rubber sponge of the type that is used to insulate pipes, Pauline

▲

Pauline Theriault has installed foam rubber pipe insulation on her tripod, making it more comfortable to carry.

▲

Some people prefer to camouflage their tripod legs with special tape, available from hunting supply stores.

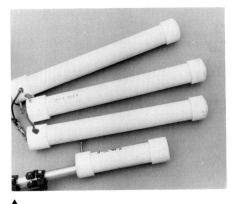

▲

You can make protective "booties" for a tripod's legs from inexpensive plastic pipe; the method is explained in the text.

slit the tube, slipped it over each leg, and then taped it in place. It's possible to buy camouflage tape at archery and hunting stores, which some people might find the best kind to use. The insulating tubing can be obtained from many plumbing supply houses, but take along your tripod to be sure you get insulation with the correct inside diameter so that it fits snugly on your tripod legs.

Tripods have to be well maintained to work properly. Dirt, grit, and other foreign materials that get into the leg sections can bind, score, or ruin the joints. Sand and mud are two major enemies. But you can make tripod "booties" that will keep the legs spotlessly clean. Take your tripod to a good hardware store or plumbing shop where plastic pipe is sold. Determine the smallest diameter pipe that your lower tripod legs will fit into. Cut three pieces of pipe (one for each leg) to the desired length—twelve inches is a good working length—and secure a cap on one end of each pipe with the plastic cement made especially for this purpose. On the other end add a coupling (to give double wall thickness) and thread the coupling for a 1/4 × 20 screw. Install a thumbscrew at the top of each pipe in the coupling. All you need do now is slip a tripod leg into a pipe and make it secure by tightening the thumbscrew.

Monopods are similar to one leg of a tripod. Just like the leg of a tripod, the monopod has several sections that can be extended, the lowest section always smaller and less stable than the upper sections. The top of the monopod is usually fitted with a ball joint. The camera is mounted on the top of the leg, which is adjusted to eye level, or whatever height is needed. Some monopods are not long enough when fully extended to meet the eye, and this can mean bending over to view through the camera—a tiring and unsteady position. A monopod is never as steady as

a good tripod, but it is infinitely better than hand-holding the camera, and thus is recommended for many outdoor activities. Obviously, it would be much easier to carry a monopod in a backpack than a tripod. But care must be exercised in using one. Try to keep the monopod and your body from swaying, and trip the camera shutter gently to get sharper pictures.

Monopods can also be used to gain elevation or an unusual photographic angle. This usually works best when wide-angle lenses are used, since you can preset the focus for the approximate distance, and when the picture is taken, most subjects will appear sharp. For this purpose, a camera is mounted on the monopod with a long shutter-release cable attached. The camera can then be extended above a crowd; out over the side of a boat so that a picture can be taken looking back into the boat; held up near a bird's nest too high to get to; or for similar unusual angles. The shot is taken by using the cable release to trip the shutter.

There are several considerations when purchasing a monopod. The most important is that it be stout and have secure locking sections (some people use the monopod as a walking stick). Next in importance is that the ball be strong enough to hold the camera/lens combination at the desired angle. A wrist strap is also recommended, and a monopod without one can be tiresome if it has to be carried a long distance. With models that have no wrist strap, you can lash one on them. Look at the smallest section of the monopod. If it is thin, it will probably not be a good steadying device. I feel that the thinnest section should be no less than three-quarters of an inch in diameter, and one larger is better. A rubber foot on the end is not as durable as a metal one, but it has the advantage of not slipping when the monopod is positioned on a rock, a log, or some other slick surface. If you do much work

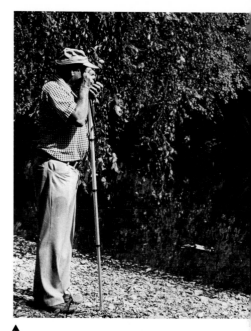

▲
A monopod will let you get a lot of sharp pictures you couldn't get by hand-holding the camera.

with your camera in which the monopod is placed on ice or similar surfaces, you may need a metal foot. Some monopods have the largest section at the base, and the bottom is permanently sealed, making it waterproof—ideal for swampy areas.

Some monopods also have an adjustable shoulder brace at the top that is held against the body to create a steadier mount. However, this does add weight and means you have something else to carry and get in the way. A good monopod is an inexpensive photographic investment, and, while not as steady as a tripod, it is portable and can help you obtain sharp pictures that you may not otherwise be able to get.

Other Steadying Devices

In addition to the tripod and monopod, all sorts of clever devices have been developed to help steady a camera for expo-

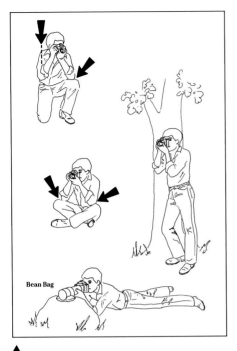

▲

A few of the ways you can steady a camera if you don't have a tripod or monopod with you.

An example of a miniature tripod, sometimes called a table tripod.

▼

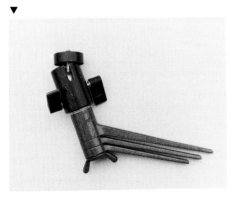

sures at slow shutter speeds. Fortunately, most of these are very portable, an important factor for the outdoorsman, and most are rather inexpensive. Some, in fact, can be homemade.

The first device that comes to mind is the miniature tripod. These tiny tripods have been improved over the past few years and are being constructed of lighter, stronger materials and have better locking legs. They do have some drawbacks, however, that should be considered. Obviously they won't raise to eye level, unless placed on something, and they cannot be lowered since the legs are at a fixed angle. Their thin legs tend to sink into soft earth when making many photos, such as shooting wildflowers. Also, these miniatures have such short legs that if a longer telephoto lens is used on the camera, the tripod tends to tip over.

Perhaps the most stable and certainly the most famous of all of these tiny tripods is the Leica Table Top Tripod. It has three solid legs that radiate out from a very solid centerpost and lock into the desired position. To carry it, simply swing all the legs back into a single plane and lock. Because the legs are not adjustable, this tripod cannot be elevated or lowered. When set up, this tripod is incredibly steady. It has been so successful that other companies have copied its design.

There are a host of these miniature tripods on the market, and many of them are poorly designed, have weak, trembly legs, and are really unfit for use. Test any you are thinking of buying in the camera store by setting them up and firmly pushing down on them. If they give at all, look for another model. While they lack the ability to be adjusted to eye level, these miniatures can be held firmly against a rock, on a limb, a log, or the side of a building— anything that will provide steady support. They do have a place in outdoor photography, and their greatest asset is that they are so light and portable that people will take them along on many outdoor activities.

If you are handy with the basic tools (hacksaw, drill, and hammer), you can

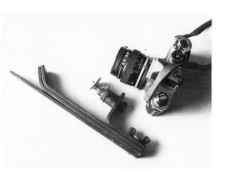

▲ A Ned Smith "shorty" tripod, folded for carrying.

► Just one of the many angles at which you can set up the Ned Smith tripod.

► Instructions for making the Ned Smith tripod.

Several of the positions available with this homemade tripod.
▼

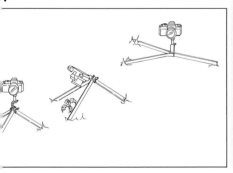

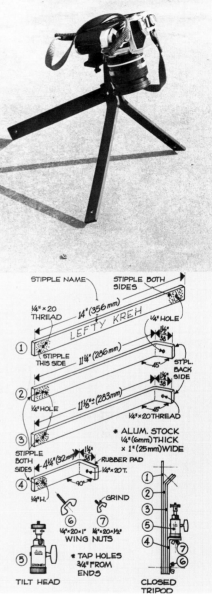

make what I believe is the ultimate in miniature tripods; I've been using one for more than twenty-five years. It is portable, easy to set up, can be used at ground level, and is adjustable for almost any surface, since all three legs can be put in a myriad of positions. This tripod was invented by Ned Smith, one of my best friends and one of this country's greatest wildlife painters. Ned needed something he could easily

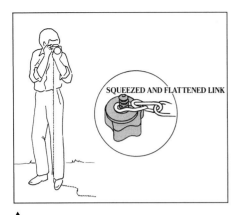

SQUEEZED AND FLATTENED LINK

▲
A "chainpod," another homemade steadying device.

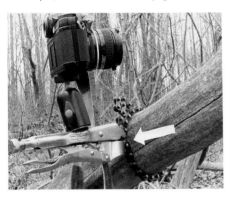

▲
A plumber-type wrench with a 1/4 × 20 screw welded on it.

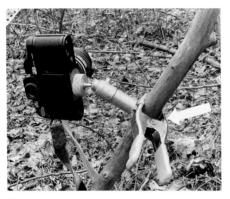

▲
A handy steadying device made from an A-clamp.

carry in the field that would hold his camera steady so he could shoot various subjects that he would then paint. He tried commercial mini-tripod models, but finally invented his own. You can make this tripod from materials available in almost any big hardware store, and for only a few dollars. The accompanying plan shows all the necessary details for making it.

Another camera-steadying device is the clamp—of which there are a host of extremely clever ones, from suction cups to massive jaws that will hold almost anything. Most of these clamps can be gripped on many objects, including fenceposts, tree limbs, tripod legs, and car windows or bumpers. The clamp usually has a 1/4 × 20 threaded screw, which fits the standard threaded mount of a ball head or camera. Many of these clamps are cheap—and they'll deliver poor performance. More expensive clamps will grip so securely that they won't slip, and often the jaws are lined with rubber or some other tough material that aids in secure holding power and won't tear or scratch the gripping surface. The best clamps not only open wide, but will close down well on thin objects, too. Test in a store any clamps that you think you might use. Generally, clamps come without a ball head, but the same head you use on your tripod can be utilized.

A unique type of clamp is the suction clamp. This is usually a ball head that is mounted on a heavy-duty suction cup. Moisten the rubber surface, press it firmly against a window or a similar smooth surface, and throw the locking lever. When properly mounted on the correct surface, this clamp holds surprisingly well. It is especially suited for mounting on a car window, so that the photographer can shoot wildlife from inside the car with a long telephoto lens. A drawback is that this model does require a smooth, slick surface.

A good homemade clamp can be made by having someone weld a 1/4 × 20 threaded screw to the top of a pair of Vise-Grip pliers or a welder's clamp used to hold metal sheets together when welding. A ball head is secured to the screw. The Vise-Grips or clamp will hold lighter cameras and lenses firmly on many surfaces. The disadvantage of these is that they don't open very wide and often won't hold heavy cameras.

Another practical homemade device is simply a short section of two-by-four wood with a slot in one side and a 1/4 × 20 threaded screw in the other. The slotted wood is fitted over a car window and the ball head attached to the screw, which will hold the camera. The photographer can slide the wooden block along the window

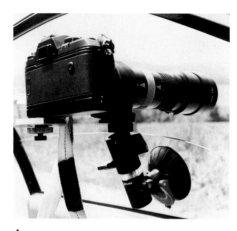

▲
A suction cup and ball head available commercially.

A simple device that works well for shooting wildlife from a car; it is explained in the text.
▼

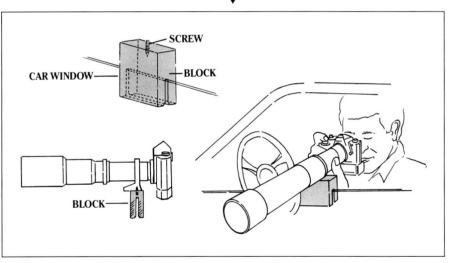

▶
A slit piece of soft insulation foam placed on the window makes a relatively good device to lay your long lens on.

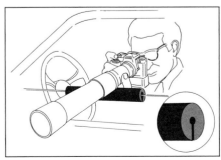

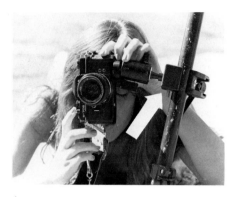

▲

One of the most useful and inexpensive tools that the photographer can own for low-level work—a Bogen Super Clamp. The arrow points to where it is secured to the tripod leg.

Joe Dorsey shows how you can shoot at ground level using a Bogen Super Clamp. His subject is a turtle.

▼

so that he or she can photograph wildlife from inside a car, using a long lens. The accompanying illustration explains how to make this simple gadget.

One of the best clamps of all—maybe the best—is the Bogen Super Clamp. This is a rather inexpensive clamp that will perform heavy-duty tasks. It has movable jaws that will open to at least three inches, with a rubber padded base on each inside jaw that, when locked—holds! My favorite method of using this clamp is to mount it on the base of one of my tripod legs, inches from the ground, for low-level photography. This is infinitely better than mounting the tripod's centerpost upside down. It can be used without a ball head; however, I find that the addition of a good ball head gives me more mobility to compose the picture. If vertical pictures are taken, the clamp sometimes holds the camera so close to the tripod leg that adjustments for various angles are sometimes restricted. But an extremely stable and inexpensive extender arm is available from Bogen. With this clamp I can take all sorts of low-level shots: wildflowers, mushrooms inches from the ground, dogs pointing birds, and many other subjects. I can't recommend this clamp highly enough.

A metal spike with a 1/4 × 20 threaded screw in one end has often been recommended, but I find its use to be highly limited. A "chainpod" is a simple device, but it will work fairly well. Install a short 1/4 × 20 screw in one end of the chain (use light chain, sometimes referred to in hardware stores as *jack chain*), making the chain at least as long as the photographer's body. Thread the screw into the bottom of the camera and allow the chain to fall to the ground in front of you. Stand on the chain so that it can be pulled taut. This gives you a reasonably satisfactory brace that will allow you to take sharp pictures that you wouldn't be able to hand-hold.

Beanbags are something else—they have a lot of uses. You can buy commercial models, but can make your own from an old sock, a bank deposit bag, or any small bag that has a closure. These bags are filled not quite to capacity, then laid on

something (car hood or top, log, rock, or anything else very solid) and the lens barrel pushed down into the bag, nestling in the groove so that it can be held steady.

Beanbags need not be filled with beans, rice, or sand; these are too heavy. One of the best materials is the small styrene beads that are available in many handicraft stores. This is a good tip for backpackers who carry such a bag. Some photographers carry the bag empty, with a plastic Ziploc-type bag inside. When they need it, they fill the plastic bag with sand, gravel, or small stones, and place it inside the beanbag. After use, the contents can be discarded. The plastic bag prevents the beanbag from getting soiled. It is really a good idea to have several sizes of these beanbags.

Other stabilizing devices are natural. A tree limb, rock, log, stump, earthen mound, or other such feature can be used to set the camera on for a solid holding position. Doubling up your coat or rain jacket and placing it between the support and the camera is recommended for added steadiness and to protect the camera.

▶

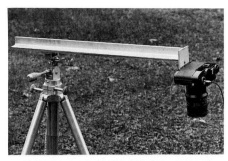
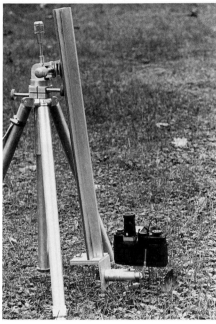

A device designed and used by Irv Swope for getting unusual angles. This homemade device works extremely well.

Wildlife photographers worry about an animal scenting them, and try to stay downwind of the subject. A frayed short section of sewing thread tied to the lower portion of the tripod centerpost works well. The slightest breeze puffs against the thread, indicating its direction.

▼

If you take both color and black-and-white photographs, you may want to use a quick-release unit on your tripod head. Camera bodies can be changed in seconds with this device.

▼

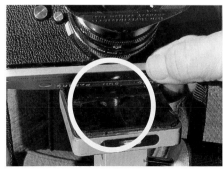

CHAPTER 7

FILTERS

Mention filters to some outdoor photographers and they turn away, feeling that altering a scene with them is not proper. Others, however, feel that judicious use of a filter can enhance a photograph. At the far end of the spectrum are those who desire to alter the scene deliberately by the use of filters. Since photography is purely an expression of the individual, how you view the use of filters is entirely personal and there is no right or wrong way.

There are filters for color film and for black-and-white film, and many of these can be used with both. With black-and-white film there are three categories that most filters will fit into: *contrast filters,* which alter the film's response so that various shades of gray (in a black-and-white print) are changed; *correction filters,* which change the film's response to different colors so that all are shown in a print at approximately the same relative brightness

values; and *haze* or *UV (ultraviolet) filters,* which reduce the haze in photos, but do not affect the color.

Filters for color film vary widely in their effects, but a good basic rule to remember is that the color of the filter used will mean that the final slide or color print will be heavily influenced by that hue, and those features of the scene that are dark will probably be darker and blacker. For example, if you are taking a photograph of a page in a book with a green filter (something very useful when showing a slide of a book page), all of the black letters will remain black, but all of the white page will turn green.

With the exception of the haze or UV, neutral-density, and polarizing filters, almost all others will alter the final color of your photo. Realizing that and understanding just a little about filters allows you to make subtle or substantial alterations to

the scene or subject that you may find desirable. As an example, if there is a rather sorry sunset, in which the clouds have a tint of orange with no red, and there is a very pale blue sky, you can dress up the sunset without the viewer being the wiser. Put an orange filter in front of the lens. This will cause the orange in the photograph to turn red and the light colors to turn orange, and by underexposing a little, you can further deepen the colors. The result could be a sunset with spectacular reds and oranges that is very natural-looking. Some people will use a red filter for this same purpose. If you like its effects, that's fine—do it. But many viewers feel that a sunset that is totally red is unrealistic. The point here is to experiment with various filters and then decide what pleases you.

There are a host of special-effects filters that create an artificial starburst, darken or tint the upper or lower portion of the photo, give you multiple images, split the picture into two different focusing areas, and much more. I feel that most of these do not usually create a realistic outdoors effect, and like many others who shoot pictures outdoors, I avoid using them. There are manuals on these, and all filter companies supply information on their special effects. This chapter will deal with what are considered to be the "normal" filters generally found in many advanced amateur and professional photographers' bags.

Filter Designs

Filters are constructed in several ways, but for the outdoor photographer who must pack his equipment with him, I believe those made of glass are best. These are mounted in circular metal rings that are held by threads to the front of the lens, and are often called *glass-mounted* filters. The forward portion of the filter has a female thread, allowing you to attach additional filters so that you can use two or more at the same time. The filter threads must match your lens threads. Fortunately, camera shops sell step-up and step-down threaded rings that allow you to attach different filters to your various lenses. You must be careful when "stacking" filters one on another—that is, adding two or more on front of the lens. You may get *vignetting,* which simply means that there will be darkened, round corners on your photos. What happens when you install several filters is that the lens may actually see their rounded edges. Wide-angle lenses are especially prone to vignetting. It's similar to a person standing at a porthole looking out to sea; the porthole isn't noticed. But step back a little and the edge of the porthole begins to hide the scene. There is a very simple trick to determine whether the number of filters in place are going to cause vignetting. Install the filters you plan to use, set the lens aperture at f/16, and then hold the camera up toward a bright sky while pressing down on the preview button. If you see a slight darkening in the corners, you will get vignetting. One other caution: to save money, many people will not buy a polarizing filter (there will be more about these later in this chapter) from the company that made their camera and lenses, but a less expensive one made by an independent firm. Sometimes that works out fine; but often a polarizing filter not made by the manufacturer of your camera and lenses will vignette with wide-angle lenses, such as 28- and 24-mm ones. It pays to buy at least the polarizing filter from the company that manufactured your camera and lenses; they have designed their filters to work on their own equipment without vignetting.

An inexpensive but very handy device, if you use glass-mounted filters, is a pair of protective metal caps for them. Screw together the filters you'll carry with you, and then attach the male and female metal

threaded caps on either end of the stacked filters. This is the most practical method I've seen for carrying glass-mounted filters. Another neat trick is either to label or paint each filter when using the metal protective caps. I use hobby paints and add a dash of red, yellow, or green to the metal rings of the red, yellow, and green filters.

Slightly different from the glass-mounted, screw-on filters is the Cokin, or one of a similar type. This is more difficult to carry in the field, but has won wide acceptance. It differs from the glass-mounted type in that a filter holder is screwed to the lens. Various solid gelatin filters are then slipped into the holder. Cokin makes an enormous number of filters—more than

100. This type is bulky and often difficult to carry with you outdoors, but for those who enjoy many special effects with filters, the range of results you can get from them is truly amazing.

One mistake made by many outdoor photographers is to place a skylight filter on their camera lens to protect it. I prefer plastic, spring-loaded protective caps for all lenses except those wider than 35 mm—since these caps will vignette with wider-angle lenses. On very wide-angle lenses (28, 24, or 20 mm) I use a glass-mounted filter—but not a skylight. If you are using a skylight, I urge you to replace it with a UV or haze filter. Hold a skylight filter against light cardboard or sky and you'll see that it has a slight pinkish cast. There are good uses for the skylight filter, but not here. What happens when you use this filter to protect your lens is that it puts a little tint of pink in every one of your color pictures. Some people can't understand why their color photos of the sky are

Two types of popular filters used with SLRs: on the left is a Cokin, one of several designs in which a holder is attached to the front of the lens and then various filters are dropped into position. A huge assortment of filters are available for this type of unit, including special-effects filters. On the right are two typical screw-in glass filters.

▼

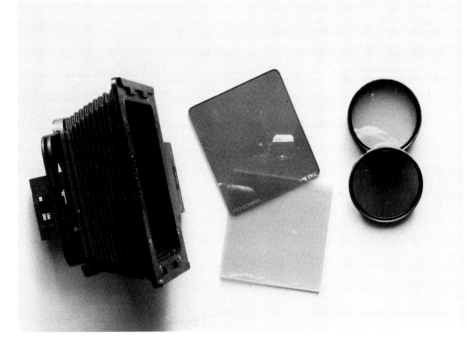

▲
Screw-in filters have a thin ring that holds the glass. Should they become stuck, the easiest method of removing them is with the fingertips, as shown. The usual method of placing a finger on each side of the filter causes it to distort and bind even tighter.

▲
A handy tool is a filter wrench. This is the best device for removing a stuck filter from a lens.

warns the owner that meter readings made with a polarizer may not be accurate.

never deep blue; with a skylight filter you'll never get that effect. The haze or UV filter, however, is perfectly clear, and, aside from often eliminating haze, has no effect on the color of the picture. If you want to use a glass-mounted filter as a protector in front of your lens, it's much better to get a haze or UV filter.

Any filter that you place in front of your lens will cause a loss of light striking the film. This is called a *filter factor,* and by a computation the light loss for an individual filter can be figured. Most filters, when purchased, come with a small slip of paper that gives the filter factor and often the amount you should open the aperture to compensate for the light loss. However, it's important to realize that four examples of a specific kind of filter from four different manufacturers will probably all have slightly different filter factors. For the person using an SLR, that's really no problem. The behind-the-lens meter takes the light loss into account when it gives you an exposure reading. The only time this isn't true is with a very few camera models when using a polarizing filter. In such cases, the manufacturer's manual always

The Polarizing Filter

Bright reflection or glare is all around us outdoors, and is usually the enemy of good photographs. Whenever there is a bright sun shining, its reflections will reduce the color saturation of subjects photographed. A man in a red shirt, a blue hat, and brown pants, standing in bright sun, will be photographed with the three colors showing poorly because of reflected glare off the clothing. But those same clothes would look rich and colorful if that glare could be eliminated. Rocks on a mountain, an old, storm-washed tree trunk on the beach, a wildflower, or a person paddling a yellow canoe (with sun shining on all of these) will be depicted in a photograph as less rich in color than they actually are.

Proper use of a polarizing filter can enormously enrich the colors of most things we take pictures of outdoors. The polarizing filter won't remove glare from all things— but it's easy to determine what it will do by looking through the SLR lens.

A polarizer is actually two filters attached together so that one screws into your lens while the outer ring rotates. By

▲

This shot was taken without a polarizing filter; note that the sky is light in color.

▲

This is the same photo, but a polarizing filter has been used to darken the sky, and the sailing ships and their masts stand out much better.

rotating the outer ring while looking through the lens, you can see what effect the polarizer is having on the scene. With a rangefinder camera (where you can't look through the lens and see the filter's effect), there is a knob or marking that is rotated on the outer ring until it points at the sun for maximum polarization. This is one of the disadvantages of a rangefinder camera; you can't see what effects filters are having. The sky, for example, will darken and then brighten as the outer ring is rotated. Most of the time we want the sky to be darker and richer, so we should rotate

The polarizing filter was used in two ways to good advantage here. The sky was darkened, and the glare was removed from the clear waters of the atoll on Christmas Island in the Pacific Ocean.

▼

the filter until the sky is at its darkest—and then take the picture. This filter also eliminates most and sometimes all of the glare from water. (It's easy to see how much reflection has been eliminated by simply viewing the subject and rotating the ring.) A wildflower can often be enriched by looking through the lens and rotating the filter until you see the flower at its pure color. In practice, that is about all you have to do to make the filter work. What is especially desirable about the polarizer is that it works with either black-and-white or color film.

You get the maximum effect with it when you shoot at right angles to the sun. Shooting toward or away from the sun, the filter is less effective. The polarized light in the sky varies according to the angle of the sun. When the sun is low, the portion of sky overhead is darkest; and when the sun is high, the sky close to the horizon is the darkest.

Polarizing filters have a light loss of between one and a half and two stops—which means that if the meter reading was f/16 without the filter, you will need to open to f/8 or near it to get a proper exposure with the filter in place. There is a misconception that as you dial the outer ring

you change the exposure. The light loss is dependent upon the glass in the filter, and once you have installed the filter and made a reading, rotating the outer ring to get the desired polarization will not affect the meter reading. Another good tip: It is difficult to try to use the filter while wearing polarizing glasses, though in a pinch you can. Simply rotate the outer ring until the scene is at its brightest—not its darkest—and you will have obtained the full polarizing effect for that subject.

The more expensive polarizers made by the various camera companies cost more because they produce more. High-quality polarizing filters absorb all of the polarized colors equally. That is often not true of less expensive ones. Instead of absorbing the reflected glare from all colors polarized, with these less expensive ones you end up with a blue cast to your photos and a loss in true, rich colors. Don't skimp on buying your polarizing filter.

This filter is terrific outdoors when you want to darken skies (especially with color films) and still have snow-white clouds. Flowers that are photographed with it will seem much richer in color, since there is no glare reflected from the petals. Skin tones and the clothing people wear are all displayed in the final print in more beautiful colors. This filter is really effective when you want to see through water. If

there is a particularly beautiful fish lying on a gravel bar, using a polarizer will often eliminate all glare so that the fish shows clearly. You can also make a rainbow more colorful—or eliminate it entirely—by rotating the polarizer and then shooting after you get the desired effect. Any subject or scene that you want to depict in its true colors will usually be enhanced with a polarizing filter.

There may be a time when you would like to eliminate the glare from water or to obtain a polarized effect, but don't have a filter. The accompanying drawing shows that if you hold your *thumb* as indicated in the direction of the sun, where your finger points there will be little or no glare on the water. This is an excellent trick if you need to take a picture when you don't have the filter. Try this the next time you are outdoors.

Some people discover the polarizer and decide they like the effect so much that they will simply leave the filter on the lens all the time. But that's not a good idea. Remember that you'll lose from one and a half to two stops of light with the filter on. In many low-light situations, this makes picture-taking difficult or nearly impossible. And the polarizing filter works best at certain angles to the sun. At other angles there appears to be little or no effect. The trick is to be aware of its benefits and to learn to exploit them.

A polarizing filter can be used in other situations in which it is difficult to obtain quality pictures outdoors. If there is atmospheric haze (not pollution smog), the polarizer can often have a profound effect upon the photograph; again, it depends upon the angle of the sun to the subject. In some pictures taken on a hazy day, most of the scene is almost invisible. Yet, when taken under the right conditions with a polarizing filter, the photograph appears to have been shot on a clear day.

Another situation that the polarizer can

Hold the fingers in this position and point the thumb at the sun. Where the first finger points there will be no glare on the water.

▼

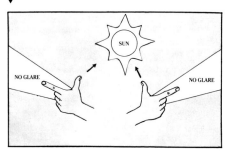

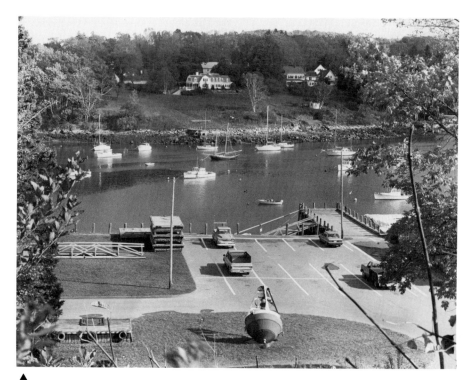

▲

This Maine harbor was shot during a day when there was a little mist in the air. Through the use of a polarizing filter, the haze was eliminated. Polarizing can remove much haze, but not that caused by pollution.

improve is one in which there is too much light for a scene. This often happens when one is using a very fast film on a sunny day. For example, suppose you found a beautiful waterfall that was tumbling over the rocks, and you wanted to blur it so that it would appear to be painted. With a fast film you might not be able to get to a desirable slow speed of 1/15 to 1/2 second. By adding the polarizing filter you can lose two stops in speed, and the picture can be made. Using outdoor film and a combination of an 80B filter (dark blue) and a polarizer while photographing the sun when it is behind a thin cloud, you can realistically make the picture appear to have been taken on a moonlit night.

Even if you have little desire to use filters to obtain various final effects in your pictures, I urge you to try a polarizer. It is the single most important filter you can use.

A filter that has no effect on the film is the neutral-density filter, which simply reduces the light coming into the lens without altering the color. Most of these filters are assigned a number in tenths, while some have a number on the filter that corresponds to how much of a stop is reduced. It's best to buy the filters in one-, two-, and three-stop reductions. Then, by using one of them or a combination, you have a good idea what you are working with. These filters are used only to reduce exposure (such as in the example with the polarizing filter and the waterfall).

A favorite filter of mine for outdoors is the 85B. It has a slight gold cast. When used around water it turns the water

▲

The small arrows point to male and female metal caps that are screwed on the stacked filters to act as protective caps. In this manner a number of the same size filters can be conveniently carried.

▲

When carrying a number of filters screwed together for convenience, it pays either to label them (as shown) or to paint the outer rings to code them, e.g., red paint on a red filter, green on a green one.

golden, and is extremely effective with silhouettes. It can also be used to enhance a sunset. I have submitted a number of photos taken under these conditions with and without the 85B filter to magazine editors. Inevitably they have bought the shot taken with the gold filter. Obviously, if you were trying to depict a cold scene, say a snowfall, such a warming filter would not work. But try it; I think you'll agree that it does beautiful work. Another tip: when using it, I prefer most pictures underexposed.

Filters for Black-and-White Film

If you are shooting black-and-white film, a simple rule when using filters is that the color of the filter will tend to lighten that same color in a black-and-white print. For example, a red rose, when photographed with a red filter, appears white or very light. A green filter is often very useful when taking pictures in the woods, since it lightens the foliage and makes the subject stand out better. Filters of the same color can be purchased in light, medium, or deep, rich color; the deeper the color, the more effect it will have on the photo.

Here are some of the reasons for using various filters with black-and-white film:

Yellow—Darkens the blue in the sky and enhances cloud formations. Often good for taking yellow flower pictures. Excellent for shooting pictures of sand, stone, or wood grain.

A yellow filter used with black-and-white film slightly darkens the sky, enhancing the clouds.

▼

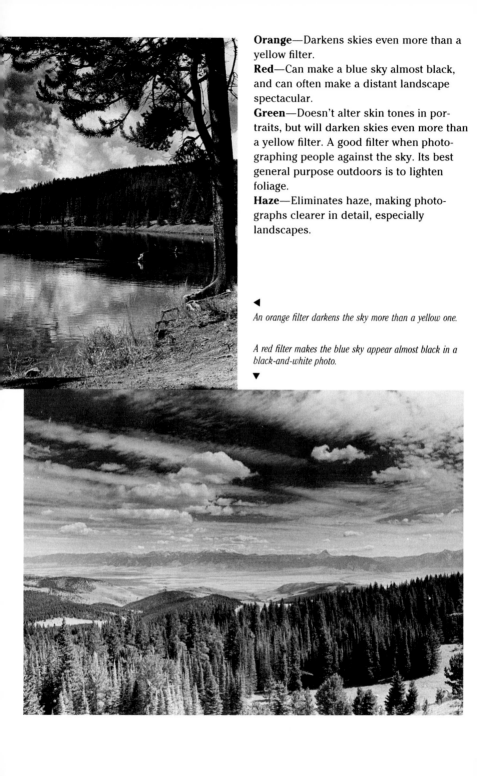

Orange—Darkens skies even more than a yellow filter.

Red—Can make a blue sky almost black, and can often make a distant landscape spectacular.

Green—Doesn't alter skin tones in portraits, but will darken skies even more than a yellow filter. A good filter when photographing people against the sky. Its best general purpose outdoors is to lighten foliage.

Haze—Eliminates haze, making photographs clearer in detail, especially landscapes.

◀

An orange filter darkens the sky more than a yellow one.

A red filter makes the blue sky appear almost black in a black-and-white photo.

▼

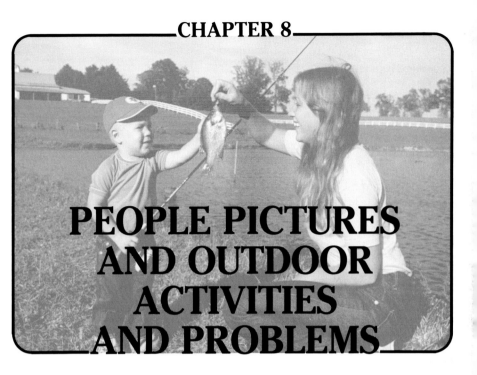

CHAPTER 8

PEOPLE PICTURES AND OUTDOOR ACTIVITIES AND PROBLEMS

Most of our outdoor pictures involve people doing things. And if we are honest with ourselves, we know we take a lot of bad, or at least not very flattering, photos of our friends. It takes some awareness of the problems to get pleasing pictures and also to realize that we don't photograph children with the same techniques we use for adults. The lenses we use, the backgrounds and foregrounds we choose, the time of day, the season, and a host of other factors—all easy to learn and understand—have major effects on how our pictures of people turn out. We should enhance the subject and make him or her look busy or comfortable, but never posed as if to say, "I'm having my picture taken." Given the restrictions of light and weather, we sometimes need to use a flash, and how and where we use it can make or spoil a great picture.

This chapter will also deal with the various activities that people enjoy in the outdoors, and some of the unique problems associated with taking pictures of those activities. Coupled with those are other, more general hazards that photographers must face outdoors, such as rain, snow, sleet, fog, dust, salt spray, and changing light. We'll explore many of these in hopes that after digesting the contents of this chapter you will recognize opportunities for great shots and be able to foresee problems, so that you can be prepared in advance, and can make consistently better photographs.

Some People Picture Ideas

When the eye is visible in a picture, always make sure that it is in sharp focus. This should be a firm rule when photographing anything that has an eye—including people, animals, snakes, bullfrogs—anything.

▲

Having the gunsmith look at the stock, rather than at the camera, makes a much more pleasing photo. Most pictures of people are best when the person does not look directly in the lens.

▲

Nearly everyone is looking at the hunter who is telling the warden just how he shot the big buck. If several people had been looking at the camera, it would have ruined the picture's mood. Most of the time, having everyone look at the activity being photographed enhances the picture.

If it isn't sharp, then people generally regard the photograph as out of focus. If the eye of a beautiful girl is clear and sharp, and the nose and ears are slightly out of focus, people have the impression that the picture is sharp. But get that eye fuzzy in the same picture, and it will fail. This is especially critical if you are using a very wide f-stop, such as f/2, in which depth of field is very shallow. With people pictures, I believe that this rule is critical to good photos and that often the photographer fails for the simple reason that the camera was focused on the subject—but not on the eye.

Most of the time, people should not look straight into the camera. If a strong personal portrait (usually of just the neck and head) is desired, then having a person stare into the lens is often very effective. But in most situations outdoors, if the subject is busy doing something while being photographed, the result is a much better picture. This means that they are not looking into the lens but are involved in an activity. It could be a backpacker pulling her-

self up a steep incline; a white-water paddler avoiding a standing wave; an angler releasing a trout (not holding the fish and looking at the camera, as is so often portrayed); or someone putting up a tent or building a fire. Far too often we have the subject stand up and look in the camera, and then we trip the shutter, resulting in a really uninteresting picture.

One of the most common mistakes when taking pictures of friends is to take the photo from too far away. The results are a cluttered and uninteresting background, which has little to do with the subject, and a person who appears too small. Remember, the first rule of photography is to put only in the picture what you want your viewers to see. When shooting photos of people, you should move in, get close. Or use a long lens and fill the frame with the person. Only when the surroundings improve the photo of the person should we use them. Obviously, a commercial fisherman repairing a lobster pot would make a better shot if one or several traps were also included. A kayak depicted rather tiny

▲

Occasionally, violating the rules can make a good picture. In this case, Bob Clouser has caught a nice smallmouth bass. His grin as he looks directly into the camera conveys his pleasure with the catch. This quality would have been missing if he had been looking at the fish.

▲

What gets most people's attention about this picture is the intentness with which both grandfather and grandson are looking at a trout that they hope the youngster will catch.

in the picture among a number of big, dangerous-looking waves will enhance a photo. But when taking people pictures, most of the time we should try to fill the photo with the subject, leaving most of the background out of the picture.

As mentioned in the chapter on lenses, with all but very wide-angle lenses, one of the best ways to control the depth of field is to use the f-stop or aperture on the lens. Opening the aperture wide (for example, to f/2) makes the depth of field so shallow that features in the background become fuzzy and the subject can often be isolated. (This is especially useful when the background is distracting.) Combine a wide aperture with a long lens, and you can make the background even fuzzier—something to consider when a background is creating a problem.

One of the worst things to do is to ask the person to smile or say "cheese." What usually results is a sorry-looking picture. A trick that works wonderfully well with most people is to take your meter reading, focus on the eye, and, an instant before you are ready to press the shutter release, ask them to talk to you. At first they'll say nothing, but keep insisting that they talk. Since they have no idea what to talk about, they begin rambling and become silly as they talk. Keep at it, urging them to continue talking. As they talk, they get all sorts of wonderful and unposed expressions on their faces. Just keep shooting pictures; it's amazing how many natural and interesting expressions you can capture. Another factor that's important in getting good people pictures is not to take just one shot. Instead, take a number of pictures as the subject talks or does something. Many of the shots may be average, but often one

◄

By showing Captain Flip Pallot looking at the redfish while he is removing the fly, the photograph directs our attention to the fish, which is the center of interest.

truly great picture will result from making a number of exposures.

There are a number of basic techniques practiced by almost all professional portrait photographers that can help you to get better people pictures. Here are some suggestions. If a person wears glasses, be careful at what angle you hold the camera. Make sure that the frames don't cut through the eyes. To eliminate this problem, move the camera to a higher or lower angle. Also watch for reflections on glasses, which can often spoil the photo. However, with many sunglasses, you can move in extremely close and photograph a portion of the person's face, but include the reflection on the glasses' surface to make a more interesting photo. If a man has a bald head or the hair is thin, and you would like to deemphasize this, shoot from a low angle, where the top of the head doesn't show—or have him wear a hat.

If a person has a double chin, also shoot from a low angle and have the person look slightly upward. This will remove most of the second chin. A person with a weak

chin is also best photographed from such an angle. Wrinkles in the face can often be disguised by using a soft-focus lens. This is a special-purpose lens that is deliberately not sharp and is used mainly in portrait photography. In overcast or diffused light, wrinkles don't show well, but in harsh sunlight a deep shadow is produced on one side of each wrinkle, making it appear to be even more deeply etched than it is. Of course, if you are attempting to portray someone who appears ancient, then the harsh light would do a better job. Sometimes a nice pose is to have the person look over his or her shoulder at the camera. But be careful that ugly wrinkles don't show in the neck. If they do, a scarf or a raised collar can be used to hide them. Someone with a wrinkled neck can be attractively pictured if the camera is held at a high angle and the person looks upward, stretching and removing many wrinkles from the skin.

A person with a long nose should not have his or her picture taken from the side, which will only make it look longer. In this case, have the camera a bit lower than the nose, and shoot straight into the face. Some people have large ears, which can be disconcerting in a portrait; have this person turn his or her head so that one ear is hidden and the other is in shadow. People who have broad faces can be made to look thinner by having them turn slightly away from the camera, with the camera slightly higher than the subject. Of course, you can also make a profile shot.

Women who have beautiful hair, especially if they are blondes or redheads, can be made to look great by posing them with their backs to the sun. The backlighting of

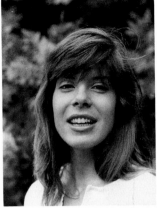
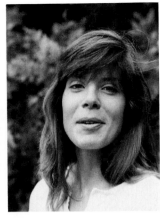

▲

When I asked Lauren Green to talk to me, she really didn't know what to say. By keeping her talking, I was able to photograph a number of natural expressions. This is a much better technique for taking natural portraits than asking someone to smile or "say cheese."

▶

Photographing blondes with their back to the sun and against a dark background creates an attractive halo of light that streams through the outer edges of their hair.

a low sun that streams through the outer rim of the hair will create a very attractive "halo" that can often be striking.

Hands can either help or hurt a picture. Many people look awkward if not told what to do with their hands. For such people, having them place their hands in their pockets is often a good idea. Hands can also be used to make the face more pleasing. If you are taking a photo of a person from the belt up, and the hands are placed forward of the face, they often are distorted and spoil the image. But hands that are kept on the same focal plane as the face, or even a little to the rear of the face, can often enhance a photograph. When photographing groups, try to arrange taller people in the back. A tripod is especially good for taking such a picture, since you can compose it more carefully, making

sure that no person is hidden by another. Also, group pictures will often have one or two people making an uncomplimentary face or smile, so take a few shots, then select the one that seems best.

If a group is not large, it's best to have them all looking at a center of interest. One person could be filling a backpack while the others watch, or someone could be pulling a canoe up on the bank while others either help or watch the operation. Group pictures are almost always best taken in open shade or overcast light. Strong sunlight makes everyone squint and places harsh shadows under the eye sockets. Hats worn in bright sun often result in deep shadows on a portion of the face.

Taking good pictures of children requires patience, timing, and planning. This is one place where a tripod is usually not a good idea. Children move around so much that you have to be mobile and able to keep after them. Sometimes a high angle is good, but most of the time a low one is best, requiring you to jump quickly from one position to another. Try to show the kids doing the things they naturally do and enjoy, not as the proper little people that parents often want them to be. The more impish they are, the more people seem to like the photos—even parents, once they see them. You can't just ask children to walk out in front of the camera and start posing; you have to get them used to the camera—and then hope they will forget it. It takes a little time to make friends with them and get them into a natural mood. But that time spent can often make a considerable difference in the quality of the pictures.

Wide-angle lenses, which require you to be close—or even normal lenses of 50 to 60 mm—are poor choices for kid shots. I like a lens of about 105 to 135 mm in length, and sometimes even one of 200 mm is excellent. The farther away you get from the child, the more natural it becomes and

Shooting pictures of youngsters while they are engaged in doing something gives a natural appearance. Here the author's grandson, Larry Kreh, is so involved in casting to a rising smallmouth bass that he is actually biting his tongue.

▶

Photographing Matthew Price from a low angle, just after he caught this big fish, helped capture the confident look on his face.

▼

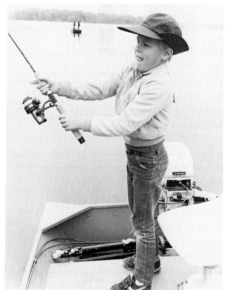

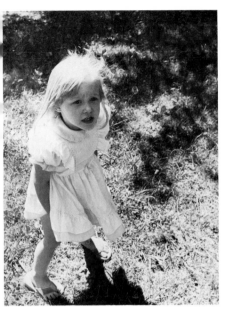

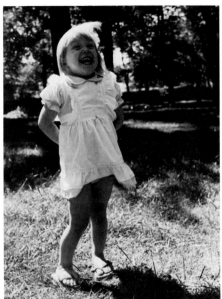

▲

What a difference in these two pictures! The first one was shot from an adult's eye level down on the child, making it appear distorted. But lying down and shooting up at the pretty little girl results in a totally different and more enhancing photo. Most of the time, subjects smaller than the photographer are best shot from a low angle.

the less posed the pictures seem. If you are photographing really young children, give them a toy or something to occupy them; this will also help them to forget about you. Always be aware of the background. Since children are smaller than adults, background objects will appear large and can intrude upon the final picture.

Perhaps the most important factor in taking children's photos is to shoot most pictures from a low angle. We have all seen photos of a little girl or boy who had his picture taken by a six-foot adult. With the normal lens aimed downward toward the child, the resulting picture shows a child with a head like a watermelon and ten-inch legs. Look at any book that contains photos of children, and you'll see that almost

all the photos are taken with the camera as low as or lower than the child. Nearly always, the lower the angle of the camera, the more pleasing the photograph. Try also to avoid taking photos of children in bright sun, where there can be harsh shadows.

Knowing that bright sunlight produces squinting and harsh shadows under the eyes, we can sometimes eliminate that problem by having the subject turn with his or her back to the sun. Take your meter reading on the face from close up, then take the picture. An attractive halo is often produced around the hair, and the person no longer squints. An even better idea is to move the person to open shade if it is convenient, where there is no squinting because the light is soft and pleasing.

A majority of outdoorsmen wear hats. That means that in bright sunlight there will be a deep shadow under the brim, obscuring the face. One way to get around this is to move the subject to open shade—or wait until a cloud comes over

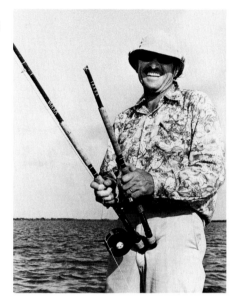

Ed Givens has just broken a rod on a huge tarpon. The hat caused his face to be in deep shade, and that smile would have been difficult to capture on film. But by using a very small, weak flash, I was able to fill in the shadows under the hat.

and the sun's intensity is reduced. Another way is to use flash fill. There are complicated formulas for computing just the correct amount of flash to use—but in my experience few people take the trouble to do this. I feel that when a flash is used while a person wears a hat, it's important to leave a trace of shadow. The viewer expects to see some shade under the hat. A brightly lit, shadowless photo looks unnatural.

If you have a dedicated flash for your camera, flash fill may be easy. With many dedicated models you can adjust the ISO (which controls the amount of light the flash will emit). However, with some dedicated units you cannot. Here's how to get good flash fill if you can make ISO adjustments on your unit. Normally, you would have the ISO of the flash the same as the ISO of the film speed set on the camera. For example, if you were using ISO 100 film, you would set both the camera and the flash at ISO 100. To use flash fill with some dedicated flash units you will have to make a few test shots to see if the following method works with yours. Take a meter reading with the camera, being sure that the speed setting is at the synchronized flash setting (many cameras need 1/60, 1/125, or 1/250). You must do this with the dedicated flash unit in the off position. Then turn on the flash and change the flash ISO (not the camera ISO) to about two stops higher—or about 400 ISO. Now the flash will deliver about two stops less light—filling in the darkened area, but still leaving some shadows on the face and not affecting the sunlit areas of the subject.

Another method that may work to get flash fill with a camera that has TTL (through-the-lens) metering is to take the normal meter reading on manual setting, at a correct synchronization speed. Then turn on dedicated flash (the meter on the camera will not work with the flash switch turned on). Adjust the EV dial that controls under- and overexposure to one stop underexposure. Then take the picture. You'll get about one stop of underexposure on the face, and there will be some shadow remaining.

Most important, after you have made your flash pictures, *be sure to set either the flash or the EV dial back to normal settings, or you will be making underexposed flash pictures, and getting underexposed meter readings.*

Another and much simpler method of getting flash fill that is not as consistent but is easy to use and usually results in a nice flash-fill photo is to purchase an inexpensive and very weak flash. These are small manual flashes, usually no larger than a pack of cigarettes. Attach the flash, take a normal meter reading of the subject, making sure that the camera speed ring is at a synchronized speed for the flash, then

▲

This large Mylar reflector folds into a small circle and is carried in the tiny dark bag shown here. It or a piece of white Formica can make a nice reflector to add light to the shade under a person's hat on a sunny day.

▶

A few pieces of household aluminum foil (or a Mylar space blanket) laid on the boat deck on a bright, sunny day reflected enough light back into Butch Ward's face to show his features clearly.

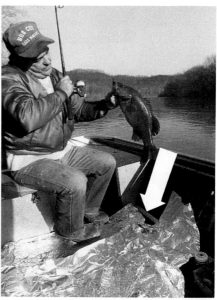

▶

Flash can be used at night, when no light is available. Here flash was used to show a fisherman throwing a cast net.

turn the flash on and make the picture. If you are between three and eight feet from the subject, a pleasing fill flash will generally result, simply because the unit is small and doesn't have the power to make a fully lit picture under bright sun conditions at these distances.

Sometimes you don't have a flash, or you don't want to use one. Reflectors work fairly well. There are several folding circular reflectors on the market that are very portable and can easily be carried in a camera bag or backpack. These are made with a thin, flexible metal band (similar to a sewing hoop). Stretched across the hoop is a metallized material, usually white or silver, that reflects considerable light. The hoop is folded into a tiny circle and inserted in a cloth carrying bag. When needed, it is withdrawn from the bag and it opens into a large circle. This reflector can be used to fill shadows on people's faces, for wild-flower photography, and for many other purposes.

Other things can be used for reflecting a little light into the face, if you have someone to help you. I have used a piece of white cardboard, a large aluminum pie pan, and many other items. In boats or canoes, you can lay down heavy pieces of aluminum foil that are designed for kitchen

use. Even better is a "space blanket" with a silver coating of Mylar—which can be used for other purposes as well.

Lenses

Selecting the proper lens is critical to taking good pictures of people. Wide-angle lenses are almost always bad. They tend to make objects close to the lens look big and things farther away look smaller. Longer lenses make people look more normal and tend to flatter the features. Thus, a person whose picture is taken close up with a wide-angle lens, such as a 20, 24, or 28 mm, will seem to possess a nose, lips, forehead, and eyes that look abnormally large and distorted. Even a normal lens of 50 mm will cause some of this type of distortion. Step back and use a longer lens and

the person will appear much more attractive.

Long lenses for taking people pictures offer other advantages. They allow you to stay farther away from the subject, so people act more naturally, resulting in more pleasing photos. Long lenses also tend to isolate the subject, a decided advantage in most cases. Long lenses also have less apparent depth of field, so the backgrounds seem to be fuzzy and don't intrude. When taking pictures of people, the closer we get to them with the camera, the more they feel intruded upon, and they lose their natural appearance and almost take on a defensive stance. For me, the ideal portrait lens is 90 to 135 mm, but 70–210-mm zoom lenses are terrific for this, too. Some photographers enjoy using a 28–85 or even a 28–135 zoom, but at the wide angles you have to be careful about distortion of your subject. The wider angles do allow you to

Lauren Green is shown here as photographed with a 24-mm lens. Those features nearest the camera (nose, lips, and eyes) all appear larger than life, while the parts of her head farther away look smaller and her features are distorted.

▼

A 200-mm lens gives a more realistic impression of Lauren, and it's easy to see that she is a very pretty girl. Choice of lens is important when making portraits.

▼

get group shots or to include both the subject and much of the surroundings. Zooms allow you to compose instantly how much of the person you want to show, and to do it from one position. Some very interesting portraits of people can be made with 300- and 400-mm lenses, but you usually have to stabilize the camera with a tripod to get sharp photos.

Photographing Outdoor Activities

Outdoors-minded people participate in a variety of activities: snorkeling, backpacking, canoeing, fishing, hunting, birdwatching, skiing, and a host of other endeavors. Many factors either hinder or help the

Outdoor pictures are often made under difficult weather conditions. This is a "body booter" who is standing in the frigid waters of the Chesapeake Bay, trying to lure in geese or ducks. Such pictures help us show those who don't spend time outdoors some of the unusual activities we engage in.

▼

photographer in these sports, and each has some special photographic problems. A better understanding of the specific problems associated with a given activity, and learning how to either cope with them or use them to advantage, results in better photographs.

Hunting

Most hunting is practiced in the fall and winter. There are all kinds of hunting situations: a group of sportsmen in a deer camp; a pair of men squatting in a duck blind; a solitary bowman perched in a tree stand. How can we make better hunting pictures that appeal to viewers—some who either don't hunt or may even be mildly opposed to hunting? First, we don't show photographs that depict the birds or animals in an unattractive manner. Blood spilling out of the mouth of a deer or seeping over the feathers of a bird ruins the picture for many—and there's no need for

▲

Often scenics or silhouettes of hunting or fishing activities are more pleasing than a photo of an animal or fish that has been captured.

▲

For many sportsmen, the real reason for hunting birds is that they enjoy watching dogs work. This is typical of the kind of scene so enjoyed by bird hunters.

▲

Hunting squirrels at dawn, with mist on the river, can make a memorable picture for those who enjoy the sport. Here, Dick Kreh wades back to the canoe with a squirrel. Taking the photo directly into the light makes the mist show clearly.

it. A leering hunter holding up his weapon and a dead bird, or standing with a gutted deer hanging from a pole, may seem macho—but it's not a pretty picture.

I think that a mistake made by the average person in shooting both hunting and fishing pictures is that they really don't take many photos that demonstrate why they love these sports. Certainly an attractive shot can be made of a hunter approaching a downed buck with a huge rack (one that doesn't show the bullet hole and blood), or of a hunter sitting on a stump, with his dog beside him, holding a pheasant or grouse whose feathers have been arranged correctly. These are pictures that show the quarry we bagged, but in a pleasing manner. But I think we need to take more pictures that depict the real reasons why we hunt—not simply to kill something. We need to take pictures of hiking along the trail and taking a moment to view a valley filled with fog, or a tree in full fall foliage. Pictures of sipping coffee around the campfire after a day of hunting, or of putting out decoys against a sky tinted red by the dawn sun, are easy to make—but we seldom do so. If we want others to enjoy our hunting pictures, we need to take more of these expressive pictures.

In every hunting situation there is one critical moment when all things come together. I think this is exemplified in the accompanying photograph of the hunter swinging on the ring-necked pheasant that has just flown over the dog's head. The viewer sees the bird in all its glory, feels the satisfaction of the dog and the hunter at locating the quarry, and we never know whether the hunter made or missed the shot. Even pictures of a slow sport, such as rabbit hunting, can be enlivened. We know that beagles love to trail rabbits. If we see where a rabbit has escaped across an opening, we can run to the area, lie down, and get a low-angle shot of the dog that

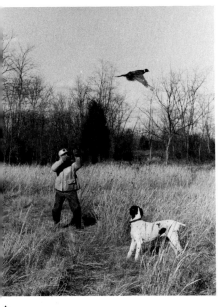

▲

Clicking the shutter at the right moment can make a difference. I think this shot emphasizes that point.

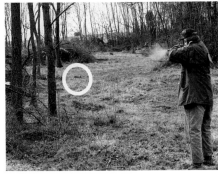

▲

In many outdoor situations (especially with wildlife), we can often anticipate the moment the action will occur, which makes for a good photo. Here the dogs had been pushing the rabbit toward the clearing. By standing behind the hunter, I was able to show the fleeing rabbit, the hunter, and smoke from the fired gun. (Incidentally, he missed the rabbit.)

Moonlit shots can often make an outdoor photograph even more interesting.

▼

will soon be coming, nose down and tail wagging, following that delicious scent.

Sometimes after you have bagged your limit for the day you can make some great hunting pictures. For example, if you have your limit of ducks, unload the guns (so that you are legal) and continue to call in birds. Have a companion hold his unloaded gun while you have a loaded camera. Use a wide-angle lens, and as the ducks begin settling into the decoys, have your friend stand up and pretend to shoot at them, while you take pictures over his shoulder. This will give the exact feeling to the viewer of what you see when ducks are finally lured to the blind and become aware that something is wrong and try to escape.

Early morning set-up pictures can also be taken that add to the excitement of your hunting pictures. One example is this shot taken by the author of a hunter setting up a goose decoy before dawn, with a full

moon in the background. It took only a few moments to set the picture up, but it's much more attractive than a picture of a hunter holding up a dead goose by the neck while he stares into the lens.

PEOPLE PICTURES AND OUTDOOR ACTIVITIES AND PROBLEMS • 107

▲

By lying on the ground and placing George Soule's favorite gundog, Smokey, in the foreground, I was able to emphasize the dog and still show the famed Maine grouse hunter.

▶

Two things help make this shot of Walt Lesser and his dog on point. First, both are looking in the direction of the bird, and, second, a low camera angle with the dog in the foreground emphasizes the animal's importance.

A high angle (from a bridge) allowed me to show fly caster Gale Hill on a North Carolina trout stream in a different way.

▼

▲

This very low, close-to-the-water angle of Gene Anderegg lifting a small tarpon from the water before releasing it gives an unusual viewpoint to the shot.

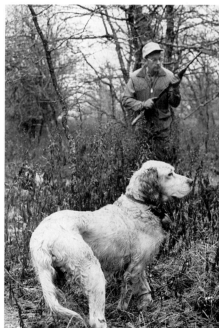

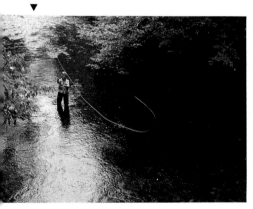

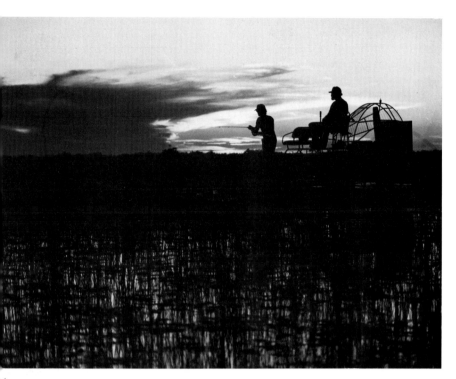

▲

Many early-morning and late-evening pictures are best shown by using a silhouette. Here, Captain Flip Pallot watches from his airboat as Jose Wejebe casts at dusk for largemouth bass in the Everglades. There was only enough light for a silhouette.

Hunters who have pointing dogs make the same basic mistake that adults do when taking pictures of children; they take their pictures from an angle higher than the dog. If you want the dog to look really terrific, get down on your stomach and shoot *up* at the dog while it holds a staunch point. The dog will look truly magnificent.

Fishing

Much of what has been suggested as good technique for pictures of hunting applies to fishing, too. Early-morning and late-afternoon photographs (especially during sun-

rises, sunsets, and afterglow) can make outstanding visual memories. One advantage of fishing over hunting is that, when taking fishing photographs, you usually don't have to worry about startling the quarry. Taking a picture of a deer means you probably won't get a shot at it with a bow or a gun, owing to camera shutter noise. But shooting a photograph of salmon or trout finning on a gravel bar, provided you are in a concealed position, means you may still be able to catch the fish later.

There are certainly a few problems unique to angling photos. Water becomes dull and lifeless if we shoot with the sun behind us. With sidelight, or especially with backlight, water takes on a sparkling quality that can really enhance a photograph. Remember, anytime you can look at sparkling water, or glare upon the surface, you can take a good picture of it. But if the

glare is bright enough that it causes you to squint, the film can't record it properly. Incidentally, this applies to silhouettes, too. If you have to squint to look at the bright area around the subject (whether it is sky or water), then wait until the light level has been reduced to gain maximum detail and color from your film.

Glare on water also means your film will have difficulty seeing through it. There are two ways of beating this. One is to use the finger-and-thumb technique (pointing the thumb at the sun and the index finger at the subject) to locate an area of water that is without glare. This is explained fully in the chapter on filters. The other method is to use a polarizing filter. This doesn't always eliminate all glare, but it does remove a considerable portion of it. Not only will the glare be removed, but all colors in the photograph will be enhanced because the polarizer allows the pure colors in the photograph to be shown.

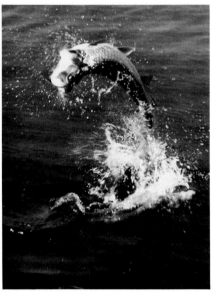

▲

Waiting until the proper moment and using a short tele-photo lens near the boat allows you to focus better and catch the fish at the moment of the leap.

Everyone likes to get pictures of leaping fish. And we almost all make the same mistake of using a telephoto lens and trying to capture the fish in the air. The problem with this technique is that you are never quite sure where the fish is going to jump. This means that it may be backlit, sidelit, or frontlit (all requiring different exposures), and then there is the severe problem of getting the fish in sharp focus. After years of photographing leaping fish, I finally developed a technique that works well for me. Instead of trying to capture the leaps early in the fight, I wait. Near the end of the fight, with a short telephoto or zoom ranging from about 90 to 135 mm, I am able to see the fish, or at least the leader leading to the fish, allowing me to carefully focus. And the fish, now much more tired, cannot leap as swiftly, and often comes only halfway out of the water, at a slower speed. The results are crisply focused shots of fish that fill the picture.

Fly casting is beautiful to watch, and provided it is photographed properly, it can make an outstanding action shot. I once did a book on fly casting, and after eighteen months of testing, I determined that the very best fly-casting pictures should be made on a stream that runs north and south, with a cliff on the east bank and a bright sun rising. Of course, fly casting photos don't have to be that complex, but there were some lessons I learned from that book that could help you take better photos.

My first mistake was in using a shutter speed of 1/2,000. I finally determined that the best fly-casting photographs are taken at a speed of 1/250. Here's why. At 1/2,000, the line moved only across a small area of the film, resulting in a super-thin fly line that was barely visible. At 1/1,000, it moved twice as far (the shutter being open twice as long), so the line in the photo was twice as large. At 1/250 it was four times larger—and still recorded the

◀

The best speed for photographing a fly line during the cast is 1/250th of a second.

ine as sharp. But when I shot pictures at 1/125, the speed was so slow and the line moved so far that it blurred and too much detail was lost.

Aside from using the correct shutter speed, there are a few other things that can improve your fly-casting pictures. Ask the caster to slow down the line's speed a little, while urging him to concentrate on making good line loops, so that the cast doesn't look sloppy. And—very important—when people know they are having their pictures taken, they stand upright and the resultant photo is not realistic. If the subject were actually fishing, he or she would be crouched low, almost as if stalking the fish, and the picture would portray a charged situation. Therefore, when taking someone's photo while fly casting, have them bend their legs just a little and look at the target, not at the fly line; it will really improve the photo.

The best fly-casting photographs are almost always those taken against a plain, pure, dark background and with light streaming from behind and the caster positioned between the sun and the camera. That was why the situation I mentioned earlier worked so well. The river running north and south, with a cliff in the background, and taking the shots early in the morning on a clear day, meant a cliff in shadow (resulting in a solid dark back-

ground). The rimlighting created by the sun striking from behind the subject caused the line almost to glow against that dark background.

The color of the rod and line can make a difference, too. I prefer fishing with bright yellow or chartreuse lines most of the time, simply because they show up well in a slide or print (both color and black-and-white), in almost any kind of light. Another good color for fly lines is bright orange—which doesn't do too much in black and white, but in slides or color print film, that fluorescent orange jumps at the viewer. A black rod disappears in a photo against a dark background, so for years I have used rods tinted with pale yellow epoxy paint that matches the tone of bamboo. You have to see it to believe it, but it really makes an outstanding difference in a print or a slide. This same technique applies to pictures of either spinning or casting gear as well.

When taking photographs of an angler casting with either spinning or casting gear, essentially the same techniques apply, although shutter speed doesn't seem to be critical. In front of a darkened background, with backlighting, the transparent nylon monofilament line really glows, and during the cast the line appears to be much larger than normal, and you can actually see it against the sky.

There are right and wrong ways for someone to hold a fish, too. Study the two accompanying pictures of the angler holding a largemouth bass. Both shots were taken with a 35-mm lens. In one photo the angler is holding the bass on the side of his body *away* from the camera. In the other photograph, the fish is held on the same side of the body as the camera, and the fish appears to be twice as large. If you want to enhance the angler's catch, always

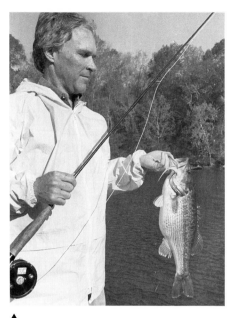

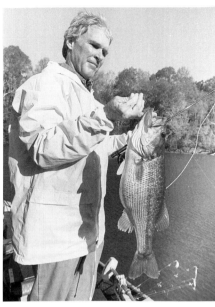

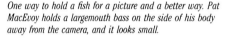

▲

One way to hold a fish for a picture and a better way. Pat MacEvoy holds a largemouth bass on the side of his body away from the camera, and it looks small.

▲

When he holds the fish on the same side as the camera, it looks much, much larger.

have the angler hold the fish with the hand nearest the camera. But don't have him push the fish toward the lens; that only distorts things. Of course, if you don't care for the fellow who caught the fish, you now know how to make his catch look smaller—only kidding!

As in hunting photos, low angles are often very appealing in fishing shots as well. Too many pictures are taken from a high angle, where a low angle would really enhance the shot. A photograph of a young angler with a smug look on his face holding a fish can be improved by keeping the camera low. A shot of an angler lowering a small tarpon to the water to release it can be made by holding the camera overboard and low. What I do to get this unusual angle is to take the meter reading and set all controls, wrap the carrying strap around my hand, and place my fingers on the bottom of the camera—with the thumb

on the shutter release. Lowering the camera, always trying to keep it level with the surface, I hold it as close to the water as possible (if my fingers touch the surface, I immediately raise it a little), and then take the picture. You can get some really interesting photos this way. By using a monopod with a long cable release attached to the camera and running down the monopod, and a wide-angle lens, you can hold the camera high above the people in the canoe, raft, or boat, or even outside the craft, and take unique pictures normally not seen.

Wide-angle lenses (20 to 35 mm) are ideal for many fishing photos taken inside a boat. The great apparent depth of field, and the ability of the lens to take in so much in such a close area, makes it ideal. An example is the photograph, taken with a 24-mm lens, of the author battling a 100-pound tarpon on a fly rod. The nine-foot

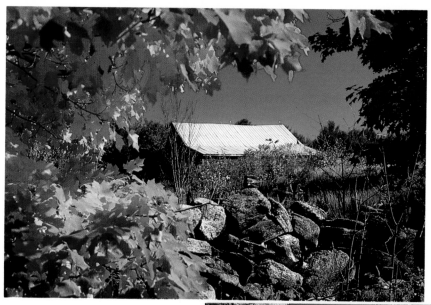

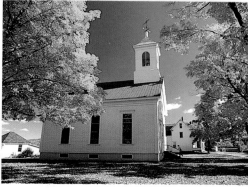

These are typical examples of how colors are enriched in a picture when the glare is removed by using a polarizing filter.

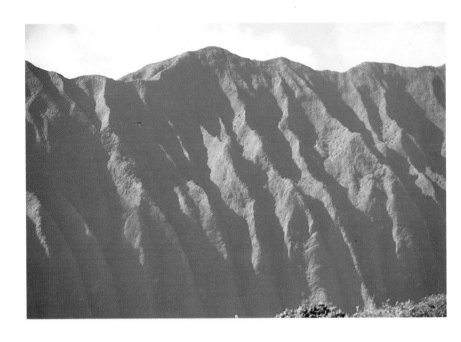

A polarizing filter can remove much of the haze caused by humidity but cannot penetrate pollution haze. There is some haze in the clear air of Hawaii between the camera and the mountains, but a polarizer penetrates that haze, as shown in the photo below.

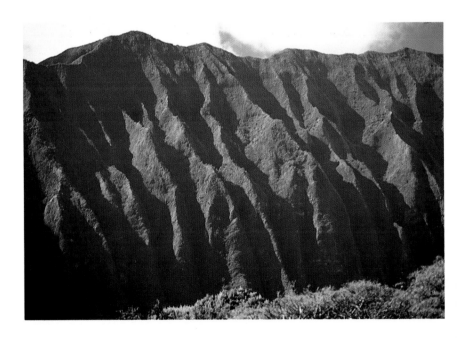

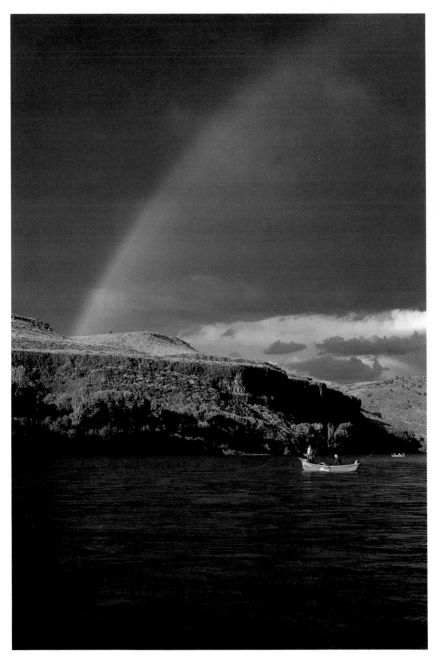

A polarizing filter can often make a rainbow even more striking. By adjusting the filter, you can enrich the rainbow or remove it entirely—so be careful.

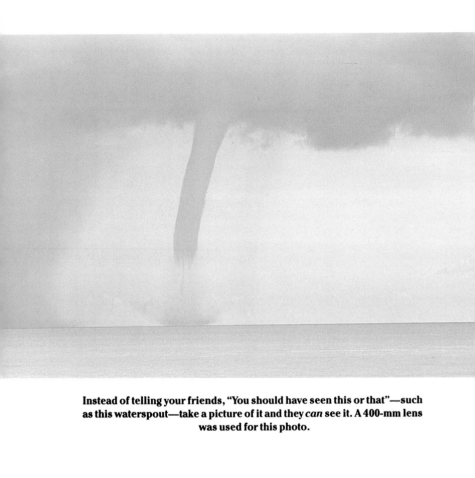

Instead of telling your friends, "You should have seen this or that"—such as this waterspout—take a picture of it and they *can* see it. A 400-mm lens was used for this photo.

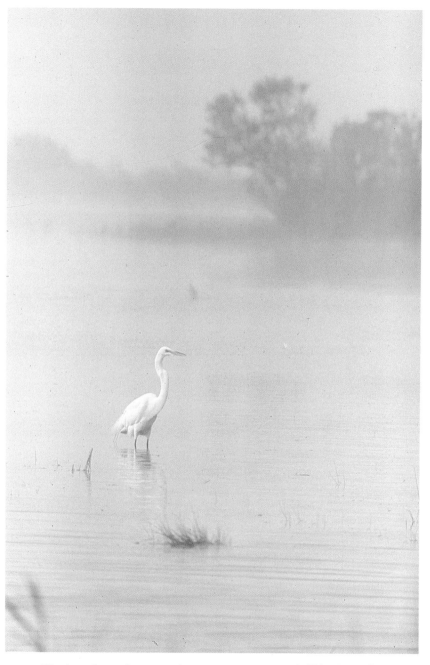

Weather often enhances a picture or creates a mood. This photo of a white bird in fog is almost monochromatic, but most people like it.

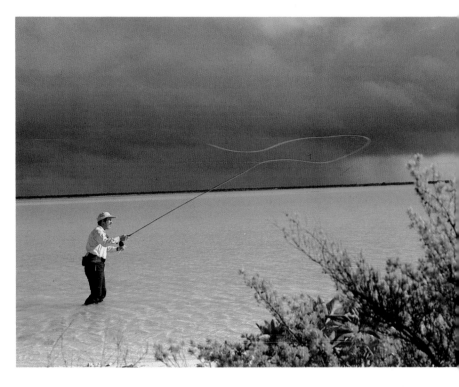

When outdoors, always be on the lookout for a storm in the background and sun shining on the subject. It really makes the subject stand out in the picture. Here a storm on Christmas Island creates a dark, moody background, but the angler and his fly line stand out clearly because they are illuminated by the sun.

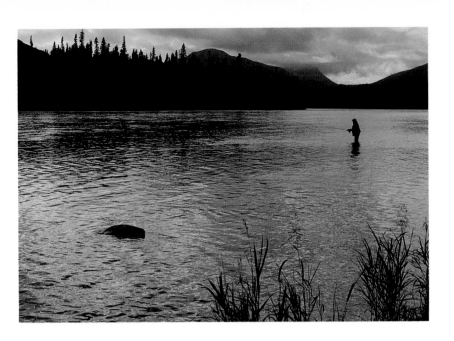

When used with color film, colored filters tend to tint everything in the picture the same color as the filter used. A blue filter and a yellow one are used here to demonstrate this.

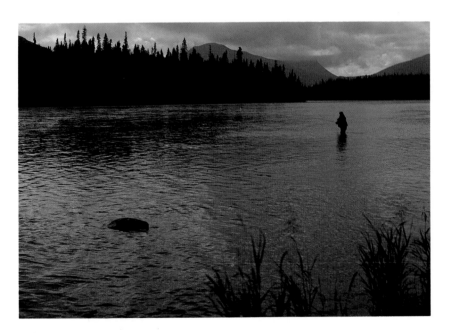

What happens when you overexpose, properly expose, and underexpose a photo. The top photo shows a day lily that has been slightly overexposed; the colors are lighter than normal. The middle photo shows a proper exposure, which gives the true colors of the flower. The bottom photo demonstrates that by underexposing you can enrich the colors. Many times the most pleasing photo is not what is assumed to be the perfect exposure.

That's one reason why it's important to bracket your exposures.

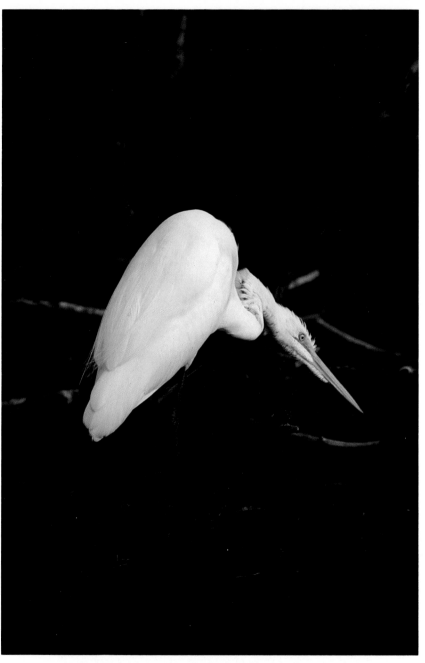

This all-white bird has been deliberately underexposed about two-thirds of a stop. This causes the background to be darker than normal but allows the viewer to see subtle tones in the bright feathers.

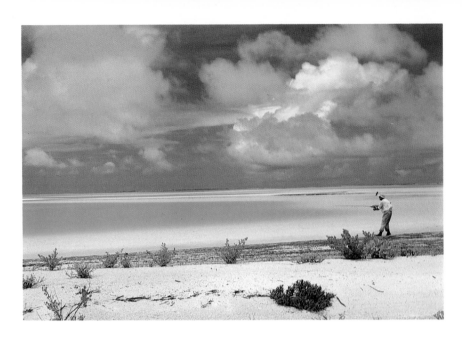

The photo above shows a normal exposure. But by underexposing about two-thirds of a stop, as in the photo below, the skies are made much darker. Some people like one of these, while some prefer the other. Exposure is a very personal thing.

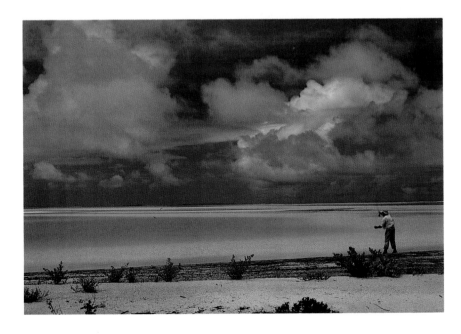

The photo on the left is an example of what happens if you depend solely on the meter, or use an automatic-exposure camera. The meter "sees" all of the bright glare surrounding the subject and closes down to compensate for that background. This produces a very underexposed subject. To eliminate the problem, move in close, take a meter reading off the skin tones of the subject, and use that meter reading for the picture—as in the photo below.

This white roof in Bermuda catches the rain that the residents of the house use for drinking purposes. Bright subjects like this, when underexposed slightly, show much more detail. In this case, the ridges in the roof are easily seen. But a normal exposure for the scene would have resulted in a pure white roof, devoid of detail.

When slide film is used, the best results are usually obtained by metering on something in the picture that is light in color and important to the shot. In this case the exposure was made on the area inside the circle on the white Dutchman's breeches flower.

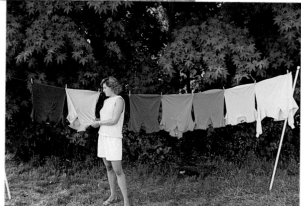

When there are shades or tones of color in a photo with high contrast between them, it's really impossible for film to expose properly for all of them. We must decide whether the light, medium, or dark tones are most important, and expose for them. The top photo shows the proper exposure for the blue blouse. Since every other blouse and Beth Keyser's skin reflect more light than the dark blue sweater, everything but the sweater is overexposed. The middle photo is exposed for Beth's skin, and things darker than her skin reflect less light, so they go darker. Blouses lighter than her skin are overexposed, so they are lighter in tone. The bottom photo shows the white sweater properly exposed. Since all the other blouses reflect less light to the film, they are darker and underexposed.

Motion also affects a photo. The top photo was exposed at 1/250, while the bottom photo was exposed at 1/2.

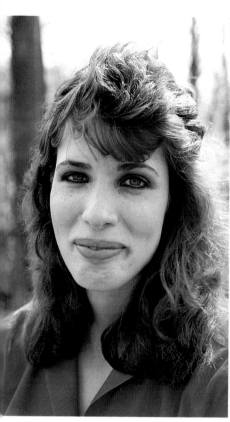

Lenses can enhance or distort subjects. A wide-angle lens was used for the photo on the left, and since things close to the lens (cheeks, nose, and mouth) appear larger, the girl's face is distorted. But with a 200-mm lens (below), the face appears normal and we find a pretty girl.

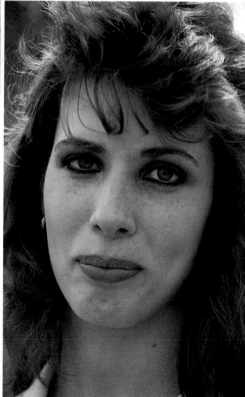

You can often preplan your picture. In this case, the paddler was sure to
go through the gate, so the 200-mm lens was focused ahead of time on
the waterfall at the gate.

Using a lens 105-mm or longer allows the photographer to get away from
subjects, so they tend to be more relaxed.

Examples of how three different lenses can give you a totally different view of a subject. A 24-mm (top), then a 200-mm (middle), and finally a 400-mm (bottom) lens were used. Notice also that wide-angle lenses make the bridge piers appear far apart, while longer lenses tend to compress them together.

Here is an example of how a macro lens of 50 to 60 mm works. All four pictures were shot with such a lens. Unlike a zoom, a pure macro lens gives greater magnification—but you have to move closer and refocus for each shot.

This shows how you can affect a photo by using different lenses. The above photo, shot with a 24-mm lens, shows the angler casting in knee-deep water, with the heavy waves well behind him. But telephotos (a 400-mm lens was used below) tend to compress the photo or bring the background closer to the subject. This makes it appear that the angler is casting in dangerous water—which he is not.

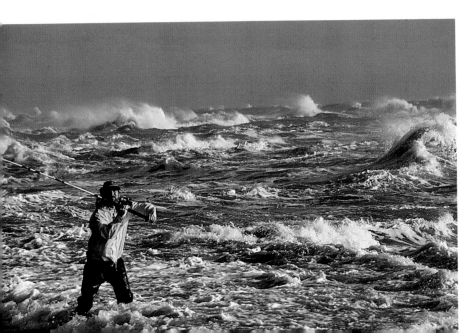

When you use a wide-open aperture, such as f/2.8, as used here (indicated by the large dot), very little of a photo is in focus.

But when you use a very small aperture (f/32 was used here), you get a great deal more of the subject in focus.

Even something as plain as a wet tidal mud flat can be enhanced by using different kinds of light. The top photo was taken with the sun at the cam-

eraman's back. The middle photo was taken with light falling on the mud from the side, and the bottom photo was shot with backlight.

Here is a good example of how backlight
can often enhance a photo. Anything that
light will pass through is usually better
photographed with either sidelight or
backlight. The photo on the left shows
a church window with the light behind
the camera falling on the window
(frontlighting). In the photo below, shot
inside the church and toward the sun
(backlighting), the window's colors
come alive.

Notice how backlighting passing through the maple seed and the muzzle-loader's cloud of smoke makes details easier to see.

Overcast light has very little glare, so rich colors show well on film—especially if they are light in tone. Overcast light also reduces the contrast between dark and light colors. In the case of the wild turkey, the gray feathers and the dark brown ones both show rich coloration.

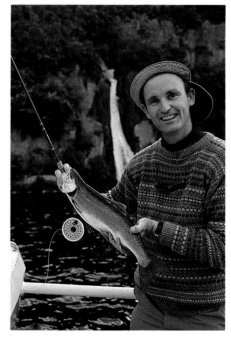

Examples of sidelighting, which puts a shadow on the far side of subjects, so that footprints in the sand are clearly visible in the top photo, and the deep shadows show rugged rocks in the photo on the left. Sidelight penetrating the water droplets makes them stand out on the leaf in the photo below.

Examples of how backlight penetrating fog or leaves helps enhance the picture.

There is nothing but overcast light inside this fishing hut in Scotland, but this allows rich tonal colors to be captured on the film.

Using flash fill to light up a shadowed face helps make pictures more exciting and interesting. The text explains easy ways to accomplish this.

A framed rock garden and an unframed one. Framing often makes a photo much more interesting.

A scene is usually improved if a person or other subject is introduced into it.

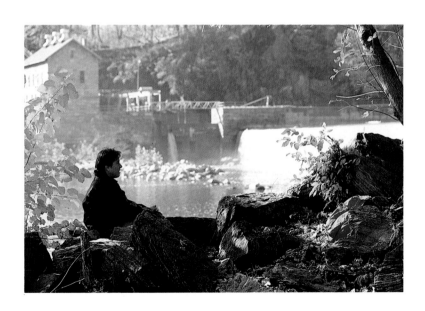

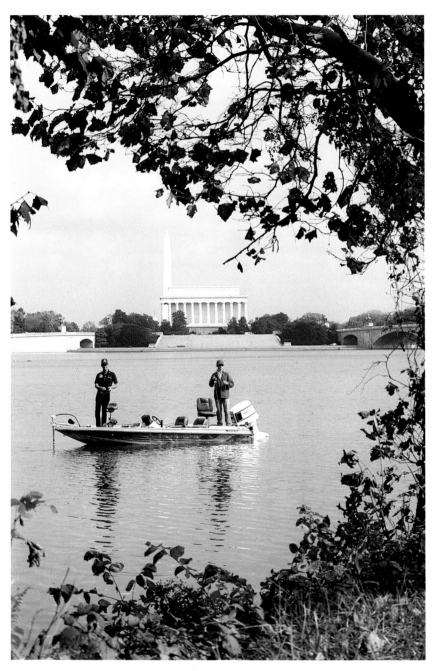

An oak tree was used to frame this photo. When using frames, be careful not to allow the frame to block out or intrude upon any of the subjects. Care was taken to ensure that the Lincoln Memorial in the background was not partially hidden by branches.

Almost always, in composing a photo of something small, it makes for a better picture if the camera is as low as or lower than the subject. Note how a lower angle (right) improves this flower photo.

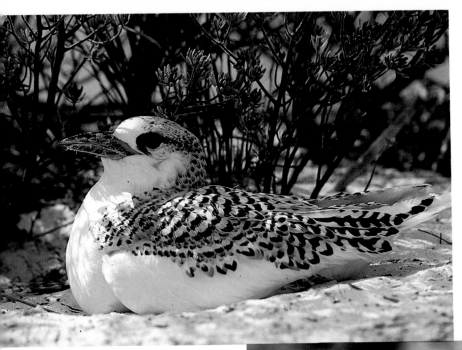

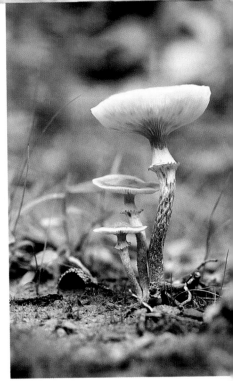

Lying on the ground, shooting from a very low angle, enhances the photos of the bird and the mushroom.

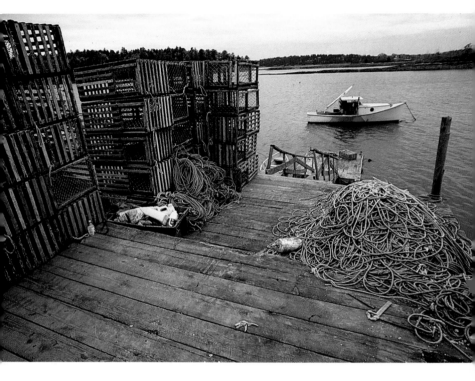

Using a normal or wide-angle lens and placing the subject up front in the photo makes it dominate the picture. In this case, the lobster traps on this Maine pier become the most important feature.

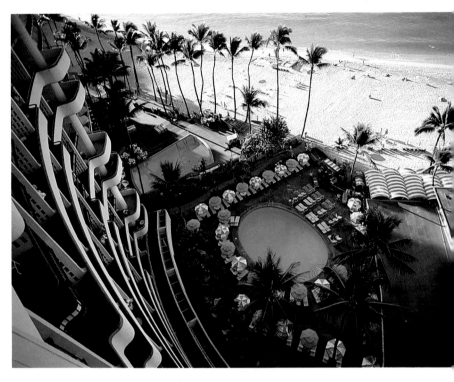

Repetitive patterns sometimes make an interesting photo.

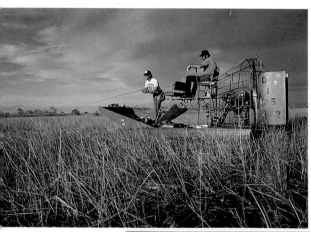

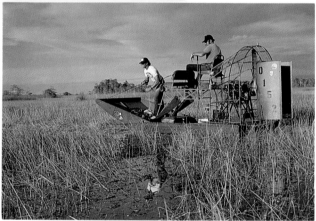

You can often improve a photo by making little adjustments. The photo on the bottom pleased the author more than the one on top because he tramped down some of the sawgrass in the Everglades so that he could get a reflection of the angler in the water.

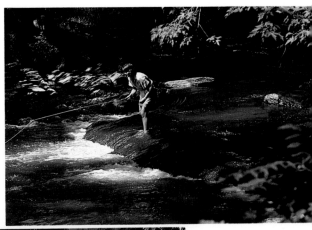

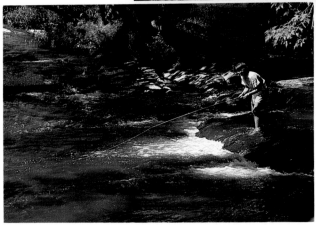

Action should always flow into a photo, not out of it. Beth Keyser is fishing out of the picture in the top photo, but the bottom photo shows her fishing into the picture—much better.

Composing a photo around some important feature sometimes gives the picture interest. This is a "moon gate" in Bermuda.

One of the most pleasing parts of outdoor photography is capturing on film the "firsts" of our children. Here the author's grandson is having his first catch admired by his mother.

Our cameras allow us to capture unusual situations and things, and then bring them back to show to our friends. Here is a "hospital" on Christmas Island in the mid-Pacific Ocean, and a woman in the Costa Rican jungle grinding corn for dinner.

Years after this photo was taken, the hunter is going to enjoy looking at this photo of his young pup wanting to go hunting long before he is really able.

EARLY BERMUDA WEATHER STONE
This stone is the perfect weather indication:

A dry stone means ... it is not raining.
A wet stone means ... that it is raining.
A shadow under the stone means..the sun is shining.
If the stone is swinging it means..there is a strong wind blowing.
If the stone jumps up and down it means...there is an earthquake.
If ever it is white on top... believe it or not, ...it is snowing.

A camera can capture interesting sights (such as this Bermuda weather stone) that can be used later in a slide show or album.

When the photographer takes a silhouette picture, he clearly sees all of the silhouetted subject, but the film often does not, as in the above photo. Make it a rule, when taking a silhouette photo, to be sure all of the subject is in a bright area.

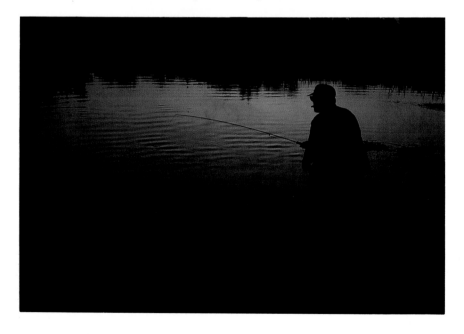

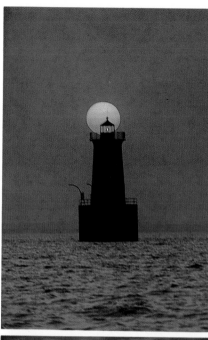

Silhouettes are perhaps the easiest of all photos to make. Just expose for the bright area surrounding the subject and then click the shutter. Remember, good silhouettes can only be made if the photographer doesn't have to squint when looking at the scene.

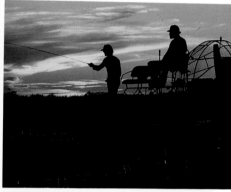

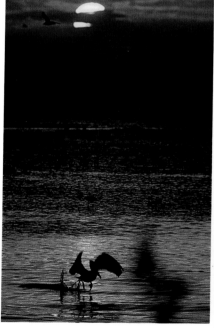

Examples of how you can obtain different results with the same subject: a mayapple blossom. The first shot (top) was made with available light, the second (right) with flash. The third (bottom) was taken with a flash, after the flower had been sprayed with glycerine.

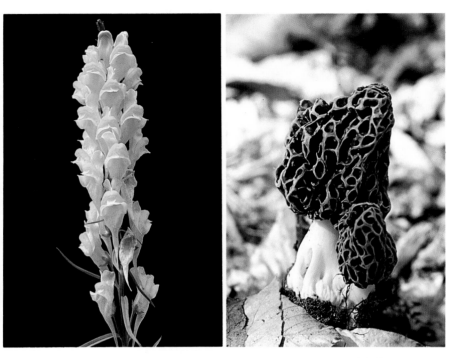

Try to photograph light subjects against dark backgrounds and dark subjects against light backgrounds.

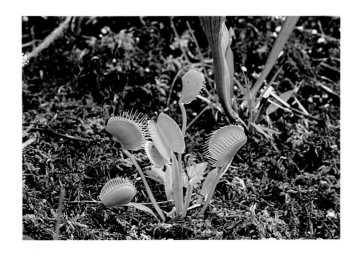

When photographing wildflowers, sometimes you will want to make a shot of the flower and its surroundings, as well as close-ups that allow your viewers to really see the blossom.

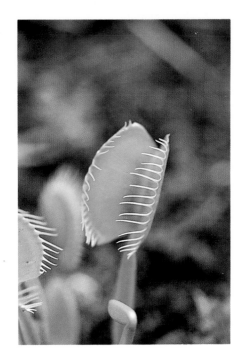

 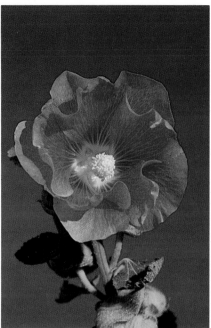

The photo on the left shows a flower photographed in light shade. The photo on the right shows the same flower, but a reflector has been used to bounce a little light onto the flower, giving it more sparkle.

Wide-angle lenses are generally not thought to be good for wildflower photography, but they can sometimes give a different viewpoint.

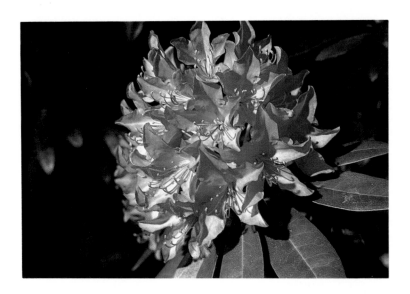

Most flowers don't photograph well in bright sun. The one above has glare and washed-out colors because of the bright sun. The flower below, much richer in color, was photographed in overcast light produced when a cloud passed overhead.

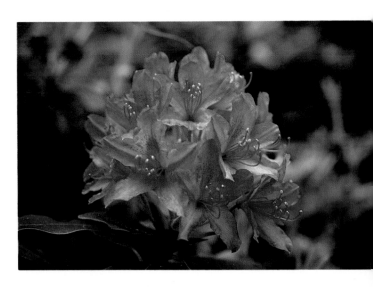

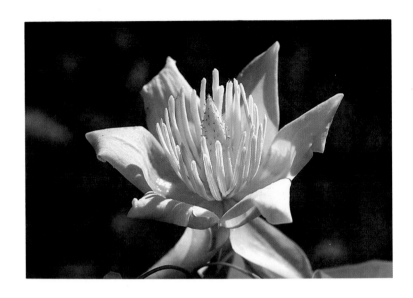

The same yellow poplar tree blossom, but in the photo below it was sprayed with glycerine.

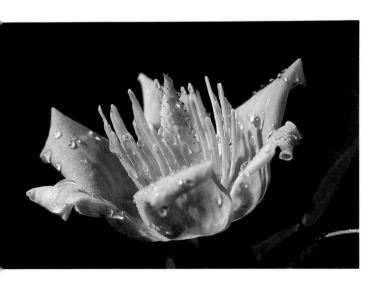

Position a stick when photographing crawling creatures. Then focus on the end of the stick and get ready. Place the creature on the stick, and it will almost always crawl immediately to the end and stop.

Backlighting often works well with insects. The light from behind this butterfly (against a dark background) makes the wing glow.

Insect shots like these can be made with extension tubes, bellows, or macro lenses.

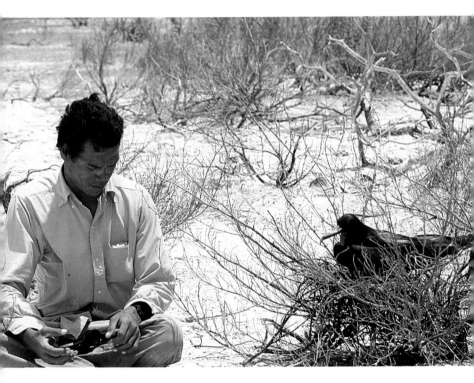

If you enjoy bird photography, you can get very close to them in many wild places, such as a Pacific island, where this frigate bird displays no fear of man.

A good trick when attempting to photo-
graph birds flying close overhead is to
prefocus the camera and then follow a
soaring bird. When it appears sharp, click
the shutter.

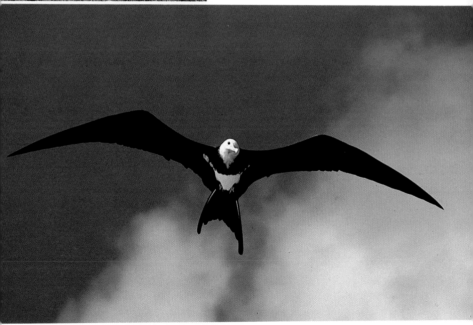

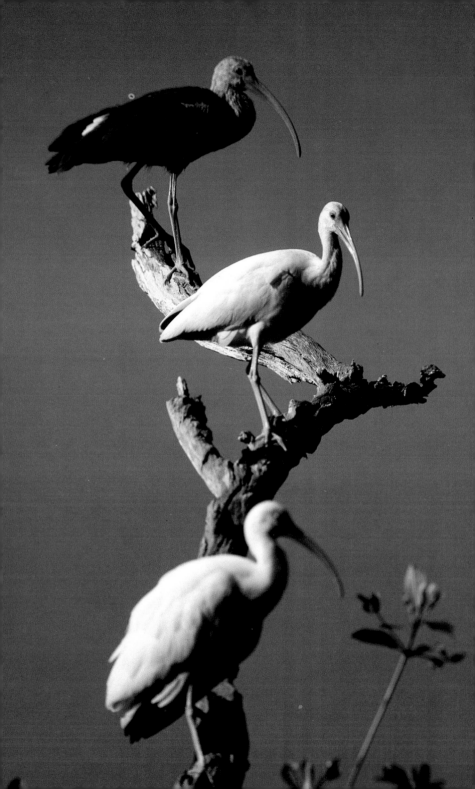

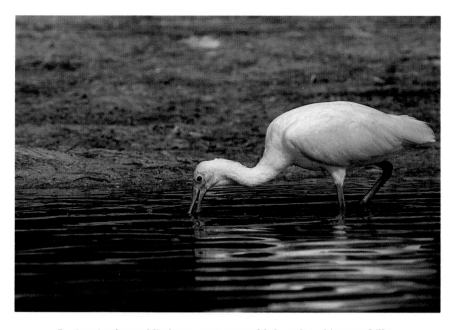

By shooting from a blind, you can get wary birds such as this spoonbill to come close.

Here is a nearly impossible wildlife shot. Because the three birds are one behind the other, depth of field becomes a problem, and only one of these birds is in sharp focus. Either photograph a single bird or change your location so that all three birds are at the same distance.

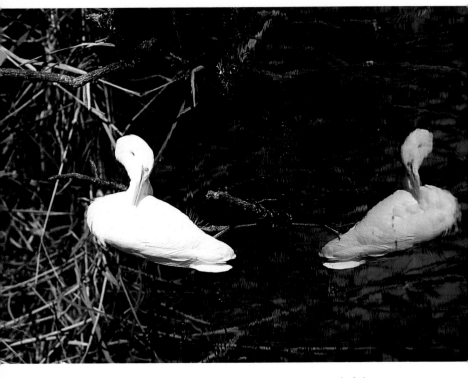

Instead of having a bird just stand there, try to capture it doing something—like this bird preening.

People and wildlife are best photographed with sidelight when the person or bird is looking toward the light. Looking away from the light creates shadows on the face.

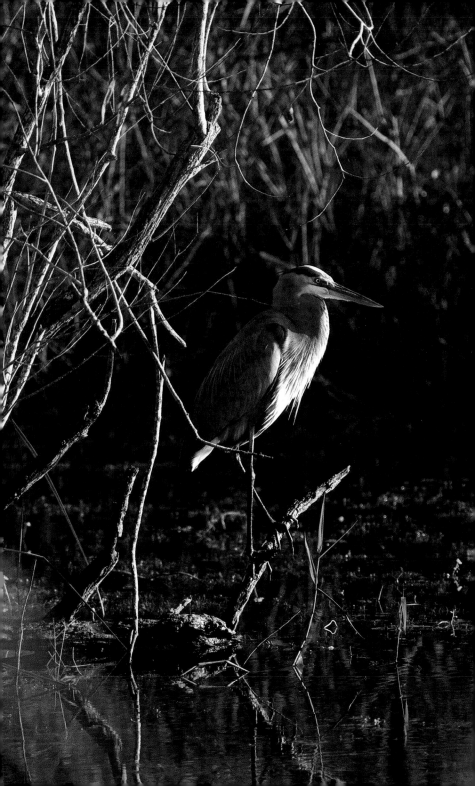

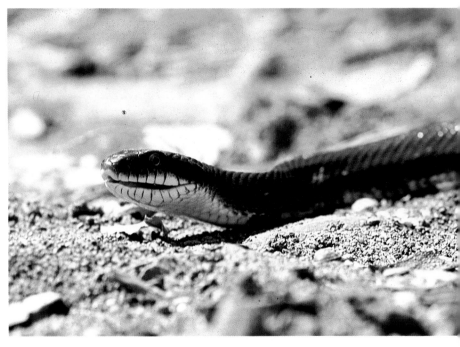

Very low angles often enhance a photo. The author lay on the ground to get this picture.

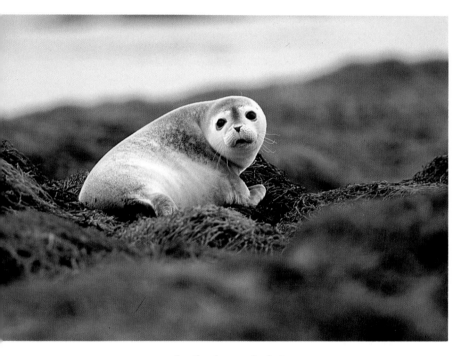

Another low-angle shot.

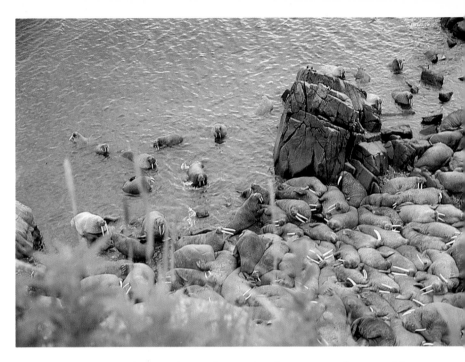

Take photos of wildlife from a distance, but then try to get close-ups with
a telephoto lens, too.

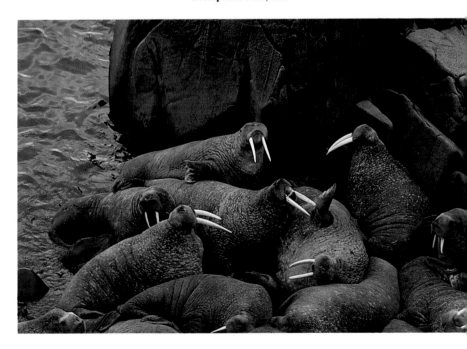

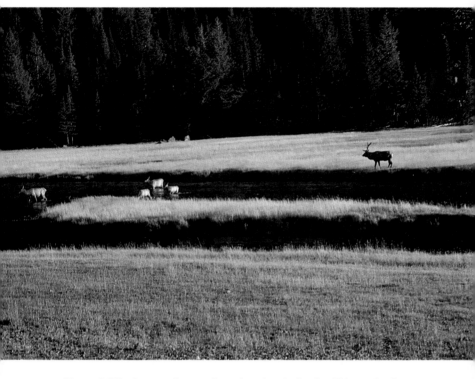

Many wildlife shots are best made early or late in the day. This one is of a
bull elk shepherding his harem across the Madison River
in Yellowstone National Park.

Here and there you can grab an unusual shot. This alligator was almost all green, coated with the aquatic vegetation that floated on the pond.

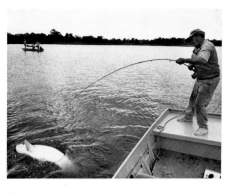

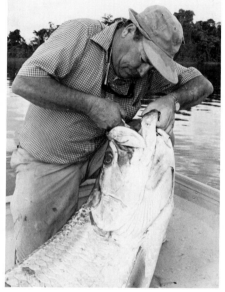

By using lenses of three different focal lengths, three totally different impressions can be given of tarpon fishing. In the first picture the author was photographed with a 24-mm lens while battling a tarpon. The second picture was made with a 55-mm lens at a distance of about five feet. The third photo is of a fish estimated to weigh about 200 pounds, and it was photographed with a 55-mm macro lens, showing just the head, the fly, and part of the hand. All three shots are totally different, mainly because different focal lengths were used.

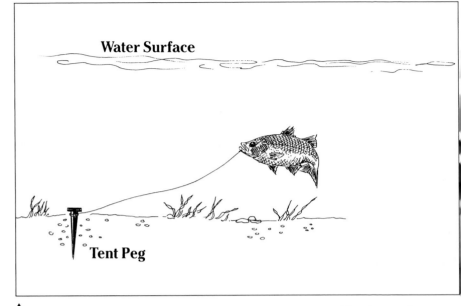

Water Surface

Tent Peg

▲

By "staking out" a fish that has been caught, using a tent peg hidden in the stream bottom and monofilament fishing line (invisible underwater), you can get some interesting set-up pictures of fishing situations.

rod, the fish, the angler, and portions of the boat could be included in the shot and are in sharp focus because a wide-angle lens was used. A word of caution, however. When using wide-angle lenses, remember that things in the distance look much smaller, and therefore subjects such as leaping fish may appear unusually tiny.

A live fish in the foreground showing clearly in the water with the angler casting to it makes a very special angling photograph. A very simple thing to accomplish. Catch a fish (sometimes the toughest part of getting this picture). Be careful not to exhaust the fish. Using a short length of 15- to 20-pound monofilament, attach a No. 6 or No. 8 hook into the roof of the fish's mouth. (If you insert it into the lower jaw, that will pull the mouth open, resulting in an unappealing fish.) The other end of the monofilament should be firmly attached to

a tent peg or something that can be secured to the bottom of the lake or stream. With the fish "staked out" in this manner, the photographer can get on one side of the fish and position the angler in the background. Use a wide-angle lens to obtain great depth of field and to enhance the size of the fish. The drawing shows the setup. Have the angler act as if he or she is casting to the fish. It makes a terrific picture.

You can set up many kinds of interesting fishing and hunting photographs. An example of how you can make a simple but "creative" picture is the accompanying photo of the woman casting a fishing lure. The lure seems to be ready to crash into the lens. Actually, the camera is on a tripod and a normal lens is used with a setting of f/22 to get good depth of field. The woman angler is acting out a cast, posing in this position. The lure has been suspended by 6X (very light two-pound test) clear nylon monofilament trout leader tippet, available in almost any fly-fishing shop. This is one time you don't want to

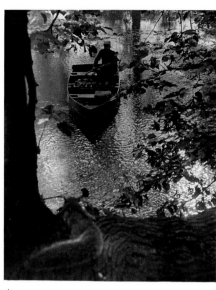

▲

Another set-up picture. Here the lure was suspended from a mangrove tree in the Florida Keys with ultra-thin, two-pound-test monofilament, and the angler was asked to act as though she were casting. A very small f-stop (f/32) was used to get almost all of the picture in sharp focus.

▲

Another set-up shot. Here a squirrel that had been previously shot was positioned in the tree crotch, and though it is slightly out of focus, it is usually noticed by the viewer.

use backlighting, since the leader material would be rimlit and show up in the picture.

The kind of light you use to take fish pictures is also important. Bright sunlight creates glare, and on light-colored fish such as bonefish, tarpon, rainbow trout, and salmon, very little of the subtle details of the fish will show. If the sun is shining brightly, take the fish into the shade or wait until a cloud comes over, then shoot the picture. This overcast light will have little glare, and the subtle shades of color on the fish will show well.

Around the Water

Outdoorsmen enjoy the water, whether they are wading in it to cool their feet after a hard hike, fishing in it, or paddling or boating on it. A photo of a beautiful waterfall or a wind-driven wave crashing on the

beach is a good subject for our camera. When taking pictures around water, a few precautions will keep expensive cameras in good shape and result in better pictures. The Nikon Nikonos is mainly designed for underwater work, but is an acceptable camera to be used for much above-water shooting. A detailed explanation of the use of the Nikonos, as well as waterproof point-and-shoot models, was covered in the chapter on cameras. A note of caution, however: these are not SLRs. You look through a viewing port, not the lens. The lens is almost always protected from dirt and damage by a cap. You can look through the viewfinder and may not realize that the cap is covering the lens. You could see the subject perfectly, but end up with a lot of blank pictures. Be sure that the lens cap is off before you click the shutter.

Because many of these cameras have automatic exposure and focusing and are waterproof, you can make many "grab shots" while your canoe or boat is slicing through rough water, while rain is falling, or while you are riding out rough and choppy seas. If you know the area and can anticipate action, such as when you will encounter a standing wave in a river, you can be ready, pick up the camera quickly, click off a shot, then drop it. One trick to making whitewater pictures look even more dangerous is to shoot from a long angle. If you know a difficult run, and you can get off to the side away from paddlers coming through, and can anchor or have someone hold the craft, you can hold these waterproof cameras partially in the water to get that low angle, and click off your shots as they go by.

Some of the most exciting action outdoors occurs when a kayaker or canoeist is threading through the waves, especially in a meet, where the poles hang down and they must pass through the gates. Such situations lend themselves to good pictures—and make it easy for you. Because you know where the paddler will traverse the rapids or pass through the gate, you can set up your camera on a tripod and prefocus on the spot. When the paddler enters the picture, click the shutter. If you have a motor drive, you can get several pictures. This is one place where a motor drive works exceptionally well. Don't forget, however, that these paddlers are moving fast and you'll need a shutter speed of at least 1/250; I find that 1/500 is often necessary.

Waterfalls fascinate us, and we've all seen pictures taken of them that appear to have been "painted" on the photograph. Such pictures were among the first ever taken with cameras. The old, slow films did not allow stop-action that froze the water. Instead, long exposures were necessary, and so were born the first of the "painted" rapids and waterfalls.

Just what is the proper exposure to obtain this effect? There is no absolute answer, but there are simple guidelines. It's important first to understand that water moves at different speeds, so that there can be no set shutter speed that applies to all moving water. At a shutter speed of 1/1,000, almost any water is stopped, and even 1/500 will generally freeze the water's action. At 1/250, a slight blur will be evident with faster-moving water. To obtain real blur, or the painted effect, usually you need 1/8 or 1/4 as the *fastest* speed. In most cases, if you take the picture at shutter speeds longer than one second, the water is so blurred that much detail is lost and the picture is generally lacking in excitement.

The best way to take a good photo of a waterfall is to bracket exposures, using 1/15, 1/8, 1/4, 1/2, and one second. Usually two or three of these will please you. Remember, too, that the closer you are to the waterfall, the more it will appear blurred and the higher will be the speed required to stop motion.

There is a mechanical problem with waterfalls under some light conditions: being able to photograph at a slow enough speed to blur the moving water. In some cases there is so much light that, because of the speed of the film, you can't close the aperture down far enough to get the desired exposure. But the problem can be handled. By adding a polarizing filter you will reduce light striking the film by about one and a half stops. If this isn't enough, you can add a neutral-density filter, which causes no color shift, but only reduces exposure. Sometimes you may need to use a combination of the two. Another way of solving the problem is simply to shoot moving waterfall pictures on overcast days, or use a slower film. One caution: When you make long exposures with some slide films, you may get a slight color shift, which some people object to. Others find this shift more interesting. Most of the

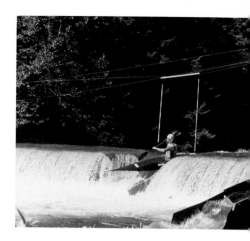

Being able to predict when and where the action will occur, and by using a variety of lenses and a motor drive, you can get a number of different photos. In the first shot, the photographer knew exactly where the paddler would enter the picture (through the gate), so he used a normal lens. The second shot was made by switching to a longer telephoto lens and prefocusing on the gate. Placing the tripod and camera at water level and using a moderately long lens made possible a third viewpoint. When you are photographing some outdoor activities, you can actually plan well ahead just how you will photograph the subjects.

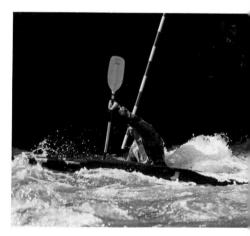

time, a good way to get a meter reading on a waterfall is to meter on the back of your hand and use that reading for the exposure. Just be sure that your hand and the waterfall are in the same light.

Although many photographers are aware of how to take good pictures of waterfalls, I've seen few pictures shot with the same concept of waves along the seashore. Some of my personal favorite outdoor pictures are of waves rolling up on the sand at dawn, just before the sun rises above the horizon. The waves appear multicolored, reflecting the light from the sky, and they have that "painted" look.

Something like 70 percent of this country's people live within a five-hour drive of either coastline. Taking pictures along the coast can result in some dramatic images that your viewers will really enjoy. The seasons along the coast vary dramatically in the northern climates and provide wonderful subjects, whether it be frozen ice spray, or warm waves crashing against the boulders, with a backlighting sun illuminating the millions of water droplets thrown high above the rocks. An interesting set of pictures can be made of the same seashore at different seasons and times of day and under various weather conditions. It is also a lesson in handling light.

Waves look higher if they are shot from a low angle, and you can compress them by using a long lens, or spread them out, making the ones closest to you dominate the scene, if you use a wide-angle lens. If a boat, an angler, or a swimmer is in the water, it often adds impact. One way to get some very dramatic shots, if you have a Nikonos or one of those waterproof point-and-shoot cameras, is to step into the water and take pictures as the waves start to crash over you—or on nearby rocks, logs, or docks. Sometimes it pays not to try to photograph just the ocean, but to concentrate your lens on an object, such as a boat anchored and riding out a storm, or

seashells on the beach, or a shorebird running behind the waves, plucking its meal from the wet sand. Many times, using an old dock, a tree, or some local structure as a frame will add mightily to a seascape. A lake or ocean surface almost always looks better early or late in the day. At that time it reflects the colors of the rising or setting sun that have illuminated the sky and are mirrored on the surface. To further enhance a sunrise or a sunset—especially if it isn't too dramatic—I sometimes add either an 85B filter, which makes the sea

▲

Cameras and lenses have to be protected from spray when photographing like this around salt water.

▼

appear golden, or a yellow filter, which will add color to the sunrise or sunset.

If you are using a nonwaterproof camera, such as a conventional SLR, you do have to be careful about salt spray—especially if the wind is blowing. Sand can also be an enemy in the breeze. Keep all equipment in a good case or closed bag; and if you have a camera bag, storing it inside a heavy-duty plastic or garbage bag is recommended in such situations. One of the best ways to protect a lens if there is blowing spray or sand is to use the FasCap, which is a protective cover that can be snapped open, then snapped shut once the picture has been taken. Filters, such as the UV type, will protect your lens, but they have the disadvantage, if exposed to the salt spray, of getting coated, which will detract from the picture. The FasCap keeps salt spray off, and the glass is exposed only when the cap is opened. But FasCaps can't be used on cameras with lenses 28 mm or wider, since the cap causes vignetting with these wide-angle lenses.

African Safaris

Perhaps the greatest chance to photograph a variety of wildlife is still in Africa. Much of the game has been depleted and more is surely going to disappear, so going as soon as possible is recommended. What makes such a trip so interesting to photographers is that nowhere can you get so close to so many kinds of animals that in many cases almost ignore you. This is especially true on many of the great game preserves. For your first trip you should certainly book through a tour agent. Later, in some areas of Africa, you may want to consider renting a car and going it on your own. This has some disadvantages, since you have to deal with a great mass of unreliable people. But you do get to set your own schedule, getting up when you wish or staying as long as you like in a certain location.

Africa is one place I have never visited, but my friend Tony Wimpfheimer, who is a superb photographer, has made several jaunts there, and offers the following advice:

"You are in Africa primarily to photograph animals. The scenery from time to time is attractive, but the focus is really on animals. As to the scenery, the people, the animals, and everything else, it is important to mention that the schedule in Africa starts at sunup and ends at sundown. Since the animals eat in the early morning and late afternoon, your game drives occur during those two periods of the day. Except for animals seen in transit from one game lodge to another (and these are precious few, since they are not in game preserves and are therefore not protected, and are therefore nervous, and they hide), you are shooting most of your animals in light that is far from the greatest. You may want to use filters to filter out some of the red of the early morning and late evening. I myself do not use any, and I really did not find many pictures that were hurt. Somehow or other, the films have enough latitude so that if there is enough light to take the picture, the heavy red of the scale does not seem to permeate. This leads to the question of fast films. I guess that ISO 400 is mandatory, and I stick with Ektachrome 400. Also, because of poor lighting conditions, and often a need for a shutter speed of 1/250 second, I feel that Kodachrome 64 is too slow for this. Some photographers are using Kodachrome 200, but others complain that it really is fairly grainy.

"I think what comes first is choosing your tour. The answer is that all game lodges are more or less alike, and whether you get into Tanzania or maybe even Uganda, the key is how you shoot your animals. Since most tours use minibuses or the equivalent, there is a driver and an

empty seat in front. Sometimes that seat is available for a passenger, but it does not give access to the roof hatch and often necessitates shooting through the windshield. Sometimes a guard rides in that seat. That leaves two passenger seats behind the first seat. You want to make sure that your tour books no more than four people in those seats, since you need the middle area between the people to store your camera equipment and miscellaneous junk like sweaters and binoculars. Also, since you do most of your shooting not out the windows but through the open roof hatch, you need to actually stand on those seats, and four people working through a roof hatch is enough. Any more becomes a crowd. Something that I found to be extremely useful when shooting through the hatches of various vans is a very short tripod. Mine is about six or eight inches and it holds my 70–210-mm lens very firmly. The only other thing you can say about choosing a tour is to choose one that does different parts of Kenya (and preferably Tanzania as well) so that the game varies somewhat from place to place. For instance, Tsavo is famous for elephants, and you will see more there than you will anyplace else. Also, they are red, because they roll around in the red dirt to keep the bugs off.

"Obviously, since you are not going to be on top of the animals, you need a long lens. I have used a 500-mm mirror lens, but watch out for "doughnuts." I also take along a 70–210 mm or 70–300 mm on the other camera. I have used a telextender, but it cuts the light, and in the end, it really isn't satisfactory. The 70–210 mm is the primary lens you will use for game. As far as everything else is concerned, i.e., scenery and activities during the day around the swimming pool with people and/or at night around the campfire, I would recommend that someone take along one of those point-and-shoot cameras that have a 30-to-40-mm lens and a built-in flash. It is a very useful little thing, inexpensive, and with the wide angle it does most everything you need. The last thing anyone needs in Africa is a 28- or 24-mm wide-angle lens for your primary camera. Once again, it is the animals and people that you want to photograph. If you have room, you can throw in a 28–85-mm zoom. A 50–60-mm lens would only be useful for macro work, and I do not remember any great need for that.

"Because of the dust in many places, such as Amboseli, plastic garbage bags are vital. In many places you do not need them, but when you get into a dusty area in the dry season—and you are almost always over there in a dry season, since that is when game viewing is at its best— heavy-duty garbage bags are very good. A hint is that in a desperate situation you can always 'pinch' the laundry bag out of your safari lodge room. A further aid to keeping lenses free of dust is the FasCap, which can be used on lenses 35 mm or longer. Serious photographers in the field should consider one of these, but it doesn't protect the camera body. Take along some garbage bags for this.

"You shoot a lot of film and throw a lot of it away. Therefore, to keep things straight as to where you are, use some small Avery labels and prenumber them before you leave. When you finish a film, put the next numbered label on the container. Then you know what was shot and where (you should keep such a record), and you also know the sequencing of the slides when you come home. This is especially useful if you are using more than one camera, because you have to feed the stuff together.

"Your driver is very anxious to please. He will undoubtedly get you very close to the game. Sometimes too close, so that you are shooting down at game, creating distorting pictures of the animals. Much of it

is really quite passive and it sits for you. You can get very close to game in these minibuses. A beanbag or piece of sponge rubber hose can also be useful when placed on the leading edge of the window on the roof, since there is some vibration from the van and even more vibration when in some areas a four-wheel-drive vehicle is used. Often, though, you can ask the driver to turn off his engine so that the car doesn't vibrate—and to back up if you are too close to the subject."

Another popular nighttime picture is of people sitting around the campfire. But taking a long exposure off a tripod, using just the firelight, is tricky and often results in a poor picture. A much better technique is to place a flash with a slave unit attached (these are small and inexpensive) beside the fire and concealed from the camera by a person or an object. Then set the camera up with a flash on it. The camera flash is used only to trip the slave, causing it to illuminate the people around the campfire. This may sound like a complicated photo, but in reality it is very easy to do.

Weather

Weather offers opportunities for good pictures. Rain dripping from fall foliage, a snow-covered fencerow, dangling icicles hanging like an untrimmed beard from a rock ledge, boats shrouded in mist, and many other such scenes offer the photographer unique opportunities to make outstanding photos.

Snow can make everything beautiful, especially if pictures are taken soon after it stops falling. The white stuff hides all the sores of the land and gives everything a clean look. The photographer should seize the opportunity when it happens. The best shots occur early in the morning after snow has fallen the night before, and there

is good sunlight. Dull, overcast days are okay for some subjects, but lack brilliance on film. And early, strong light produces strong shadows on the snow that give shape, texture, and sometimes a three-dimensional effect. Another important reason for going out immediately after a snowfall, if the light is good, is that the wind has not had a chance to blow, nor the sun melt, the snow from branches, fenceposts, and rocks. Snow-covered things often take on a shrouded look that enhances a photo.

When you take a picture in the snow, the scene tends to be totally white. If you can locate a tiny bit of color, or even a dark object, it will stand out clearly and become the focal point of the picture, making the scene more interesting. Slow-speed color films have more inherent contrast, and the same photo taken with a high-speed film and a medium or slow one will look entirely different on each type. With the high-speed film, things tend to look more white, while the slower film will have much more detail, subtle coloring, and shadows.

Snow that is photographed on overcast days will usually have a blue cast, especially if the overcast is heavy. At such times you may want to add an 81 series filter to warm the colors and restore whiteness to the snow. Snow appears white, but on clear days it reflects the blue of the sky, and shadows especially will show blue on film. When shooting slide film, most people end up with blue snow pictures. The major reason for this is that their camera meter is calibrated for an 18-percent gray card, and snow is so white that the camera doesn't give an accurate meter reading. Many good outdoor photographers will take a meter reading from a gray card, then open up one stop. This overexposure seems to eliminate the blue from the snow. The problem is more severe when there is a light overcast than on a bright day. If you want realistic snows, try bracketing from

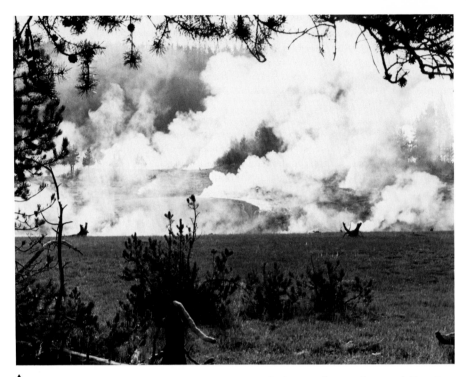

▲

You can really show off the steam rising from the thermal vents at Yellowstone Park if you can make your photos early on a cool morning, with the sun backlighting the steam.

your original reading toward overexposure. It is also important to realize that if you want to show detail and texture in snow, you need to deliberately underexpose it slightly. Sometimes shooting against the sun will backlight millions of tiny crystals on the surface of the snow and make a very interesting picture. Often a deliberate underexposure here will emphasize the backlighting and give an even more pleasing shot.

To photograph falling snow, you need to use certain shutter speeds. At 1/500, large snowflakes are usually frozen in midair. At 1/250 they tend to be a little blurry, but still show up well. At 1/30 they form streaks in the picture, and at even slower

speeds the streaks are elongated. By adjusting the shutter speeds you can obtain very different pictures of falling snow.

Ice is another feature of weather that can make wonderful photos. Ice is transparent, so light will pass through it. Therefore, sidelighting and backlighting can be used to make ice almost glow in a picture. Even in overcast light, ice can look terrific. A slight underexposure often brings out the details in ice, such as trapped air.

Rain provides another opportunity for good pictures. Many photographers put their equipment away with the first falling raindrop, but that is a mistake. You can use an umbrella, a plastic bag, or a hat to protect the camera from water. Raindrops on a flower, running down a window, dripping off a backpacker's nose, or pounding into a quiet pool can make pictures that please viewers. On the other hand, showing the rain falling in a picture is difficult.

One problem is depth of field; only a portion of the rain will be in focus. Because it is transparent, it is also difficult to see. However, look at the rain against a dark background. If you can see it clearly, you can probably photograph it. Because rainstorms and rain are often in shades of blue, low-speed films, with their higher contrast, will often portray the mood better. Two of the very best times to take an outdoor picture are just before and after a rainstorm, when sunlight is falling on the foreground, and the background is filled with dark, ominous clouds. This makes a truly outstanding picture.

Rains frequently result in rainbows. A polarizing filter can make a rainbow look even more striking. Just rotate the filter while looking through the lens to see what effects you are getting. With most rainbows, a longer lens gives a more dramatic picture.

One of the features that make a horror film so dramatic is fog or mist. Both reduce the visibility and contrast in a picture, which can make for an appealing shot. Fog and mist are giant diffusers that soften the light so that colors are subdued and distant backgrounds seem to disappear. Fog and mist can also obscure features you may not want to show in a picture—for example, a pretty scene containing an ugly smokestack can be shot on a day when there is fog or mist that completely hides the stack.

Many wildlife photos are given a mysterious mood if the subject is photographed in mist or fog. One of my favorite pictures is one I took of a white egret stalking through a pale, misty fog at Chincoteague National Wildlife Refuge. The photograph is nearly all white, and I've sold it a number of times. Telephoto lenses tend to exaggerate the effects of mist and fog, and if you can catch the sun as it begins rising through early dawn fog, you can obtain some striking photos.

Landscapes

All outdoorsmen constantly photograph landscapes. Again, applying some basic rules will help you get more satisfying pictures.

The most useful lens for most landscapes is probably the 50 mm, since it sees the scene about the same way as the human eye. But many times you may want to emphasize the foreground, and that will call for a wide-angle lens, which also has a great deal of apparent depth of field. Telephotos are especially good for selecting a special part of the landscape to portray. Telephotos can "compress" a photo, too, so that features in the distance can be brought closer together. When using long telephotos for landscapes, remember that the air is always clearer early in the morning. During the day, dust that accumulates in the atmosphere can reduce the overall sharpness of a picture—a factor that sometimes can be used to make a good photo, too.

Most landscapes appear much sharper if you shoot at an aperture of at least f/8, and even f/11 to f/16 will show more sharpness throughout the photo. Meter readings for landscapes are not difficult if you use a gray card. Just remember, if you're using a wide-angle lens, that the lens and meter are going to see a lot of sky, sometimes giving a false reading. Make sure that the light falling on the gray card is the same as that striking the scene, and you will almost always get a good exposure—especially if you bracket.

Landscapes usually look better if there is a point of interest. It can be a gnarled tree, a person, a horsedrawn wagon, or a bright red barn. But having a point of interest puts a special spark into it. A favorite trick to obtain depth in a photo is to position someone in the foreground, looking at the scene in the distance.

The most interesting light for landscapes

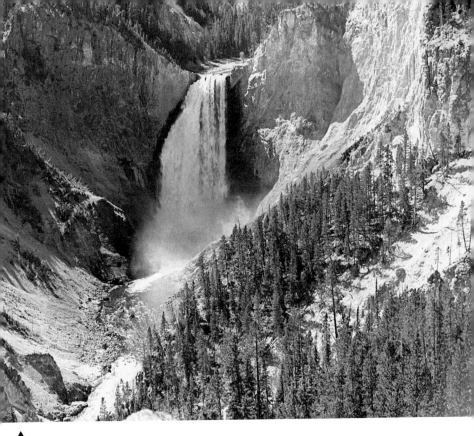

▲

By using a moderately wide-angle lens (35 mm), enough of the foreground is shown to help give depth to this landscape scene of Yellowstone Falls.

almost always occurs early and late in the day, when the rays of the sun are at an angle. This produces brightly lit and shadowed areas, and gives texture, shape, and form to the photo. Midday usually offers the least attractive light.

Double Exposures

Double exposures are often appealing and sometimes force viewers to study the picture, trying to figure out what you did. An example is the accompanying photo of the grandfather showing his grandson how to fish for trout. This was taken at an annual

outing of the Brotherhood of the Junglecock. Also shown in the photo is the arm patch that members wear. The picture was easy to take and followed the basic rules for taking simple double exposures while you are in the field. I shot the picture of the two anglers. Then I cocked the shutter without advancing the film (see your camera's instruction manual which will tell you how to do this), and took the patch to a shaded area, where I laid it on a piece of black, nonglare construction paper and took another photo. Because the paper was jet black and produced no glare, only the patch showed in the second photo, and the final results are shown in the print.

The trick to taking double-exposure shots is to make one picture, and then make another on the same frame of ex-

posed film against a totally dark background. Only what is photographed against the dark background will be depicted in the shot. When making double exposures, there is always the chance that the film may slip a little to the left or right inside the camera. If that happens, part of a photo will be impinged upon the double exposure. To eliminate this problem, make an exposure on each side of the double-exposed film with the cap on the lens. This gives you a totally black "safety area" on either side.

▲

An example of a double exposure. How the photo is made is explained in the text. It's easy to make such photos with a little bit of preplanning.

CLOSE-UPS

By using special attachments on our lenses, or lenses designed for taking photos of small things so that they can be seen as enlarged subjects, we can make what are called close-up pictures. These are usually photos of very small things, such as a tiny insect or flower, or even part of one. Generally, a subject will appear one-half to full size on the film. If it's one-half life size on the slide or negative, this is expressed as a ratio of 1/2:1, and a subject that is the same size on the film as it is in life is said to be 1:1.

Close-up photography offers the photographer the chance to let his viewers look at things in the outdoors that they may never have seen. Telephotos and wide-angles simply show what the viewer is used to looking at, though from a different perspective. But, when you get in close and photograph a tiny object, or the detail in a large subject, you are able to make a very special picture that can be surprising,

often dazzling your viewers. The dutchman's pipe is a flower that attracts insects to invade its inside so it may be pollinated. One end of the flower is slightly thinner, which allows light to be transmitted through the flower. Once inside the flower, the insect instinctively crawls toward that brighter end to get out—sort of like moving toward the light at the end of a tunnel. What better way to explain and show this than to have a backlit photograph of the insect crawling through the flower toward that end? A close-up of a cockleburr or spanish needle demonstrates how the tiny hooks on the ends of the seeds snag our clothing and hitch a free ride. A raindrop suspended from a thin branch, reflecting the area around it, is a captivating scene—only possible by making a close-up. The beauty and diversity of the geometric shapes of snowflakes can be photographed only through close-up photography.

I can think of no other area in outdoor

photography where you have a chance to take pictures of subjects where you can often show familiar features in such a way that they have rarely or never been seen before. A word of caution here: once you get involved in close-up photography, you may be hooked.

Fortunately, you can get involved in this type of photography at very little expense if you already own an SLR with interchangeable lenses. Later you may want to invest in additional equipment that will allow you to do more and expand your horizons. But for a small investment you can make beautiful close-ups.

If you are serious about close-up photography, you really should invest in a macro lens, which has been described in detail in the chapter on lenses. It was suggested there that you not buy a normal (approximately 50 mm) lens, which allows you to close-focus to about twenty-two inches from the subject, but rather a macro lens between 50 and 60 mm. This is a lens that will allow you to focus from infinity (as you do with a normal 50-mm lens) to as close as six inches away from your subject. A major advantage of macro lenses is that as you move closer and closer to the subject, you simply refocus. This is a disadvantage

of many other lenses and accessories that allow you a sharp plane of focus only at a very specific distance.

These macro lenses either come with an additional extension ring, or you can purchase it separately; this allows you to make 1:1 photos. If you added the ring and focused as close as possible on, for instance, a dime, when you got your slides back, the image on the slide would be exactly the same size as a dime.

With the 50-to-60-mm macro lens you can make many fascinating photographs, and many professional outdoor writers consider it the most important single lens you can own. I agree. However, in much of close-up photography you are taking pictures of insects, amphibians, or other creatures. If you get too close to these subjects, they feel intimidated or become afraid. They either try to retreat or act unnatural, which can spoil the photograph. What is needed is the ability to get farther away from the subject, allowing it to act naturally. This is possible by using a longer macro lens. Many manufacturers now sell one in the 90-to-105-mm range, and at least one has introduced a 200-mm lens. The advantage of these longer lenses is that they

Carrying a 55-mm macro lens as your normal lens allows you to get close-up pictures such as these bird tracks in the sand.

▼

Things that don't move and that you want to photograph close-up, such as this flower, can be taken easily with a 55-mm macro lens.

▼

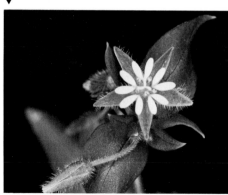

▲

Creatures you find outdoors will often not let you come close. Using a 200-mm macro lens, the author could stand well back and take a photo of this butterfly.

▲

After taking a photo of the butterfly with frontlighting, the author was able to move around until he could get a backlit shot of the sun streaming through the wings. This would not have been possible with a shorter macro lens, for the insect would have been disturbed and flown away.

This drawing shows how far away you can be with a 55-mm, 100- or 105-mm, and a 200-mm lens, and still be able to get a one-half life-size image of the subject. Obviously, the 105- and 200-mm lenses are better suited to getting photos of creatures close up, by allowing the photographer to stay farther away from the subject.

▼

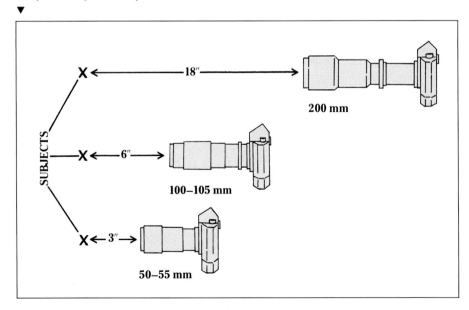

will allow you to produce the same large image that you could with a 50-to-60-mm macro lens—but from a much greater distance. For example, if you could make a 1:1 (life-size) image with a 55-mm lens from about three inches away from the subject, you could stay twelve inches away (four times farther) with a 200-mm lens. It is worth adding that these longer macro lenses (100–105 mm and 200 mm) can also be used as regular lenses of this length, so that, for example, a 105 macro is not only useful close up, but makes a superb portrait lens.

Another advantage of macro lenses is that they are corrected for a flat field. In a close-up, only a very small portion of the photo is in focus, and these lenses are specially ground so that across the flat, shallow plane they are very sharp. A disturbing feature that you learn to cope with is that in close-up photography there is an extremely limited depth of field. In very close-up work, only a few millimeters of the subject will be sharp in the final photo. That means you must take care when viewing the subject and decide which portion of the picture you should focus on. The disadvantage of almost all macro lenses is that they are slightly slower than most normal prime lenses in the same focal lengths. Thus, a 50-to-60-mm normal lens usually has an f-stop that is at least f/2.8 and often much larger, whereas many macros of this length will have an aperture no larger than f/3.5. This means, of course, that less light enters the viewfinder, sometimes making it difficult to focus quickly; but since most close-up work is not a hurry-and-shoot operation, most people who use macros don't find this too much of a problem. There are also zoom macro lenses, but these are not true macro lenses. Though they do allow you to come a little closer and make the image a bit larger, they almost never allow you to enlarge the subject as much as you can with

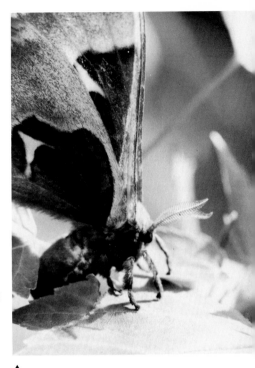

▲

In close-up pictures, the depth of field is very shallow. Note that with this moth only the wing and a portion of the antennae are in focus. Try to keep the subject parallel to the lens, and use a fairly small f-stop to help you obtain more depth of field.

a true macro lens. And because zooms are constructed with a large number of elements, almost never does a zoom macro approach the sharpness of a conventional macro lens.

Accessories

If you don't have a macro lens, or you don't want to spend the money for one, there are other options:

Close-up or supplementary lenses. These resemble a clear filter and they screw on the front of your lens, allowing you to focus closer than the lens normally could. Aside from their relatively low cost, these

lenses have the advantage that they require no exposure compensation. When attached to the front of your lens, they magnify the subject, depending upon the strength of the lens. The strength is expressed as a diopter number, such as No. 1 or +1. You can combine diopters to get increased magnification—such as adding a +1 and a +3. Many people who have used these lenses extensively feel that you get your best results when working with +2, +3, or +4, but that once you get beyond +5, you seem to have a slight quality loss. Perhaps the two most useful close-up lenses to have are a +2 and +3. A word of caution: when you combine supplementary lenses, be sure to attach the higher numbered lens to your camera lens for best results.

Supplementaries can be added to any of your lenses. The obvious advantage is that you can remain farther away from the subject. For example, you can add a +2 close-up lens to your normal 55-mm lens, but you will have to get very close to obtain a sharply focused subject. You could add the same +2 lens (if it will fit) to a 400-mm lens and be able to sharply focus the subject from a much greater distance.

The great disadvantage, which you soon discover when using these close-up or supplementary lenses, is that you can only be in sharp focus over a very shallow distance. For example, you may be able to focus on a subject from eighteen to fourteen inches away—but not farther away or closer than this. Another supplementary lens may allow you to focus from fourteen to twelve inches, etc. Move in or out of that narrow range from the subject, and everything goes fuzzy. Unlike the macro lens, which allows you to refocus continually as you move toward or away from the subject, you are stuck with a certain zone of sharpness and image size. There is often a slight loss of image quality (especially at the edges of the photo) with close-up

lenses, and some perspective distortion will occur when they are used with wide-angle lenses.

Overall, they do offer a good inexpensive way to make close-up pictures with virtually any lenses you own. Obviously, you must buy the supplementary lenses in the same sizes as the lenses you intend to use them with, or else purchase inexpensive step-up or step-down rings (rings with different male and female thread sizes so they can be mated to your various lenses) that will allow you to attach them.

Extension tubes. Extension tubes are also relatively inexpensive, and they offer another method of allowing any of your lenses to focus closer than they could normally. An extension tube is simply a tube or spacer that fits between the lens and the camera, extending the lens away from the body. This results in a magnification of the image. Extension tubes contain no glass elements, so you are taking your pictures through the high-quality lens on your camera. The amount of magnification is controlled by the length of the tube used. If the extension tube is the same length as the lens, it will result in a life-size image on the film; if it is longer than the lens, the

These are two examples of extension tubes that are designed for this specific camera and act automatically; that is, they stop down the lens to the desired aperture when the shutter release is pushed.
▼

Inexpensive automatic extension tubes that can be mated to many kinds of cameras may be purchased from many camera outlets. Just be sure you inform the salesman which type of camera body you plan to use the tubes with.

image will be larger than life-size on the film. You could use a relatively short extension tube of, say, 50 mm on a 35-mm lens and get large magnification. But the problem with the wider-angle lenses is that you must get extremely close to the subject, often so close as to intimidate a creature, or interfere with the light falling on it.

There are two kinds of extension tubes: manual and automatic. "Manual" simply means that you must open up the lens aperture to get enough light to focus, though before you trip the shutter, you must manually close down to the desired f-stop. This can be a cumbersome process. Automatic extension tubes allow you to focus with the lens wide open; when you touch the shutter release, the lens automatically closes the aperture to the desired f-stop before making the exposure. Since extension tubes are rather inexpensive to begin with, it makes sense to buy only automatic tubes.

Because you are extending the lens away from the camera, and light reaching the film has to travel a longer distance, com-

pensations must be made in exposure. If you are using a through-the-lens meter (TTL) on the camera, the camera will automatically compensate for the reduced amount of light that will strike the film because of the tube's extension, and will give you the correct exposure. But if you are metering by hand, or with a meter that is not TTL, you will have to compute the loss of light created by adding the extension tube.

Reversing rings. Conventional, non-macro lenses are designed to focus from a few feet to infinity. But they will give their best close-up results if their lenses are reversed. Reversing a lens means positioning the front of the lens against the camera body so that what is normally the rear portion of the lens faces toward the subject. To accomplish this, a reversing ring is attached to the camera body, and the lens added to it. These can be obtained from most large camera shops. They increase the ability to magnify the subject. You do lose the automatic operation of the lens, so that it won't automatically close down to the desired f-stop. But it is a simple way of getting extremely high-quality photos, if your lenses are top grade. Reversing rings

A reversing ring has been used to mount this lens on the camera body back to front. Lying in front of the lens is another reversing ring, to show what these look like.
▼

work best with lenses that are no longer than 60 mm.

Bellows. This is the supreme close-up accessory, allowing you to get extremely high magnifications. With a seven-inch bellows fully extended, and a 50-mm lens reversed on it, you can get an image on your film that is five times life size! The bellows is a lightproof flexible "tunnel" (actually a flexible extension tube) with one end attached to the camera, and a lens on the other. By turning an adjustment knob, you can move the bellows along a rail (a double rail is better) and this extension moves the lens farther away, increasing the magnification. The outstanding advantages of the bellows are the ability to magnify the subject greatly with either normal or macro lenses, and to focus continuously as you increase the magnification.

Better-designed bellows have two features that photographers will soon appreciate after using this useful tool. One is the

The drawing shows three methods of obtaining close-up photographs: close-up lenses, extension tubes, and bellows.
▼

ability to flip the camera quickly from horizontal to vertical format without disturbing anything. (Bellows without this feature often require removing the camera from the bellows and then reattaching it.) The other feature is that the bellows will accept a dual cable release, which is a cable release that actually has a single plunger and two cables. One plunger is screwed into the bellows near the lens, the other into the shutter release on the camera. This way you can focus through a wide-open lens, but when you press the plunger, the cable at the forward end automatically closes the f-stop to the desired setting. This greatly speeds up operations when you are trying to photograph living subjects close up.

For unusually high magnifications, two or more bellows can be added together to obtain some truly outstanding photographs.

Whenever you employ the bellows or extension tubes, you are moving the lens away from the camera. Because less light will strike the film, exposure compensations must be made. With TTL metering

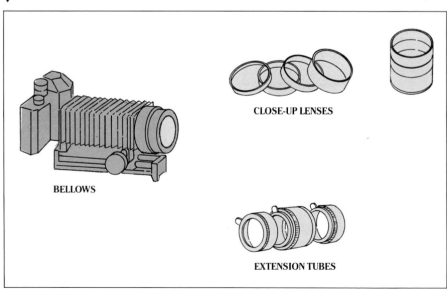

CLOSE-UP LENSES

BELLOWS

EXTENSION TUBES

this is no problem, which is why such cameras are superior for most outdoor photography. However, many cameras don't have TTL. If you have a friend who has a camera with TTL that will accommodate your extension tubes or bellows, there is a simple method of making a table to determine how much exposure increase is needed. All you need is a Kodak 18-percent gray card and a tripod. Let's assume you have three extension tubes of different lengths. Be sure that you have a constant light source (a lightbulb shining on the gray card will do). Then take a meter reading with the lens on your friend's camera. Record that exposure. Add the shortest extension tube and take another meter reading. Record that reading and then compute the difference in exposure. That will tell you how much you will have to adjust either the aperture or speed to compensate for the loss of light when using a particular extension tube. Do the same for all your tubes and at marked distances on your bellows. Then take a normal meter reading, and add whatever compensated exposure you have already calculated for the particular extension tube or bellows being used.

One of the major problems in close-up photography is the same as in telephoto work. You are magnifying the subject, and along with it, you magnify any motion, which results in a blurred picture. Extended bellows and tubes combined with low light conditions require long exposures. If either the subject or the camera moves during the exposure, a fuzzy photo results. There are some ways to overcome this. A tripod is one solution that immediately comes to mind, but often the legs of a normal tripod get in the way, and most of them won't get down close to the ground where many of the subjects being photographed live. For such close-up work a mini-tripod is often ideal. If a conventional tripod is used, it should have a short center post or one that can be shortened, along with the capability of having all three legs extended outward. In that way the camera on the tripod can be lowered very close to the ground. Since long exposures are often encountered when long lenses or extension tubes are placed on the camera, the camera support on the tripod should be very solid indeed. SLRs, when the shutter is tripped, flip a mirror up and out of the way so the film can be exposed. With long exposures in close-up work, the "banging" of that mirror can cause camera vibrations that cause a slightly fuzzy photo. There are two ways to overcome "mirror slap." The first is to lock the mirror up prior to exposure (see your camera manual for this operation) and then use a cable release. Then all you need do is gently press the plunger for a solid shot. The second method is to use the self-timer on the camera body. Depress the plunger and remove your hands. About 9 seconds later, after the vibration from the mirror slap has settled down, the mechanical timer will activate the shutter.

Though many experts stick with slow color slide films, there are some low-level light situations when a faster film is required.

Some of the best close-up photography can be made of insects, snakes, or wildflowers when there is a clear, cool night, with no wind. Early the next morning these subjects are drenched in dew. If the day was a bit warm and the night chilly, try locating flowers or insects near a pond, creek, or swamp. During the night, heavy fog rises from the water and bathes everything nearby in a heavy mist. Insects that are cold and coated with dew can't fly; they need to warm up and dry out first. Just as the sun comes up, it can be used to backlight many of these wet creatures or flowers. Spiderwebs are easy to locate if they are backlit. Walk in a field so that the sun is behind any possible webs, and they

will glow when wet, which makes them very easy to see. When taking pictures of insects, be careful to walk slowly, and not to brush the bushes, especially along the pond edge, where damselflies and dragonflies will remain immobile while you take their picture.

Wildflowers are never more beautiful than when they are drenched in dew and the sun sparkles on them from behind or to the side. Overcast mornings with dew on the blossoms make spectacular shots.

Because you walk and crawl around in the watery grass, some people call this "wet belly" photography. When I'm out on such mornings I always wear a pair of hip boots, drawing a pair of rain pants over them, and adding a rain jacket. I carry at least two small terry-cloth towels that I can use to wipe equipment that often gets wet. If you have to lie down, nothing is better than a "space blanket." The silvery Mylar coating on the blanket is completely waterproof and allows you to lay things beside you such as lenses, film, and accessories, without placing them on the wet ground. I also take along a small pair of gardener's pruning shears. It's the best way I know to carefully trim away a few intruding leaves, sticks, or limbs without disturbing the dew or the subjects. I always carry a walking stick, too. I've used it to ward off unfriendly dogs, knock dew from grass in front of me, and I have a 1/4 × 20 threaded bolt in one end, which allows me to mount a ball head. You can also use a monopod for a walking stick. The monopod has the advantage of letting you get in close for long exposures with a fairly well-supported camera. Unlike a tripod, whose three legs always seem to be disturbing my subjects or knocking the dew from them, a monopod can be slipped in and out easily, although it is admittedly not as solid as a tripod.

If you are going to make close-ups of insects, it pays to know a bit about them.

Monarch butterflies feed almost exclusively on milkweed, which tells you where to look for them. Different types of spiders live in different habitats, and knowledge of other creatures' habits or needs will help reduce the time you have to spend searching for them. Good field guides are invaluable.

Brightly colored, especially red or orange, insects are often less afraid of predators and can be approached comparatively easily. If I locate butterflies feeding on a certain flower, I will sometimes drench that flower in diluted honey water, which seems to keep some butterflies drinking for extended periods, giving me a better chance to take their pictures. When you approach an insect, don't wait until you get as close as you dare before taking the first picture. Instead, take a number of pictures as you advance on it. That way, should the insect escape, you will have something to show for your efforts. All of this emphasizes why the longer macro lenses are so helpful in close-up photography.

Some people who work with close-up subjects outdoors feel that flash is too harsh, destroys the impact of the photo, and gives an unrealistic picture. It can also cause bright spots from reflections (particularly if there is dew or moisture) that can be disconcerting in some photos. Others reason that flash can give you needed light when you don't have it, and the increase in light allows you to get more depth of field and obtain more of the subjects in sharp focus. It can also allow you to shoot at small f-stops, thus achieving greater depth of field. And you can stop action, since most flashes are faster than 1/1,000 in duration. If you don't like flash, don't use it. But for many photographers, flash offers a way to get pictures outdoors that otherwise would be missed.

Just about any flash can be used for close-up work. But the small lights with a guide number of about 30 or less, with an

▲

These two photos represent the difference between sunlight and flash for illumination. The available-light photo (above left) clearly shows the transparency of the wings, but the shallow depth of field required to obtain the pictures shows some of the subjects out of focus.

When flash is used (above right), greater depth of field is available, which puts more of the picture in focus. But there is glare on parts of the wings, and the backlighting that helps show the markings in the wings is lost. Often you must decide what you want to show, and then determine the lighting you need.

ISO 25 film, will do well only with lenses shorter than 100 mm. If you work with longer lenses, light output is often not sufficient to obtain magnifications from one-fourth to twice life size. Small flashes can work exceptionally well with macro lenses of 50 to 60 mm. Such flashes have the added advantages of being small and easily carried in a pocket, requiring little battery power, and being very inexpensive.

Flashes that have slightly more power would be considered medium in light output. These are still very portable and will work well with macro lenses up to 200 mm.

Many of these medium-powered lights have a variable power adjustment, allowing you to have more control over the light. But if you want to work a great deal with longer lenses and macros in the 200-mm range, a flash that has a guide number of 35 to 45 with a film of ISO 25 is suggested.

The most helpful flash for close-up work is one that is a dedicated TTL type, which means that the proper exposure is automatically determined by how much light reaches the film. When the amount of light for a correct exposure strikes the film, the flash is automatically shut down. This gives instantaneous corrections for exposure as you move in and out or try to keep in focus a subject that is crawling about. With a dedicated flash you can also set the ISO on the flash to achieve underexposures or overexposures. However, a word of caution when using dedicated flashes: the subject must be near the center of the photo, for that is where the meter is reading the exposure. If the subject is off center or is small and being photographed at night, often the flash will calculate for the

With the flash clipped on the camera or on a short bracket that holds the light close to the camera but at one side (as used here), a distracting shadow is thrown directly behind the subject.

background and give you a poorly exposed subject.

Another type of light that is sometimes used for close-up work is the ring light, a flash that actually encircles the lens. It is discussed in detail on page 60.

God sends light from above, and in close-up photography we should always have the flash higher than the subject to get that natural look. Shadows above something will ruin a photo, and often the viewer doesn't know why, but is only aware that something is wrong. Placing the flash in the hot shoe atop the camera is often not a good idea. If you get too close, the light is aimed above the lens and the subject will either be lit from beneath or only a portion of it will have the proper amount of light. The best results occur when the light is removed from the camera and held slightly above and to one side of the subject. An extension cord is required for this. With a dedicated flash you can get an extension cord that runs from the flash to the camera's hot shoe. What is good about this is that the hot shoe attachment holds the sensor controlling the light.

Thus the sensor is looking at the subject, and should you have the light inadvertently tilted slightly away from the subject, the sensor will not shut the light down until the proper exposure occurs. This is one of the best aids to close-up photography for the average person in the field. It is especially helpful when you are bouncing the light off a white card to obtain a soft, diffused light with no harshness.

Once you understand the advantage of holding the flash off the camera at a slight angle above the subject, you realize that it's a good idea to have a bracket to keep the flash in position so that it is at the same distance from the subject (making exposure reliable) and aimed correctly. You thus move one step closer to good picture-taking. Upon examination of your pictures made with a single flash, you see that one side is well lit, but the other is in shadow, often deep shadow, where all detail is lost. The answer is a bracket that holds two flashes, with both aimed at the subject and capable of being fired simultaneously. Such brackets can be purchased from some mail-order houses, but they can also be made inexpensively from 1/8-×-3/4-inch aluminum strap material. There are also available twin release cables that allow you to push a single plunger to fire both flashes at the same time. A nice accessory, although not necessary, is a pistol-grip handle attached to the bottom of the bracket; it has a trigger that, when squeezed, exposes the film and trips the flashes.

What you generally do not want is to have both sides of the subject exposed to the same amount of light (a ring light effect). Instead, one light (the main light) should be more powerful, simulating the sun shining on the subject. The other (called a fill light) should give one to as much as two stops less light on the subject and be on the opposite side of the subject from the main light. This creates one side

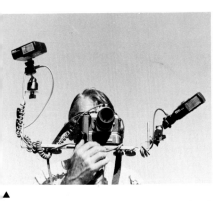

▲

Use of two flashes on a bar, with one flash higher than the other, can often produce extremely satisfying results. Such a rig is ideal for getting quick close-up shots of many insects, and is often used for flower photography.

When photographing at night with a bar holding one or two flashes, focusing is often difficult. A fisherman's flexible light attached to the bar, as shown here, can be aimed just where you want to focus.

▼

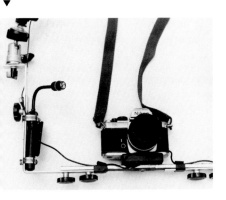

properly lit, with the other slightly shadowed, giving form and shape to the subject. This can be accomplished with manual flashes by moving the fill light slightly farther away. But an easier method is to purchase some neutral-density filters that can be cut to size with a pair of scissors and taped over the lens of one of the flash units. This allows you to reduce the light to the exact desired amount.

If you have dedicated flashes, exposure is not so great a problem, but if you are using two manual flashes, you will have to run a few test shots to determine what aperture settings you will need. Once that is determined, record that information on the flash unit, turn it on, and go hunting. When you see something to photograph, move in to the proper distance, focus, and, when things look right, trip the shutter. Many top professionals scorn this setup, but it provides the average person with a tool that permits "grab" shots in the field at close-up ranges that would surely be missed otherwise.

A common mistake made by many photographers with macro lenses is to close down to f/32 to get the maximum depth of field. The difference between what is in and out of focus at a 1:1 magnification with an aperture at f/32 and f/16 is almost impossible to tell. However, light has to creep through the tiny f/32 hole, and much of it is bent as it works around the edges of the aperture. The results are usually that a photo taken at f/16 will result in a slightly sharper, clearer picture than the same shot taken at f/32—and you need two f-stops less power from your flash unit, which means a saving of battery power.

Depth of field is a problem whenever you take close-up pictures. *The closer you get, and the higher the magnification, the shallower becomes the depth of field.* One way to alleviate the problem is to try to keep as much of the subject as possible in a plane parallel to the lens. For example, if you are photographing a small lizard, don't take the photograph from a head-on angle; only a portion of the head will be sharp, and the rest of the body will be fuzzy. By moving around so that the lizard is lying parallel to the lens, most of the creature can usually be rendered sharp in the picture. If you have an insect or a small animal as a subject, make sure that the eye is in sharp focus (unless you are trying to emphasize another portion of the subject, such as the claws on a praying mantis). If

▲

By using a two-flash setup on a bar, these photos of an emerging seventeen-year locust were made near midnight.

▼

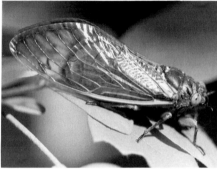

▲

The following morning, the author photographed the mature locust with available light and a 105-mm macro lens.

the eye is sharp, most people will regard the photo as being sharp.

One tool is extremely helpful if you get serious about close-up photography: the focusing rail. This is a geared track, the base of which sits on the tripod, with the movable track above, to which the camera is attached. The simplest designs allow you to move the camera with great precision toward or away from the subject. A better design, and usually only a little more expensive, is the focusing rail that allows movement not only back and forth but sideways as well. This tool just about eliminates the bothersome problem of moving the entire tripod and camera in or out or to the side for minor adjustments in composition. Simply place the camera and tripod about where it belongs, then use the focusing rail to get precise focus and composition. The device is also helpful when your subject tends to crawl around a bit while you are shooting your pictures.

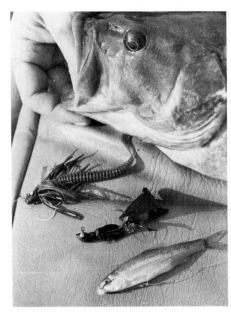

▲

One of the very nice features of macro lenses is that they allow you to show things close-up to your viewers. Here, examples of effective smallmouth bass lures are shown large enough that the viewer can easily identify them.

WILDLIFE, BIRDS, AND FLOWERS

One of the major reasons that we enjoy spending our time outdoors is to observe all the fascinating creatures that live there. Everything from a soaring bald eagle, with that pure white head and tail outlined against a blue sky, to a tiny chipmunk scurrying along a fallen log in the forest is a source of pleasure. Gradually, you become aware of a desire to share these visual treats with your friends, and so you get the urge to photograph the wild things that inhabit our mountains, deserts, forest, fields, swamps, and waters. Once you get involved in taking these photos, the outdoors becomes immensely more fascinating—and challenging. It's difficult to explain to the uninitiated how much pleasure you can derive from looking at a good photo you managed to get after many frustrating attempts.

There are some basics that need to be understood if you are going to take consistently good pictures of outdoor creatures. Equipment—what kind and how much—might be the first thing you think about, but there are more important considerations. If you think that having good photographic equipment and then walking through the woods is going to get you a lot of excellent wildlife photos, you are going to be very disappointed. Once in a great while you'll make a "grab shot" that happens in front of you when you are ready, but it's a rare occurrence.

Perhaps the most important factor in obtaining good pictures of animals or birds is to know as much as possible about them. People are at a disadvantage in the outdoors. Deer, moose, ducks, geese, eagles, hawks, otters—in fact, all creatures that live in the outdoors—have to be forever vigilant, or they won't survive. Some use their eyesight (which can be equivalent to a human looking through 6-power field

glasses) to see anything approaching; others can smell you hundreds of yards before you get near; and some combine either scent or sight with exceptionally keen hearing. If we are going to get close enough to take good photos of these creatures, we have to know a great deal about them. You can figure that for every creature we see in the woods, several hundred probably became aware of our presence and made themselves unseen.

Field guides are invaluable. Whether you are seeking wildflowers, animals, fish, or birds, such guides will help you locate and identify the creatures or plants you seek. They tell you what habitats animals frequent, and this can vary during the year or seasons. Knowing what food an animal eats means you can locate the food sources and enhance your chances of locating it. What kinds of nests or dens they use are often explained in these books. You'll learn that brown trout spawn in the fall, making you realize that's the time to locate extra big ones on their beds. Learning that squirrels prefer denning in big old trees with large knotholes means you have narrowed the places where you need to look. Deer do most of their feeding at low light levels (from dusk to dawn); squirrels, using their tails as safety parachutes in case they fall, don't move around much during the rain, when their tails are soggy; and otters have fun zipping down mud slides they build along the banks of streams and rivers. Knowing what to look for, and then locating your camera near these at the right time, can get you sparkling photos. One of the hallmarks of successful outdoor photographers is that they are constantly learning more about the creatures they take pictures of. Indeed, this gathering of knowledge is one of the most fascinating aspects of taking wildlife pictures outdoors.

The clothing you wear in the woods will to some degree determine how close you get to wildlife. Obviously, you don't want to wear brightly colored outfits; there is a lot of well-designed camouflage clothing available that fits into the outdoor photographer's scheme of things. Some clothes are harsh and hard-surfaced, and make scratching noises as you brush against twigs or vegetation. That rustling noise can alert animals with keen hearing. Wear soft

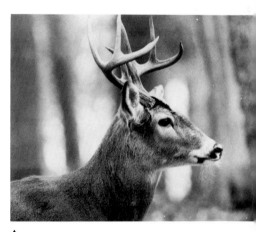

▲
Wildlife pictures can often be obtained near home. From inside a house, this photograph was made of a dove sitting on its nest—just outside the window.

▲
Knowing the habits of animals helps you get into a good position for taking their photographs. Deer are especially creatures of habit.

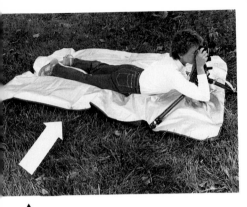

▲

Lynn Hendrickson is able to stay dry because she is lying on a waterproof Mylar space blanket.

▲

Rabbits will remain frozen in position if they think you haven't seen them. This one allowed the author to get close enough with a 200-mm lens to fill the frame.

▲

This bull moose seemed to resent intruders, so the author used a 400-mm lens to take this shot.

clothing and dress in layers, so that you can remove some and carry them in your pack if it gets too warm. Consider the terrain you'll be moving over, and get proper footwear for it. Obviously, rubber boots are needed for swampy places, but in leaf-covered woods, where you frequently walk on steep hillsides where you could slip on the leaves, shoes with lug soles give a better grip. Early in the morning the grass and vegetation are often soaked. This can work to your advantage, for many small creatures won't move about until things dry off.

Once you know something about the animals, birds, or flowers you want to photograph, you should determine the kind of equipment you need. What is just right for some subjects may be totally wrong for others. For animals and birds you will usually be working with telephoto lenses, and every outdoor photographer has his own special choices. What is important to know is that the longer the lens, the greater the magnification of the animal or bird—*and of your own unsteadiness.* If you are photographing where there is much heat, such as in a desert, heat waves rising from the earth, when viewed through a very long lens, can distort the subject. This is one reason for considering making long telephoto shots in the desert early in the morning, before it gets too hot. Another is that the air is clearer at that time.

For most wildlife and birds, your longest lens should never exceed 600 mm. Anything longer than that is usually very expensive, generally has a small maximum aperture opening (which makes focusing difficult because of reduced light entering the lens), and is very bulky and difficult to transport. It also must be very securely mounted; often this is best handled with two tripods, one for the camera and one for the lens. Perhaps the shortest telephoto lens you should use for birds and animals is 300 mm, which, for me, is almost always not enough. I prefer the 400

mm as the best all-around working tool for distance-shooting birds and animals. Sharp pictures cannot be taken with such a long lens if it is hand-held; the photographer is almost always unsteady. But with a gunstock, a monopod, or a tripod, you can take many photos with a 400-mm lens that are crisp and sharp. In a pinch, you can lay such a lens on your folded jacket or a beanbag, or even in the crotch of a tree, and, by carefully squeezing off the shot, get a sharp picture. There are many times when a 500-mm lens, or even a 600-mm one, will obtain a larger and more pleasing image, but when I use lenses longer than 400 mm, I find my problems of holding it steady increase. Regardless of what lens you use, there are times when it never seems long enough, but you learn to live with that.

Some very successful photographers now prefer one of the heavier zoom lenses, such as the 200–400 mm. Such lenses are very expensive, bigger, heavier, and harder to lug around, but they offer advantages not available with a prime lens. For example, if you are in the proper position with this lens, you might be able to photograph a fox lying at the entrance to its den, stretched to its full length, then instantly zoom in and get a shot of only the head. Another outstanding advantage of these large zoom lenses is that they allow you to crop the photo quickly so that you can eliminate distractions. This ability to control composition can turn a fair picture into an outstanding one.

If you are working just with birds (even larger waterfowl), you may want to consider the 600-mm lens. Many birds are small and difficult to approach, and many waterfowl sit on the water, where they are difficult to get close to. This means shooting from distances greater than you would care to, and a 600-mm lens will help you increase that image size.

Another incredibly useful lens is a zoom

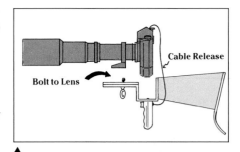

A simple gunstock that can be made in most home workshops. The stock should allow the camera to swivel so that either a vertical or horizontal picture is possible.

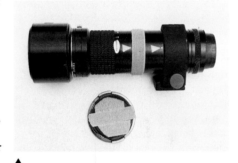

Longer lenses should have a rotating barrel (seen near the rear of this lens) that allows you to attach the lens to a tripod instead of mounting the tripod to the camera, where the weight of the lens may harm the camera. Also, the author uses a band of Velcro on the lens, plus some on the lens protective cap. When the lens is in use, the cap is stuck to the Velcro on the lens to prevent loss.

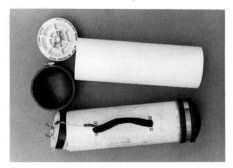

A very good protective, totally waterproof case for a long lens can be made for a few dollars. Cut a piece of PVC pipe to the correct length and secure a flexible neoprene or rubber test cap to one end. The other end receives a test plug, which, when the wing nut is screwed down tightly, forms a waterproof container. All parts are available from plumbing supply houses.

▲

Lying on the ground to obtain a desirable camera angle on this raccoon, the author used a 200-mm macro lens to get these two photos. Because this lens will focus close to the subject, both of these pictures were possible without changing lenses.

that has a range of approximately 80–200 mm. (Many are in the 70–210-mm length.) This lens is light enough to carry easily, and with care it can be hand-held so that sharp pictures result. Most popular models of this length generally have about f/4 as their widest aperture, which means that in early-morning, low-light conditions they may be extremely difficult to use. If you are going to specialize in outdoor photography, you may want to consider one of the 80–200-mm lenses that have a much larger aperture, although these lens will often cost two to three times more than the usual type.

Another lens that I find to be extremely helpful in all kinds of nature photography is the 200-mm macro. This is a lens that is a conventional 200-mm lens, light and easy to carry, but has the capability of allowing you to focus so close that you can get an image half the actual size of small creatures. This is a very valuable lens that many outdoorsmen overlook. A workhorse lens is the 50-to-60-mm macro, which, as I've suggested elsewhere, should be your basic normal lens, but can be used for close-up work as well. I also suggest a 28- or 24-mm lens. Many times you will want to show the habitat, or much more than

just the animal or bird—and one of these lenses does that very well. With such an assortment of lenses you can cover almost all bird and animal situations you will ever want to photograph.

In addition to lenses and cameras, there's a choice of film. Most photographers prefer Kodachrome 64 for their all-purpose film. But there are situations in which a faster film is required, and ISO 200 or even 400 films may be needed in some very low-light situations. (In many instances, the use of a tripod can be substituted for higher-speed films.) Most successful photographers of wildlife and birds will try to use Kodachrome 64 if it's at all possible.

If you are a serious photographer of birds, animals, or flowers, I urge you to consider buying a one-degree spot meter. This type of meter allows you to take a measurement on a tiny portion of the subject. Thus you can meter on the flank of an animal, the side of a bird, or a tiny blossom (rather than the entire flower and the surrounding leaves). The spot meter, I find, is as useful in flower photography as anywhere. Another important item is a light pair of field glasses—about 6 power. Such glasses allow you to observe much wildlife from a distance, thereby locating it sooner, so you have time to ready your equipment and make your approach. Field glasses are also valuable for studying wildlife to learn its habits, so you can better plan later photo sessions.

Some sort of apparel that you can use for carrying your film, lenses, meters, and a host of other items is also vital. Several special jackets are now available, some of which have in excess of a dozen pockets. One pocket (usually in the rear) should be large enough to carry a folded space blanket and rain gear. Some jackets also have a sort of sock on the back, which will carry a short tripod. I have never seen a jacket that has a waterproof flap that is attached at the bottom rear of the jacket that can be unrolled and used to sit on when needed. (At other times it could be rolled up and held in position with Velcro tabs.) Such a flap would certainly add to your comfort if you had to sit on the ground for extended periods. Jacket pockets should be large enough to carry most of your lenses—except the very long ones, of course—and plenty of film. I mark one pocket for used film and one for unexposed film, and as soon as I shoot a roll, I remove it from the camera and place it in that special pocket. This can prevent losing valuable film, which I have done in the past. Those pockets that will carry lenses, meters, and other fragile items should be lined with foam. The best foam is closed-cell type that will not absorb water even when wet. Zippers should have large teeth—I've had too much trouble with the little teeth that even a single thread can bind. I also like a loose belt with a quick-detaching buckle that can be closed easily across the front, which allows the jacket to remain open but not to flop around. Actually, you may want two photo jackets: one for hot weather, constructed of a mesh material where possible for ventilation, and another for cooler conditions, made of a waterproofed material. A good vest is an investment (no pun intended) and should be selected with care. Also, I don't care for a bright-colored vest as much as one of a more subdued color.

Your tripod should be as heavy and sturdy as you can afford to carry. One feature that many pros feel is vital is the ability of the unit to be lowered close to the ground. A tripod with fixed legs that don't allow you to get your camera low can often mean losing great pictures. I suggest either painting the main legs and upper portion of the tripod in flat black, green, or brown, or wrapping the legs with the camouflage tape that archers use to disguise their bows. You may find a lot of use for a shoulder pod, more commonly called a gunstock, on which a camera can be mounted. There are a number of commercial ones on the market, though you can easily make one if you are at all handy with tools. One of the most important features of any gunstock is the capability of holding the camera in either a horizontal or a vertical position; some pictures should definitely be shot one way or the other. Another good feature of a commercial camera gunstock is that it has some adjustments as to length, allowing you to determine the best working distance from your trigger finger to the shoulder. I like a gunstock butt (the part of the stock that contacts the shoulder) lined with rubber. I use a piece of truck inner tube for this purpose; this prevents it from slipping when in position. I also like the lower portion of the gunstock butt to have a curved ''hook'' to it. This hook locks under my armpit, and once settled into position, it tends to remain there—especially with the rubber liner. Though most people think of a gunstock for use with long lenses, it can be extremely helpful when utilizing macro lenses from 50 to 200 mm in many close-up situations where you don't have or can't use a tripod.

For much work outdoors, I carry a pair of gardener's pruning shears, which I mentioned in the previous chapter. I also bring along a few plastic garbage bags, and one of these makes a nice waterproof ground-cloth when I want to lay equipment near

me. A small day pack that is padded where it rests against your back, and with a number of smaller pockets on the outside and inside, is extremely useful. Combined with a photo vest, such a pack allows you to carry most everything you need—but get it in a subdued color. I have tested a number of extremely well-designed backpacks made just for photographers. One carries fourteen pounds of my camera equipment. But I consider them to be impractical. They are designed to carry only photo equipment, and none that I've seen even had room for a rain jacket. I feel that a day pack as described above, when combined with a photo jacket, will do the job nicely if you have to carry a considerable amount of equipment for a distance in the field.

Bears can be found near their dens, and they visit bee trees and other favorite feeding places. Knowing something about an animal's habits allows you to preplan your photo sessions.

▼

If you want to photograph many woodland animals, sometimes a portable tree stand, such as those used by bow hunters, is an excellent place to sit. Make sure that it is comfortable, and always have a safety rope tied to you to prevent falling from the stand. Often, it's a good idea to make a small blind on the stand. The floor of the stand should be large enough to handle the tripod you intend to use, although a monopod is often better, since animals are generally moving and you must track them with the lens. The only problem with such stands is that most of the time you are shooting down on the animals. The serious deer photographer may want to consider some of the commercial scents developed for hunters. Some of these mask human odors and others attract deer—especially in the fall rutting season. Some predators, such as coyote, fox, and hawks, can be called in very easily. The callers can be purchased from hunting supply catalogs, and they do work if properly used. There

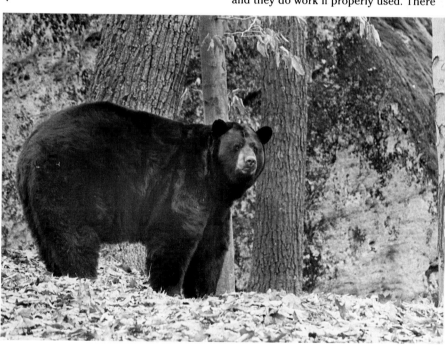

are tapes and records that will teach you how to work these callers, which are easy to use. You can also use electronically operated callers that imitate various birds and animals in distress, and that will pull hawks, owls, doves, foxes, raccoons, and many other animals right to the caller. This technique works best if one person calls and the other takes pictures, since often the animal or bird comes in fast and you have to be ready.

There are some rules that are basic to all serious bird and animal photography. The most important thing is to have patience. Without it you will miss many, many good pictures. Even when you have taken what you feel are great shots, if the wildlife is still within camera range, hang around and don't move—something completely unforeseen and interesting may happen. The greatest hunters and the best photographers spend endless hours just waiting. This is perhaps the single greatest key to getting good pictures. Concerned people also don't disturb either the wildlife or their dens or nests.

Most animals follow fairly well established life habits or patterns. Deer move out of orchards just at dusk along certain trails, birds feed at special places, and a groundhog or fox will sun outside its den each afternoon. With field glasses and careful observation, you can often note the characteristics of an animal, and, just as important, be able to predict its movements. Many times, people who live near the animals or birds can help you. Farmers often know where a fox has a den, and game wardens and wildlife biologists can often tell you exactly where a grouse drums on a log or where there is an osprey's nest.

Another important point that you quickly learn is that most of the time you want the subjects to come to you. Trying to stalk sharp-eyed animals and birds usually results in spooked subjects and poor photo-graphs. Almost all animals have some sense of smell, and those animals that are often preyed upon by predators have developed it highly. That means you should stay downwind of the creature you plan to photograph. Sometimes the breeze is so subtle that you may have difficulty detecting its direction. Use an old trick of bow hunters. Attach a piece of very light sewing thread to your tripod, walking stick, or monopod. Then fray the end of it. The slightest breeze will move the thread. If you are shooting animals near water holes, get there before they arrive to prevent spooking them (before dawn, or well before sunset). This allows you to conceal yourself, and the animals will act more natural. You will find that being in the field before dawn or staying until after sundown will be worthwhile. Wildlife is generally most active early and late in the day and "lays up" during the middle portion.

When you enter the field or woods, take a meter reading and adjust the camera for proper exposure. Every few minutes, if you feel the light has changed, take a new meter reading and make proper adjustments. That way, if you should suddenly encounter a subject, you need only focus and click the shutter. Also, if you can, carry two camera bodies with a different lens on each of two different types of film; one lens or film may be better suited to the conditions, and in an emergency you can shoot away. Another reason is that you can run out of film at a crucial moment; a second camera, ready to go, is a godsend. It pays to check your camera before entering the field where you feel you will get your photos. If the roll is near the end, it may be better to replace it so that you will have enough film to cover at least the first situation. And I always carry several rolls of unused film outside of the containers and in a place where I can get to them quickly, if needed.

Many of the best and most successful

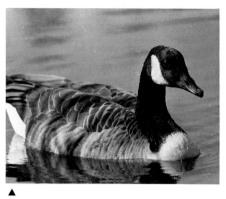

▲

Getting the camera low for shooting pictures of wildlife, especially birds, often enhances the photo. Some of the most pleasing waterfowl shots are taken with the camera at or very near water level.

▶

This pelican has almost a regal look because the camera was situated well below the bird.

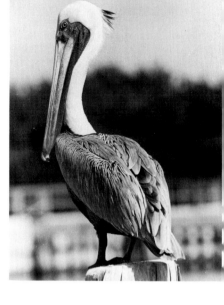

animal and bird photographers believe that the single most important compositional element in this kind of work is to have the camera at the animal's level or lower. Such low angles enhance the subject and make it look more majestic. Shooting from an angle higher than the bird or animal generally results in a less appealing picture. Look at any pet magazine or book; almost all the dogs and cats have been photographed from an angle lower than the animal. You can violate any rule, but if you take most of your pictures from a low angle, you will generally improve your pictures of animals.

As with any other pictures, a background can make or ruin an animal or bird shot. When possible, plan your shot beforehand, with consideration not only of the light and other composition factors, but of the background as well. A "junky" background or foreground, or a light-colored animal or bird against a light background or a dark one against a dark background will mean a poor photo. Backgrounds are often ignored

when concentrating on the animal or bird, but they can make or break a picture, and we need always be aware of their importance.

Motor drives are especially helpful in allowing you to shoot from gunstocks or take a number of photos in a short period. But they do make a lot of noise. One way to beat this is to take a few household sponges and secure them around the body of the camera and the motor drive. Generally, strong rubber bands will do nicely to hold the sponges in place.

As I mentioned before, when photographing any animal or bird, you should make sure that you focus on the eye. If it is unsharp, people regard the entire picture as unsharp. You should watch the subject, too. If the animal or bird turns away from the camera, so that the eye doesn't show, most of the time the picture is not as good. Think of a mountain lion looking away and one looking at the camera, and you can visualize how much more impact a shot has when the subjects' eyes show well. If an

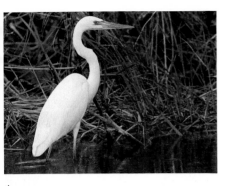

▲

This is a typical pose that is often captured on film.

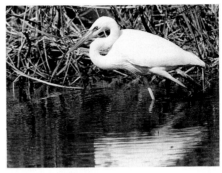

▲

But if you wait until the bird is doing something—in this case, stalking a minnow—the picture seems to have more interest. Have your wildlife doing something and you increase the pleasure of the viewer.

animal is looking away from you and you want to get its attention, carry a silent dog whistle. When blown, this will always cause the animal to quickly look your way. Other techniques are to kiss the back of your hand or manipulate one of those chirping bird calls or a toy cricket, to get the attention of birds and animals. And if there is a little catchlight in the eye, it adds sparkle to the photograph.

Most magazine and book editors today prefer an animal or bird doing something besides just sitting or standing there. They want to see the animal or bird photographed as it scratches its head, jumps, flies, crawls, climbs, or does something that is natural. This often adds humor to the photo, but it also gives it a lifelike look. A squirrel climbing a tree, or cutting a nut, is more interesting than a squirrel just sitting on a limb—as is a beaver swimming with a branch in its mouth, or actually gnawing away at a tree. Often these shots are made after the photographer has had the patience to wait.

Many animals can be approached close enough to photograph, if you move s-l-o-w-l-y and not directly toward the subject. If you walk at a slight angle to it, it often assumes that you are going to pass by, and it will remain close enough for you to get

your picture. Many small animals can be enticed to the photographer so that you can get excellent photos. Some parks forbid feeding any wildlife, and that must be taken into consideration. But I have found that where it is legal, I carry some oatmeal cookies. I have never found any creature that doesn't like them—including myself. But what makes them so valuable to the photographer is that they have weight. When broken into small bits, they can be thrown quite some distance, whereas many other foods are difficult to toss.

If you have to shoot at a moving subject or one that has been frightened and is escaping, panning the shot (tracking the camera at the same speed as the animal or bird) will frequently allow you to shoot a sharp picture at a slower speed than you would prefer, although the background will be blurred.

Most photographers have read that if they plan to shoot under very cold conditions, they should have the manufacturer "winterize" their cameras. However, I have never had trouble with the operation of my cameras within the continental United States, as long as I kept the batteries warm. I think the space-age lubricants used in

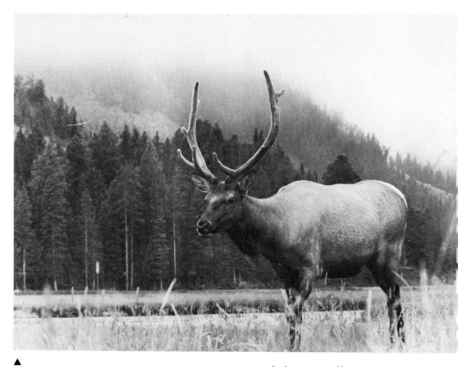

▲

This photograph of an elk was shot from a car. Especially in national parks and refuges, cars make great blinds, since animals tend to ignore the people inside the car.

modern cameras have made this possible. Obviously, if you are contemplating a photo trip to the North or South Pole, you would want the camera winterized; but for most outdoor photography today, if you keep the batteries warm, you'll have little trouble.

A blind is especially helpful if you know the exact location where you will take your photos, or if you must remain in one position for a long time. If you are in an exposed spot, such as an open swamp alongside a waterfowl area, there is no way the birds will allow you to approach. But by placing a blind some distance from the site, and then, two or three times each day, moving it a bit closer, you can eventually move the blind to the desired position without disturbing the birds. Blinds are ex-

tremely important if you want to seriously photograph wild animals and birds and to portray them in a natural way. Only when you are concealed and they don't know that you're around do they go about their lives in a normal manner.

Blinds (called "hides" in Europe) come in many shapes and forms. There are blinds so simple that they drape over your hat and you can sit, looking like a vegetative "lump." Others are complex; it almost takes an engineering crew to construct a high tower with a blind on top to photograph certain birds. Usually, somewhere between these two is what the average photographer needs. One of the simplest blinds that can be erected instantly, and one that I have used frequently to great advantage, is simply a piece of camouflaged cloth that has hundreds of small cuts in it. When the cloth is draped over you, the cut portions rise a little, thereby giving it a leafy appearance. This cloth, about six by

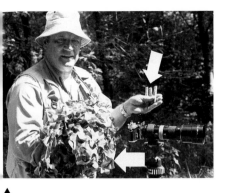

Joe Dorsey holds a lightweight camouflage cloth that has many small cuts in it. The clothespins are often used to hold the cloth in position. Such a portable blind material is inexpensive, can be carried easily in your day pack or photo vest, and can be draped over you in seconds.

Here Joe has draped the camo material over himself, becoming nearly invisible.

Portable hunting blinds are also good places from which to take wildlife photos.

▼

twelve feet, is rather inexpensive, is used by turkey hunters, and is available through hunting supply catalogs. It folds into about a six-inch bundle that can be carried in a small bag or in the back pouch of your photo jacket. When needed, simply withdraw the cloth, sit down in a comfortable position, and drape it over you. A boat cushion makes a light, portable, and comfortable seat, too. One side of the cloth is greenish, the other brown camo color, and it's wise to select a color that matches the surrounding vegetation. I have used this in state and national parks many times, since they don't permit construction of blinds. When I lie down near water holes or feeding areas and cover myself with it, animals and birds approach extremely close.

Blinds that can be set up are the most comfortable type, and that's important if you must remain inside one for extended periods. Comfort becomes vital when you have to stay put for a long time. Such blinds should be high enough so that you don't have to remain in a crouched position, and there should always be a roof on them. Birds and animals that move overhead and see you will sound an alarm call, putting all creatures in the area on the alert. Such blinds should be roomy enough so that when you move within them you don't disturb the material. Birds especially are frightened by movement. The blind should be opaque. If your silhouette is visible inside the blind, animals and birds will see any movement. Put a very comfortable

chair in the blind that has a good back support. There are a number of light, portable aluminum chairs available through hunting supply stores that work perfectly for this. Most of these chairs have a small pocket under the seat where you can put a bottle of water, spare film, and lenses. If you buy or build your own set-up blind, it's wise to have a way of shooting pictures from all four directions. We often anticipate that a subject will approach from one direction, and it comes from another.

You can easily build a blind by using PVC plastic pipe or aluminum rods and making a portable knock-down frame that can be put together quickly. Anyone handy with a sewing machine can make the camouflage cloth that fits over the frame. Make sure that no part of the blind will flap in the wind—any movement will ruin the purpose of the blind. Excellent blinds can also be made of native materials, although the law in many areas forbids using these materials, so you should check. Corn shocks, bales of hay, and deserted buildings are all potential blind sites. Fortunately, there are a number of excellent blinds on the market that you can erect in two or three minutes and that are light, easy to carry, and really cost very little.

One of the best blinds is your home. Anyone who has fed birds over the winter knows how close you can get without alarming them. By using bait and remaining in a darkened portion of the house, you can watch them act naturally. However, if you position yourself at the window with a camera, you may frighten them away. If there is a drape or a curtain that you can partially close to hide you, you can take better photographs.

Shooting from a parked car, the author was able to photograph this huge alligator, who ignored him inside the auto.
▼

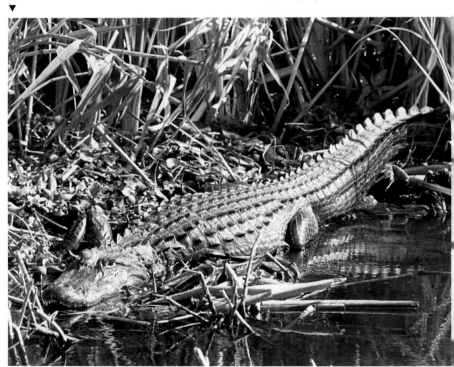

Another excellent blind, especially in state and national parks and refuges, is the automobile. Particularly on roads that traverse refuges, animals and birds become used to cars and tend to ignore them. But if you get out of the vehicle they will often flee. There is considerable vibration when the motor is running, so it should be turned off for picture-taking. There are several devices that enable you to hold a long lens steady. A simple beanbag that rests on the doorframe is excellent. There are several companies that make a steadying device that is secured to the window by a suction cup or is clamped to the window and braced on the door. All of these hold a ball head, allowing you mobility and steadiness.

Birds are certainly the most colorful creatures that we photograph, and fortunately they are everywhere, from the Arctic to the Equator. City dwellers and those who live in remote areas come in contact daily with birds—so there's no shortage of subjects. As with animals, the successful bird photographer will have to learn something about them. You need to know the type of habitats they live in, what they eat, where they rest (many birds gather in roosts), and when they are in your area. Some birds, such as the great blue heron, are edgy and don't like people to get close; others, such as robins and gulls, seem to be completely unafraid of people, so long as they don't come too near. You need to know these birds' behavior if you want to take pictures of them.

Although a long lens of 300 to 400 mm is ideal for much bird photography, you can use even telephotos as short as 135 mm, if you can lure the birds close to you with food or bait. Of course, to some degree the length of the lens is dependent upon the size of the subject; larger birds are going to fill the picture better than tiny songbirds. As mentioned earlier, blinds work especially well with birds. One factor that often

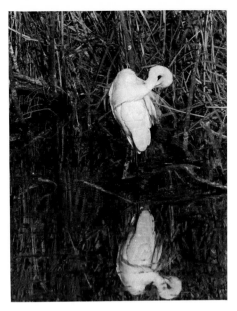

▲

Two of us entered the blind and one walked out. This egret couldn't count, so it moved near. The author was able to capture the reflection of the bird preening itself.

astounds people is that birds can't count. If two people are observed by birds as they enter a blind and one comes out, the birds think everyone has left. It's a simple trick that bird photographers have made use of for years.

Many times, you can photograph gulls and terns as they circle just above you. If you have tried to focus on them in flight and then clicked the shutter when they looked sharp, you know you've wasted a lot of film. Few such pictures are ever in focus. But there is a simple trick that I have been using for years that works wondrously well. Simply prefocus the lens at a distance you judge will show the soaring bird properly. Then don't touch the focus ring, but get the bird in the viewfinder and follow it. When it comes into focus, press the shutter release. With this method I'd guess that I get perhaps 80 percent of my pictures in sharp focus. Incidentally, motor

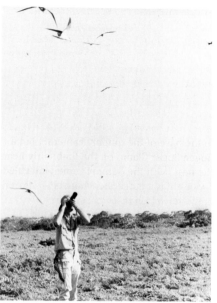

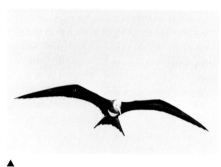

◄

When birds are circling close overhead, don't try to get one in focus and shoot. Instead, prefocus the camera to the desired distance and follow the bird. When the bird looks sharp, press the shutter release. You'll get many more properly focused pictures this way.

▲

Using the prefocus trick, the author was able to get a number of sharply focused pictures of this man-o'-war bird on Christmas Island.

Knowing the den hole of this owl, the author was able to set up his camera and prefocus on the hole in the tree. When the bird returned, the shot was made.

▼

drives are invaluable when trying to capture several photos of flying birds.

Birds (and animals) that are immobile often make a static picture. But a heron stabbing a fish, or another bird taking flight or landing with wings outstretched and feet ready to grab a branch, makes an infinitely more interesting photo. Try to get the bird when it is performing some normal activity, rather than posing stiffly.

Perhaps more pictures have been taken of birds (especially songbirds) during the nesting season than at any other time. Many ornithologists don't feel that you should photograph birds on the nest, fearing that you may frighten the parents. Certainly, you should never photograph birds immediately after egg-laying. They will often leave and not return. However, with some care, many birds have been photographed sitting on the nest or feeding their young, with no bad consequences.

There are numerous ways of locating nests. And, of course, it pays to determine beforehand the best nesting period, so that you don't waste time. Ground-nesting birds

in fields can be located with the help of a companion by dragging a loose rope between you along the grass. This will flush any bird from cover, and it doesn't harm anything. Just walking through a woodlot, listening to loud singing birds (announcing their territory), or using field glasses to study the dense thickets, can often aid in locating nests. A surprising number of

birds may nest within yards of your house in the shrubbery or small trees, and are easy to find—if you are searching for them. Hawk and owl nests are usually very large and can be spotted by walking slowly through the woods and examining the trees with a pair of field glasses. Marsh birds are easier to locate, for they often have less actual habitat in which to build their nests. Many birds will become extra noisy when you get in the vicinity of their nests.

Once a nest is located, study it. If you feel that the mother has recently laid eggs, wait a few days before moving close. Some bird books give the incubation period of eggs, which may be much shorter than you think. Many nests are located in deep shade, and it may be very difficult to photograph them with available sunlight. One thing you don't want to do is trim away brush or limbs, thereby exposing the eggs to the heat of the sun and the eyes of predators. The nest site must be left undisturbed if you want the young to have the best chance of surviving.

In some situations you can photograph nesting activities and feeding times with a long lens. But the position of many nests will require that you get in close, with a lens of 35 to 50 mm. This can easily be accomplished by having a bracket attached to a limb near the nest (see chapter on tripods and steadying devices) and placing the camera on it, aimed at the nest. To get the bird used to my camera, I use a crude wooden camera I've made (with a tin can lens) that has a 1/4 × 20 Tee Nut fastener in the base of the dummy camera. I put a Bogen Super Clamp on the limb fairly near the nest, with the dummy camera attached. Twice a day I move the whole affair closer, until I have it in the position I want my real camera to be in for the shooting session. Using this method, I have gotten birds adjusted to the camera so that they ignore it less than two feet from the nest.

Since you have no control over the exposure in such situations with changing sunlight, you should use flash. This doesn't seem to bother birds. Perhaps the duration of the flash is too brief, or maybe birds are used to the bright sun. Whatever the reason, flash has never disturbed a bird I have taken a picture of. Electronic flashes have such a short duration that they freeze the motion of the birds and the pictures are incredibly sharp. Dedicated flashes with TTL are especially effective for this kind of work.

Nesting birds can be made to get used to a camera by clamping a dummy camera (made from a tin can and a block of wood) near the nest and each day moving it closer. Then a real camera is substituted for the shooting session.

▼

Photos like this are made possible by using the dummy camera trick near a bird's nest.

▼

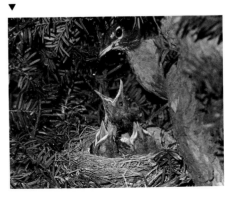

The camera is focused on the nest, the correct f-stop adjustment made, the flash turned on, and you're ready to go. But since you can't sit in the tree, some other method is needed to trip the shutter at the desired moment. One of the least expensive devices for this purpose is a long rubber tube with a bulb on one end and a shutter release on the other. If the camera is cocked and ready (a motor drive will allow a series of photos), all you have to do to make the picture is to squeeze on the bulb, which causes a plunger to trip the shutter. These long bulb cable releases sell for a few dollars, and although they limit how far you can be from the camera (usually twenty to thirty feet), they work well.

There are other methods of tripping the shutter—for example, electronically or with a specially designed cable that was discussed in a previous chapter. Since each of the devices varies somewhat from one camera to another, it's best to consult either your camera manual or some informed person as to what you need. The advantage of the electronically released shutter is that you can fire the camera from as far as 100 yards from the subject, and you can move around. Cables and tubing will chain you to a limited distance from the photo site.

Flowers are everywhere, and they are with us for most of the warmer months. Even in winter, buds, berries, and seeds make interesting subjects. And mushrooms are another great subject. The same basic techniques for shooting flower pictures apply to mushrooms. With the possible exception of some brightly colored birds, flowers have more impact than almost anything else we can photograph. The brilliant shades of color and intricate designs of each species make fascinating and exciting pictures. One of the nice features of flowers is that they aren't going anywhere. However, they are often at their best for only a day or two, so they should be pho-

▲

Knowledge of when and where wildflowers bloom, like this dutchman's breeches, is vital to getting many good flower shots.

tographed soon after they've been located. And they are predictable. If you locate a bed of dutchman's breeches in the woods on April 20, you can return to the same spot on April 20 of the next year, given similar weather, knowing those neat little white flowers will again be in bloom.

Field guides are essential if you want to take up wildflower photography seriously. These books identify the seasons when they bloom, and enable you to identify the many species and the habitats where they grow. Unless you are scientifically oriented, I suggest buying field guides that categorize the flowers according to color rather than to species or family. Then, if you locate a yellow flower, you simply look in the yellow flower section of the book. Since no one book shows all flowers, you should buy several. Also, many wildflowers that grow in the western United States don't grow in the east, and the reverse is also true. I find that identification books that portray flowers with color photographs are not as accurate as those with painted illustrations. In many cases the flowers have brighter and darker tones within the flower. If an exposure was made for the bright area, then the darker portion will be rendered darker than normal in the

print, and vice versa. But an artist can paint all colors as they really are.

Many people don't realize that flowers are with us for most of the year—even in winter where I live, in Maryland. Skunk cabbage blooms in late February or early March, followed by coltsfoot a week or so later. This reminds me of an important point. When you do photograph a lot of flowers and then show the slides to an audience, you can make it very dull for them by simply flashing a flower shot on the screen and identifying the species. Instead, learn as much as you can about the flower, and when it is displayed on the screen, relate some of those interesting facts. For example, skunk cabbage must penetrate frozen ground to bloom. To do this, the plant develops heat at the tip, which melts the surrounding frozen soil. Wild ginger has a flower that blooms under the leaves, unseen by bees. How does it get pollinated? It depends upon ants and other crawling insects. Such information makes the flowers much more interesting to our viewers during a slide show.

A few basic rules apply to most flower pictures. First, unless the bloom is a flat one, such as a daisy, it is almost always portrayed better if the camera is at least as low as, or preferably lower than, the bloom. It's the same as an adult taking a picture of a small child from the adult's high vantage point. The large head and distorted legs of the child make a poor picture. So it is with flowers. I carry a small army shovel and a plastic bag in my kit. Often, with low plants, I'll dig a small hole beside a plant (being careful not to injure it), and then lay the plastic bag in the hole to protect my camera, which is then mounted below the level of the flower.

Macro lenses, extension tubes, or supplementary lenses are vital for flower photography, since so many of the blossoms are too small for us to get good pictures of them with much detail, using standard lenses. Since depth of field diminishes radically as we get closer and closer, we should use the smallest aperture we can for the existing conditions to get the maximum amount of the flower in sharp focus.

▲

Many flowers, such as this pink lady's slipper, are best photographed from a camera angle lower than the blossom.

▲

Flat flowers like this are usually best photographed from above, with the camera lens parallel to the blossom.

▲
You may want to show this cluster of lizard's tail flowers along a stream . . .

▲
. . . but most of the time a single blossom is more interesting.

This, of course, demands a tripod. Another reason a low tripod is essential for this kind of photography is that so many pictures are taken at angles where it would be nearly impossible for you to hold the camera steady. So use a good tripod that can hold the camera almost at ground level.

There are basically three kinds of flower pictures you can take. One is an extreme close-up, where often only a portion of the flower can be seen; another is of a single flower; and the third is a shot of many blooming plants. Incidentally, I think the latter category is the most difficult to pull off well. Usually, when you photograph many flowers, only a portion of them are in focus, or too much of the surrounding habitat is shown, which often doesn't enhance the picture. It's a tough shot to do well.

Most wildflowers are protected by laws that forbid picking or disturbing them. Although some plants are so common that no one would object, you shouldn't ever handle or disturb rare plants, being content instead to get the best photo you can under the conditions at hand.

For extreme close-ups of flowers, it's best to focus on a midpoint of what is

being shot. For example, if it is a stamen, focus carefully midway between the front and back. Remember that usually only a few millimeters are ever going to be in focus—and use a small aperture to get maximum depth of field. For much extreme close-up work, it's advisable to use a flash, since pictures of flowers taken at f/16 or f/22 will often mean exceptionally long exposures with natural light—and should the flower or the camera move, a fuzzy picture will result. The flash allows you to bring it in close and throw such a powerful light on the blossom that small f-stops can be utilized. There are two cautions when using flash. As noted in the chapter on close-up photography, people expect any shadows to be beneath the subject. Therefore, almost anytime flash is used on flowers, the flash should be removed from the camera and held "above" the flower. Also, the closer you bring the flash to the flower, the more likely you are to get "hot spots"

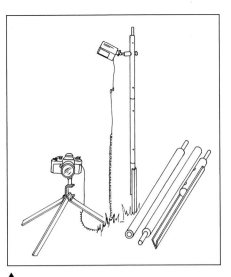

▲

Much of the time, you take flower photographs while alone, and holding the flash and working the camera can be a chore. A simple pup tent pole makes a dandy light stand. Drill a series of holes up and down the tent pole, so you can affix the flash at the desired height.

You can create your own backlighting when taking flower photographs by simply holding an electronic flash high above and behind the flower.

▼

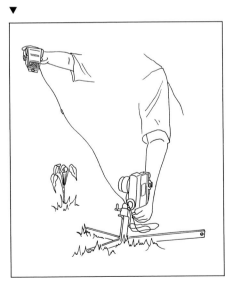

on the blossom. The intensity of the light at very close range will burn out portions of the flower (particularly those very light or pale in color), so that instead of rich colors, much of what you see is glare and overexposed white areas. By moving the flash back and more evenly illuminating the flower, you get a better overall exposure, and the flower emerges in its true colors. Another reason for not getting too close is that electronic flashes compute the light flowing to the subject and bounced back to a sensor. If the light is too close, the sensor cannot operate properly, and incorrect exposures often result.

Single flowers are perhaps the most commonly photographed. If the flower is tall, use a vertical format for the picture. Care should be taken concerning the backgrounds, and they should contrast with the bloom (remember the rule: light subject/dark background, and dark subject/light background). Many people carry cardboard of different colors into the field with them. That's okay, but cardboard soon soils and is ruined if it gets wet. Instead, I use small panels of Formica in various colors, approximately twelve by eighteen inches, which is tough, light, and easy to carry, waterproof and easy to clean. Don't get the glossy type but the flat, dull, or matte-finish kind. To save space, I contact-cemented two colors back-to-back and added a rope handle for ease of carrying. With three such panels (one has a white Formica reflector on one side and a stippled aluminum sheet glued on the other side), I have my basic colors and a reflector. I feel strongly that background colors should appear natural. I've seen wildflower pictures where a red or orange-colored panel was used behind the flower. Nothing like that exists in nature. The best colors for backgrounds are brown, black, gray, green, and blue, which simulate earth, night, fog, grass, and blue water or sky.

▲

A common mistake of many photographers new to flower photography is to make the flower too small.

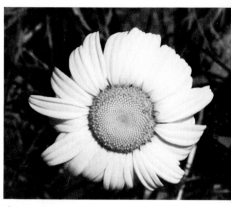

▲

Almost always, unless you want to show the habitat, it's better to photograph just the flower.

▲

Here the light and dark background were distracting.

▲

Through use of a flash, the background was underexposed and turned dark, making the trillium stand out better.

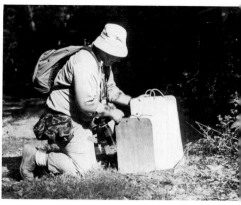

▲

Joe Dorsey shows the Formica panels used for flower background. Formica is tough, easy to clean, and far more durable than cardboard.

◄

These ferns were photographed against a black panel of Formica, with backlighting from the sun.

When a background panel is held too close to the flower, distracting shadows result.

▼

Without a panel, the background is a mix of black and white and can be distracting.

▼

Use of a panel to eliminate the background, and with no shadow on it, makes a cleaner photo of this jack-in-the-pulpit.

▼

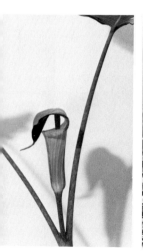

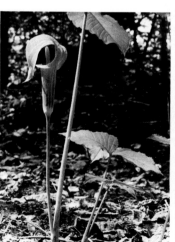

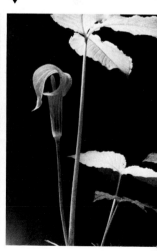

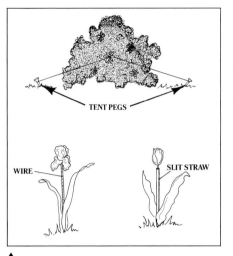

Here are three methods of stabilizing flowers in a breeze. At the top, tent pegs are pushed into the ground and strings are attached to the pegs and then to the bush. Also, a thin wire can be inserted into the stem of the flower, or you can split a soda straw and slip it around the stem.

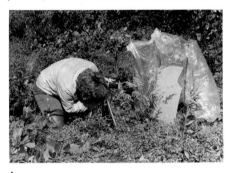

Here Susan Dentry uses several plastic bags to form a "wind fence" around a flower to keep it from waving in the breeze.

Flowers move around on their stems in the breeze, and that's one reason why I try to get as many pictures early in the day (when the world is calm) as I can. There are a number of simple and practical methods of stabilizing flowers. One is to insert a stiff wire in the ground beside the stem and then use a clothespin or even a little masking tape to secure the stem to the wire. Of course, you wouldn't do this with a rare plant, but I see no harm in doing this with many of the very common ones. Another novel method is to get a soda straw, taper one end, and then, using a razor blade, slit it along its entire length. Now the straw can be opened and slipped around the stem, and the tapered end inserted into the ground. I carry several straws of different lengths to accommodate flowers of varying stem heights. Another method that works exceptionally well with larger plants to is carry three or four garbage bags and use them to form a wind fence around the plant. Insert two sticks in the ground and drop a bag over them. Repeat the operation until you have made more than a half-circle around the flower. If you want a dark background, you can use the bags for it. If you want backlighting, use the clear bags used by dry cleaners. These allow the maximum light through the bag. For some small flowers, a neat, 360-degree wind fence can be made by removing the top and bottom from a

A simple gadget often used by the author is this piece of wood with several holes drilled in one end. On the other end, a female 1/4 × 20 nut (available in almost all hardware stores) is secured in the wood and the board is then mounted on a tripod. A branch or a stick can be inserted in one of the holes, and then insects may be allowed to clamber up the stick. In this case the device has been used to photograph a common yellow poplar tree flower.

◄

►

This yellow poplar flower was held on the board, and a little glycerine was sprayed on the flower just before it was photographed.

gallon-size plastic bottle and then positioning it so that it completely surrounds the plant. If you have none of these items, you can use your flash, which has such a short duration that motion can be frozen. Shoot the picture so that the background is underexposed, and hope that when you trip the shutter the moving flower is in focus.

Flash can be used in another manner that can really enhance a wildflower. Often a distraction when shooting flowers is the background. By using a flash at night, you can completely eliminate the background, turning it totally black, and light-colored flowers literally jump off the screen when viewed.

Many photographers know that if you spray water from an atomizer bottle on flowers, you can simulate dew or raindrops, which can often cause the flower to sparkle. But it's been my experience that water runs off the blossoms too quickly. Use glycerine instead of water in your atomizer bottle and spray it on the flower and it hangs there in wonderful, clear drops. It's available in any drugstore, it doesn't harm the flower, and since it is water-soluble, when you are finished photographing the plant, you can spray water on it to remove the glycerine.

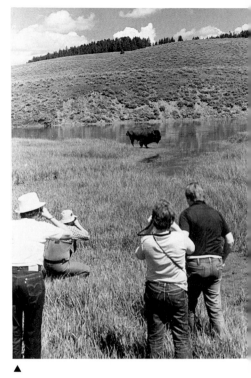

▲

Our national parks are ideal places to photograph many wild animals and birds. Purists among wildlife photographers spurn such places, but most people delight in them.

▼

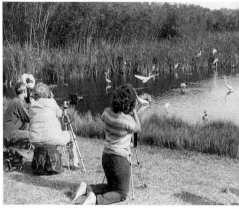

▲

Dont' forget filters when photographing foliage or wildlife habitats. These red maple trees in full fall colors would have appeared dark and wouldn't have shown against the pines in the background. But by using a red filter the author could make all the red leaves appear to be white, thereby making the trees stand out from the background.

CARE OF FILM, CAMERAS, AND EQUIPMENT

Outdoor photographers subject their film, cameras, and equipment to all sorts of abuses, whether they want to or not. Dust, rain, water, humidity, heat, and cold are some of the adversaries that photographers must face and learn to cope with. Fortunately, there are procedures that will keep your film in good condition, your cameras working properly, and your gear in good shape. But it is a constant battle.

Film

Unprocessed black-and-white and color photographic film is perishable and subject to chemical change if exposed to too much heat or humidity. Even smoke and some fumes can affect it. And if film gets wet, it can be ruined or at least have its color balance and speed altered.

The best way to store extra film (that not needed at the moment) is in a freezer. At temperatures below thirty-two degrees Fahrenheit, film can be kept for years without any adverse effects. Just be sure when you remove it from the freezer that you allow it to warm for at least an hour before using. I have film that has an expiration date of several years ago, but that film has been stored in the freezer. When I take it out, it will be as it was when first stored. This brings up another point. Each box of film carries an expiration date. Sometimes camera outlets will offer film just past expiration date at discount prices. But if you use this, you're taking a chance. It's wiser, if the photos are important—especially if you are trying to record precisely the colors of your subject—to use fresh film.

Perhaps the most common abuse of film is to expose it to heat. If film is stored at temperatures above seventy-five degrees for more than a month, both the ISO of the film and its color balance can be altered.

Film that is stored even briefly at temperatures above 120 degrees will almost surely be changed or damaged. When carrying film in the car or on trips in the outdoors where heat may occur, it's a good idea to store all film in small insulated containers. A picnic cooler is excellent for this purpose. Many come with a special bottle or pack containing a coolant that can be frozen as an ice substitute. At home, storing film at room temperature of about sixty-five to sixty-eight degrees is fine.

When traveling by airplane, you may have to take your exposed or unexposed film through a security checkpoint, where X ray is used to detect weapons that passengers may try to bring aboard. Regardless of what the officials tell you, X ray can harm film. Note that the faster the film speed (ISO 200, 400, and higher) the more damage X ray can do. It has been my experience that one or even two passes through an X ray will not harm films of ISO 25 to 80. But X-ray exposure is cumulative. If film is given multiple exposures to X ray, it will almost certainly affect it.

What determines how much damage X ray will do to film is the dosage emitted by the detecting machine. In this country the machines are almost all low-dosage types. But in other parts of the world the machines deliver a much greater charge. These machines have a powerful zap and can definitely affect film (even on the first pass with films having a low ISO). Many airlines X-ray carry-on luggage, but not luggage placed in the plane's baggage compartment. However, some countries and several major international airlines now X-ray all baggage. Because the bags are often large and densely packed, they are given a heavy dosage. Many experienced travelers use special lead-shielded bags to store their film so that X rays don't harm them. They are available through most camera shops.

I carry my film and cameras in an aluminum case on long trips or where I expect weather to be a problem. Some airport officials, impressed with their position, have given me an unnecessarily rough time, even though U.S. laws say they must hand-inspect film and cameras if you ask them to. These overzealous personnel would take out each can of film and remove the film from the container. Such a check with two dozen rolls of film and camera gear would take five to ten minutes. I finally gave up. What I do now is remove all film from the cameras and case, and pass the equipment through the X ray. The film is carried in my baggage. If I have two bags, I always place one half of the film in one bag and the other half in the second bag. On my return trip, before going through the airport security checkpoint, I remove all the film cartridges from their plastic containers and place them in a clear plastic bag. Security officials have always just looked at the film and handed it through. Using this method, only once—in Norway—did an official insist on X-raying these cartridges. Every other place they simply passed it through for me.

Cameras

Always carry your cameras on board; baggage often gets treated roughly. I sometimes carry an extra camera body in my main baggage, but it is always stored in a padded case or wrapped inside several articles of clothing to insulate it against bumps.

The most destructive thing to cameras may be shock. Cameras today are more delicate than the old mechanical types many of us cut our teeth on. With elaborate electronic circuits, such instruments (they really are instruments) can be quickly damaged by a severe jolt or shock. Always be aware that you don't want to bang a camera against anything. When not

in use, it should be protected by storing it in a camera bag or box.

Car trunks heat up quickly and are a poor place to store your camera equipment in warm weather. Camera bodies should be kept clean if you want them to work well. Routine maintenance is easy to do. There are several "don'ts" that should be heeded. *Don't* touch with your fingers the mirror on a single-lens reflex camera, or use any sharp object on it. *Don't* lubricate your camera (or lenses) under any conditions; only a professional repairman should do this. *Don't* pour lens cleaner directly on the glass. *Don't* touch the shutter curtain, which in many cameras is extremely delicate and easily damaged.

Here are some of the simple things you can routinely do to ensure that your camera stays clean and in good working order. After film has been removed from the camera, remove the lens and lock the mirror in the up position (your manual tells you how to do this). Look for bits of film or dirt inside the camera, and carefully remove them. One of the best ways to get rid of dust inside the body is to hold it open and blow it out with air. But hold the camera at such an angle (often upside down) that the

gentle blast of air against any dirt or debris will cause it to fall free of the camera. A large ear syringe (available in many drugstores) can be used.

If the mirror is dirty, be aware that it is easily scratched. But it is easy to clean. Wrap a lens-cleaning tissue around a thin stick or even the back of a pencil. Then apply just enough lens-cleaning liquid to the tissue to dampen the end of it. Use this to carefully pick off any dust that may be attached to the mirror. With care, you can clean mirrors and never scratch them. The same technique can be used to clean the viewfinder.

Remove the batteries from the camera and check the date when they were first installed. If it's more than a year, it's best to replace them with new ones. Even if the batteries are not very old, they should be cleaned anyway. Batteries tend to get a coating on them, which interferes with current flow and also can cause corrosion of the innards of your camera. They should be wiped clean with a soft tissue. If there appears to be any corrosion either on batteries or in the camera body cavity, use a

If extreme care is used when cleaning a mirror, by wrapping a lens tissue around a Q-tip or the eraser on a pencil, small particles of dust can be lifted from a mirror. A really dirty mirror should be cleaned by a qualified repairman.
▼

When cameras are used around salt water, a little demoisturizer, such as WD-40 or another brand, applied to a rag and then carefully wiped on all but the glass surfaces, will do wonders to protect the finish. Using a toothbrush very carefully, with a small amount of liquid on it, can help you get into difficult places, such as around the shutter speed dial.
▼

pencil eraser to rub off any coating. After wiping everything clean, use air to blow away any possible debris.

Use jeweler's screwdrivers and check all screws. It's surprising how these small screws on a camera can work loose, especially on the camera body near the lens and those on the rear of the lens. If the camera body is to be stored for more than a month, it's a good idea to remove the batteries. Batteries can leak and actually eat away parts of the receptacle holding them. If the camera is to be stored in a very humid area for any length of time, it's suggested that you place the camera in a strong plastic bag (the Ziploc type) along with some silica gel, which will keep the camera in excellent condition.

If the camera or lens barrels have been exposed to salt spray, use a rag that has been dampened with fresh water and wipe all outside parts of the camera that aren't glass. After the camera is dry, I suggest placing a little WD-40 or another similar demoisturizer on a rag and wiping down all metal parts. Never spray the demoisturizer on the camera. It will coat the glass surfaces and is extremely difficult to remove. I also spray a little demoisturizer on a toothbrush and *carefully* work it underneath the rewind crank and around the ISO adjustment knob. But do be careful not to flick the liquid on the glass parts of the camera. By wiping my camera bodies with a damp rag, allowing them to dry, and applying the demoisturizer as explained here, I have used camera bodies around salt water for years and had no problems.

One important thing to remember around salt water is *never* to set your camera down on anything that has been exposed to salt spray. This includes boats, logs on the beach—anything that salt spray may come in contact with. A friend of mine did, and he had to buy a new camera. If you must handle your camera around salt water, always make sure that you wipe your hands clean first.

A camera or lens that has received a freshwater dunking can often be saved by quick action. On three occasions I have had cameras go under and have put them back in good working order. If you can, quickly get it home, open the camera back, and remove the film and lens; then use a conventional hair dryer to throw heat against the body and lens. Keep the dryer at least a foot away to prevent overheating. On two of the three occasions no hair dryer was available, but by putting the open camera and lens in an oven *set at the lowest heat and with the door cracked open slightly,* I was able to dry out cameras and lenses. As soon as you can after such a dunking, take the camera to a repairman to have it relubricated. This is a way to save a valuable camera. However, if the camera is immersed in salt water, forget it. I have never seen a camera dunked in salt water that could be repaired for less than it would cost to buy a new one.

When cleaning lenses, a few precautions should always be taken. First, dust and grit should be blown (not wiped) from the glass surfaces. A combination blower/brush tool (available in many photo supply outlets) or an ear syringe are useful to dispel the dust or grit. Also, never use eyeglass cleaning fluid or tissues. Both of these have silicone in them. Silicone has a property of being nearly impossible to remove, once applied to a surface. *Always use tissues and cleaning material specifically made for camera lenses.*

Once the dust has been eliminated from the lens, lay out several lens cleaning tissues in two small piles, then place several drops of lens cleaning liquid on one of the packs of tissue and swirl it over the glass. As soon as you have removed the tissue, and while the liquid is still damp on the glass, quickly pick up the other bunch of tissue and wipe the glass clean. I find that if I wipe with the dampened tissue and

allow it to dry, it forms streaks on the lens. It is very important not to pour the cleaning liquid directly on the lens, but to use a tissue dampened with it. This same technique can be used to clean filters.

In very humid conditions, such as extended stays in the jungles, a growth or fungus may develop on your lenses. If this happens, it is usually very costly to have them repaired. Under such humid conditions, lenses should be kept in a dry container with some silica gel. Bill Barnes, who lives at and operates Casa Mar, a tarpon fishing camp in the jungles of Costa Rica, is an avid photographer. Bill has tried everything he could think of to keep fungus and mold from attacking his cameras and lenses. He had fair luck storing gear in a cabinet with two 75-watt lightbulbs, which generated heat and kept things fairly dry. But he has finally settled on a simple technique that he says has been the most successful method he's tested. Each day he opens his Pelican camera case and positions a fan so that it blows air across the equipment inside. He also routinely opens the case and exposes the equipment to the sun—although he keeps these sessions brief. He believes that a flow of air across the lenses, cameras, and other gear is the best way to keep his equipment free of fungus.

Many people protect their lenses with filters, but these have disadvantages. Filters, to some degree, often reduce the quality of the photo. And if you are around sea spray, the filter or the lens can become coated with dried salt deposits. If you are using filters, a UV is recommended rather than a skylight. A skylight has pink in it, and if used only as a lens protector, it will add a tint of pink to all your color photos, so that blue skies are never blue, as explained in the chapter on filters. The FasCap is a much better lens protector. About the same price as inexpensive filters, the FasCap (available in many photo outlets) is screwed on the front of your lens, just like a filter. It is a two-piece plastic unit with a spring-loaded snap cap. When needed, the cap is popped open, swinging to the side and out of the way. When you're finished shooting the picture, simply snap it closed, protecting the lens. The disadvantage of the FasCap is that it can't be used on lenses wider than 35 mm—thus 28-mm, 24-mm, and wider lenses can't use them—or vignetting occurs.

Carrying Your Equipment

If you own more than a single camera body and lens, you probably have invested in some type of bag or box to carry the gear, or are planning to do so. It's really necessary, both for protection of the equipment and so that you have it all with you when you need it. There are a host of different bags and boxes; the trick is to select the one that suits you. The following guidelines should help you to make the proper choice.

If you are really interested in outdoor photography, it is a mistake to buy a bag that will carry only what you presently own. We are always buying something extra, such as a meter, a flash, or another lens. So plan ahead and get a bag that will take additional gear.

There are bags in all sizes, and the best ones have padded bottoms and sides, as well as padded sections inside, to prevent damage to your delicate equipment. The best type of foam padding is closed-cell, which will not absorb water when wet. Also, look inside the bag. If the compartments inside are permanently sewn into it, you are restricted to their shape and size. The best bags have panels that can be shifted around to make different-sized cavities to accommodate your lenses and other gear. Make sure that the panels are padded.

Most bags are made from 1,000-denier Cordura nylon. What is not recommended is a bag that has a leather bottom, or is made entirely of leather. Leather absorbs moisture, which can cause the material to develop mold and which will create the same problem with your equipment. Soft canvaslike materials that are relatively waterproof are much better. A good flap that extends completely over the top is better than a zipper that closes down the middle. The flap will shed most of the rain that falls directly on the bag. I like zippers with large plastic teeth; they don't rust, and they open and close quickly and easily. But zippers should cover the entire area they are designed to protect. Some bags have zippers that stop short of doing that, allowing dust and grit to sneak into the bag. A one-half-inch wooden ball (available through handicraft stores) attached with stout cord to each zipper tab makes it easier to open and close the bags. I like small pockets on the outside of the bag, too. This allows you to store many of the

▲

Here, two garbage bags protect cameras on a tropical outing. Note that one is dark and the other light in color. In the tropics, white bags are much cooler when used as emergency storage to protect camera gear from salt spray or rain.

smaller items you use in taking photos—as well as film—where they can be reached easily. Just be sure that all such pockets have flaps that close to prevent rain or dust from getting into them. With larger bags I like to have a detachable shoulder strap as well as carrying handles. The strap should have a nonslip surface where it rests on the shoulder. A D-ring on each side, so that a strap can be snapped from one ring across the body to the other ring prevents the bag from swaying as you walk.

If there is a seam in a bag, there is a possibility that it will leak. So inside the bag I further waterproof the cameras and lenses by adding plastic containers like those used to store food in the freezer. To prevent shocking the equipment, I cut pads from household sponges to hold the camera bodies securely in position. The lenses are stored in round plastic containers cut to the correct size. One of the best containers for this purpose is the kind of plastic container that holds scouring powders and is available at most supermarkets. Take

Using plastic boxes and bottles, cut to size and fitted with foam inserts, you can feel safe if you happen to set your camera bag down where there is water. Only when the water comes in from the top would your cameras and gear get wet.

▼

your lenses to the store and buy round containers that match their diameters. In the base of each container add a piece of household sponge or, better, Ethafoam. By storing my lenses and camera bodies in these plastic containers inside the camera bag, I know that no water will get to them, unless it comes in the top of the bag. To prevent this, I always carry two or three folded-up garbage bags somewhere in the camera bag. If there is a hard rain or another situation in which the bag might get too wet, I slip it into one of these heavy-duty garbage bags.

While camera bags do a good job of protecting your camera equipment (and they improve constantly), nothing will give you the outdoor protection of a solid case. It is the choice of almost all professional outdoor writers and many other pros. The cases are made from a number of materials ranging from aluminum to tough ABS and Lexan plastic. The most popular on the market is the Pelican, which comes in several sizes. Unfortunately, the top cover is not as high as the base, and this limits a lot of equipment that could be stored in it. This case, if you maintain the O-ring gasket, is so waterproof that if you leave from somewhere high in the Rockies and end your trip at a much lower elevation, you have to open a vent on the box that is designed to allow air inside it. A vacuum is created inside, and it's impossible to open the case until it is vented—indicating how waterproof it can be. This case is available in black or gray. If you are going to be in the tropics a lot, or live where there are high temperatures and bright sun, I urge you to paint the case white. It will be considerably cooler inside. Epoxy paint is best, but even white exterior latex paint will serve well.

A case that is waterproof is also dust-proof, and equipment stored in a well-made hard case will remain clean and free of dust. Such cases prevent your camera

▲

This is an aluminum case made for the author that has been used for years and protects camera equipment very well. Hard cases are the best method of protecting your gear—if they are waterproof. The square in the center of the case is flat gray paint, tinted to reflect the same amount of light as a Kodak gray card, allowing the author to take quick exposure readings.

The interior of the author's hard case. Ethafoam, a closed-cell foam that does not soak up water, is used to hold gear in place.

▼

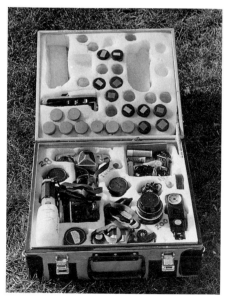

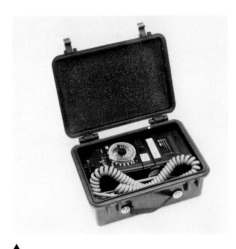

▲

A small Pelican plastic case is a wonderful, tough, and waterproof container that is ideal for carrying many small items of photographic gear.

from being banged around, and offer better protection than conventional soft bags. A word of caution, though. Some people get upholstery foam and cut it to size for the inside of the case. But some camera companies claim that such foam emits a gas that can attack the coatings on your lenses, so be advised that this is not a recommended material. Most camera cases come with an uncut foam block inside (you can also buy replacement foam), but this foam soaks up water like a sponge. That can be bad. Much better is Ethafoam. This is a closed-cell foam that doesn't absorb water and doesn't lose its shape, even after several years of hard use. It is made by the Dow Chemical Company. By contacting them you can get the address of a local dealer so that you can purchase it in the correct block size. (Then, with a sharp knife, trim it to fit your case.) If this foam gets water on it, hang it in the sun to dry for a few minutes and it can be put back in the case. The best way I know to cut round holes in the foam so that your lenses will fit is to remove the tops of various diameters of ordinary food cans. Then remove

the bottoms with tin snips (so you will have a sharp cutting edge). Select the correct diameter for the hole you want to make, and use the can just like a cookie cutter.

Two other specialized carrying cases are frequently used. One is the fanny pack, which is a small pack that sits just above the fanny and is held in place by a belt. Good photographic fanny packs are also padded. I prefer those that have at least some outside pockets, where film and other small items are handy. Fanny packs are carried on the hips, but can be swiveled around to the front of the body so that you can get at things. They can also be carried on one hip or carried like a shoulder bag.

The other specialized camera bag is one used when you need total waterproofing. This is required by white-water enthusiasts and others who carry camera gear in boats where there may be a chance for a dunking or at least water coming aboard. Most of them are made of soft, flexible, tough plastic and have an inflatable outside pouch that acts as a shock absorber. These bags are usually sealed by folding over the open end several times and securing it with a Velcro lock. There are two things I suggest you consider when purchasing such a bag. One is to get one large enough to accommodate all of the equipment you want to take with you. Some of these waterproof bags really can only carry a camera body, one or two lenses, and a few rolls of film—which may be enough for you. The other consideration is that the bag should float with all of the equipment you put into it. The better bags, when inflated, will float about ten pounds, which is about all you'll need. Also, a grommet or some other place to attach a cord is recommended, so you can secure the bag to a thwart on the canoe or boat; in case you upset, the equipment will stay with the boat.

Many people use a waterproof container

that is nearly indestructible, although the amount of equipment you can store inside it is limited. This is a .50-caliber ammo box, made by the army and available through some outdoor catalogs. These are heavy-gauge steel and have an O-ring gasket that, when firmly closed, will not leak. I suggest painting them all white to reduce heat—they are almost always army green. I prefer to line them with Ethafoam or another soft protective material that will hold the cameras and lenses. You can test them to see if they are waterproof by sprinkling some baby powder inside and then closing the box and submerging it in a sink or bathtub of water. Remove the box from the water and open it. If there is the slightest leak, the powder will give you an indication. I also suggest that you make a lanyard of stout nylon cord with a snap. The cord can be attached to the handle and then looped over a thwart and secured to the boat, so that an upset will keep the box with the craft.

Another device that is becoming popular with photographers is a photo vest. Resembling a fly-fishing jacket (which works pretty well, too) these vests have voluminous pockets that will carry fairly large zoom lenses and just about everything else you could want on a day-long field trip. I prefer two jackets. One is for hot weather, has a mosquito-netting-type weave, and is relatively cool. The other, which I use most of the time, is made of heavy canvas. Also, I think such jackets should have a minimum of a dozen pockets (padded to prevent severe bumps to your equipment). There should be some pockets on the outside that are small enough to hold a meter, several rolls of film, and other small but useful items. The back panel should have a pocket large enough to carry your rain gear—which I always want to take into the field. This pocket can also be used to carry reflectors and a space blanket.

Another very handy gadget that makes

▲

Two examples of tough waterproof cases that are designed for traveling in canoes, rubber rafts, or where water is a problem and you need total waterproofing. Good ones will float ten pounds when thrown into the water.

▲

This is a smaller waterproof soft container that will only hold one camera and a few items.

▲

An old reliable waterproof and nearly indestructible camera case is the familiar .50-caliber ammunition can, available from many sporting goods stores and army-navy surplus stores. It should be painted white to keep the contents cool. And in a boat, a short section of parachute cord (shown on the lid) should be used to secure the box to the boat—in case you upset.

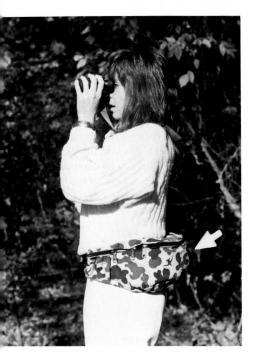

life easier in the field is a carrying strap that fits over the shoulders and holds a camera in place when walking, but allows you to use it quickly. There are at least a half-dozen such restraining devices on the market, and all that I have tested do a good job. If you do a lot of hiking or walking while carrying a camera (or field glasses), you may want to consider one of these.

Dust and Sand

Where there is a lot of dust, a camera may be in trouble. It's unbelievable how dust can seep into zippered camera bags. One of the worst things you can do is to place a camera bag in the back of a four-wheel-drive car or truck and go down a dirt road. Dust seems to seek out cameras, and it can really cause damage. Obviously, if you are on a beach and the sand is blowing, or in a desert under the same conditions, you are

asking for trouble if you don't protect your gear. Africa is a great photo trip, but everyone who goes there warns friends to watch out for dust.

Never set your camera down in the sand or dirt. If you know that dust or sand is being blown around, put the camera or gear into a plastic bag that can be sealed. The hard case is the best method of protecting gear under sand and dust situations. Only take out of your bag or case the equipment that you need for the picture-taking session, and make sure you brush it off before replacing it. Don't leave camera bags or cases open, either.

If you are taking pictures where there is blowing dust or sand, make sure that the various electronic contacts on the camera body, such as flash sockets, are covered with duct or gaffer's tape.

When cleaning lenses and camera bodies of dust or sand, be sure that you blow away as much as possible. Sandpaper is made by laying sand down on a tough paper product. Grit left on lenses or bodies will act just like sandpaper. Use an old toothbrush around the various controls on the camera, such as the ISO and speed-setting dials. Use only liquid and tissue to clean the lenses, after you are sure that all glass surfaces are free of dirt.

Water

Naturally, we should keep water away from our cameras. Use of waterproof cases or bags, as described earlier, is recommended. Be aware that if there is heavy surf along the beach, salt spray can get on your cameras and cause grief. The same situation exists at the base of a waterfall, and a camera can be soaked. Rain is a real problem. One simple method used by

many photographers who must work in the rain is to carry a small, clear plastic bag. The camera is slipped into the bag and a small opening cut so that the forward portion of the lens can be slipped through the opening. This will allow you to take pictures and keep the camera fairly dry. If you are going to work in a wet environment, you may want to purchase one of the several plastic bags that are specifically designed for the purpose.

Cold

Cold offers its own problems. One of the greatest is that batteries don't function as well in the cold. Most cameras today operate almost totally by batteries, so cold has to be considered. Much has been written about winterizing your camera for cold weather work. That is no longer necessary with modern lubricants under most chilly conditions.

The batteries that drive your camera meter are tiny cells that can lose a lot of their power when they are used much below thirty-two degrees Fahrenheit. This can give you an inaccurate light meter reading, or none. Some cameras will operate the light meter but not have enough battery power to fire the shutter. Many of these batteries are located in the base of the camera body, where it is most exposed to cold, so they lose power quickly. This is an added reason for using motor drives. When a motor drive is attached to most cameras, it (and the light meter) will be driven by the larger batteries, which are less affected by cold.

You can get around the battery problem in cold weather with some cameras by purchasing a special attachment that allows you to hook up your camera to a portable power pack that is carried inside the clothing. You can also carry spare batteries in your pocket, where your body will keep them warm, or tape a hand warmer of the sort that outdoorsmen use to the rear of your camera to help warm the batteries. It's a good idea to have two of these hand warmers in your outer coat pockets, to keep not only your batteries but your fingers warm.

There are other problems associated with the cold. The back of your camera can get cold enough that placing the face against it can mean skin sticking to the metal or plastic. This can be eliminated by putting duct or gaffer's tape on the back and all parts of the camera that will come in contact with human skin. Wearing gloves is also helpful. Many professionals wear a pair of silk gloves inside a pair of warm wool gloves or mittens. When the camera has to be handled, or when changing film (often a real problem outdoors) the outer gloves are removed.

When working with the camera in cold weather, be sure that you don't breathe on any part of it. This could cause a coating of ice to form on the lens or viewfinder—or worse, inside the camera when you are changing film.

Wear loose clothing with large pockets and, when possible, carry your cameras inside the outer clothing close to the body to keep it warm. If you have a choice when

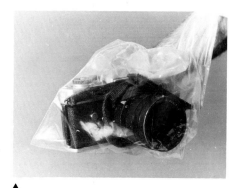

▲

To prevent condensation from forming on your camera when entering a warm house from the cold, slip the camera inside a plastic bag and then squeeze out all possible air before sealing it.

doing a lot of outdoor photography, try to use a mechanical camera or one with a minimum of battery-driven controls. The fewer parts that rely on battery power, the better your chances that the camera isn't going to fail.

When a camera is brought in from the cold, the moisture in the warm air condenses on it, causing water to form on both the inside and outside of the body and lens. Preventing this is simple. Just before bringing the camera inside, slip it into a Ziploc or other sealed plastic bag. Squeeze all the air from the bag and seal it. Then bring it in. The camera can warm without any moisture-laden air hitting it.

Care of Slides and Prints

While many of us are aware of how to care for equipment, some people allow slides and prints to suffer abuse. First, slides and prints are easily faded by exposure to strong sunlight for extended periods. Black-and-white prints, if properly processed, will last 100 years or more. But color is a different thing. With the exception of color prints made with the Ciba-chrome process (which is said to be very long-lasting), color prints will fade under bright sunlight, actually ultraviolet radiation. High temperatures can also be damaging.

To keep slides in good shape and to arrange them so you can find them easily, twenty-slide plastic sleeve holders are recommended. But the sleeve should be of the "archival" type. Those made with PVC (the most common type of holder available) emit a gas that is said to be harmful to slides over an extended period. The best holders are those that are super-thin and made for archival storage. These take up little room, and can be stored in normal file holders in a cabinet, or in boxes away from sunlight and high temperatures. Excessive moisture can cause a mold or fungus to grow on slides, so they must be kept away from high humidity. Slides stored in this manner can be kept in good condition for years.

Prints should be kept in albums, or at least in boxes away from sun and heat. Color prints maintained this way will last for many years.

SUMMARY

It is worthwhile to review some of the important points that help produce good outdoor pictures:

• Remember that cameras are like guns; they often shoot better than their owners do. Don't get so hung up on equipment that you are constantly buying new things to get better pictures. Although some cameras can do things that others can't, the most important element in obtaining good photos is the knowledge of how to use a camera.

• The single-lens reflex offers the photographer the best available camera to obtain many kinds of outdoor photos. The wide variety of lenses available for it, and the fact that you see exactly the picture that you are taking, make it the tool any serious outdoor photographer will want to use.

• If you are using an SLR and you have trouble focusing, check with your local camera store about a diopter that is suited to your vision requirements.

• Constantly check the batteries in your cameras, meters, flash, and other equipment; clean the battery contacts frequently; and don't store batteries in equipment for long periods of time.

• Read thoroughly the manuals that come with your equipment, especially those relating to the camera body and flash. Most owners don't fully understand all the features on their units and thereby miss some great photographic opportunities.

• For most outdoor photographers, the single most useful lens to own if you have an SLR is the 50-to-60-mm macro. This can be used for all normal-lens photographs, but allows you to come in very close and produce images one-half life size on the film.

• The best all-around wildlife lens, if there is one, is the 400 mm.

• Teleconverters usually mean a loss of light and some quality, unless they are specifically designed for a given lens. But

sunsets and sunrises are never razor-sharp, and a converter can double or triple the sun's image size, giving the photo greater impact.

• Carefully consider your lens needs before you buy. Most outdoor opportunities can be captured with no more than three or four lenses.

• Use care in selecting your film. Many people use only high-speed films. But if high-speed films were as good as slow speed types, there would be no slow-speed films. Remember that the slower the film, generally the sharper it is and the finer the quality.

• Next to a light meter, the most useful tool is a Kodak 18-percent gray card. Understanding and using it properly can mean you will rarely get bad exposures.

• The spot meter can help you get exact measurements on small subjects or on wildlife some distance from the camera.

• Remember when using slide film that to get correct exposures you should meter on something in the photograph that is light in color; and when using color-print film, you should meter on something important in the photo that is fairly dark.

• Learn to recognize that there are different kinds of light (side, back, front, and overcast), and that during the day light will also differ—then utilize it. Perhaps the major difference between those photographers who just take nice pictures and those (such as professionals) who take outstanding photos is how much the professionals use side, back, and overcast light—and how little they use front light. As a guide, always remember that when light will pass through something, it is usually more effective to shoot with backlight.

• Take advantage of weather, and grab some of those wonderful moody pictures. Also, rainbows and fall foliage can be enhanced by using a polarizing filter.

• You can record on color film a good sunrise, sunset, or silhouette only if you can look at the scene and not squint. If you have to squint, wait until the contrast intensity is reduced.

• Flash can give you enough light to take pictures where there is none. But it can also be used as a fill, or to deliberately create backlight or sidelight.

• Always remember that the exposure with a flash is determined by the distance from the *flash* to the subject, not from the *camera* to the subject.

• In almost every case, holding the flash off the camera results in a more pleasing picture.

• Before making the photo, consider the background. It should not intrude upon or distract from the subject. A light subject should be placed against a dark background, and a dark subject against a light background.

• Consider light as a very important element in any composition.

• If you want to emphasize anything in a photo—put it up front.

• Next to your cameras, lenses, meters, and a gray card, a tripod is the most important tool for getting great pictures. Get a good one and be willing to carry it with you.

• Remember to focus on the eye of a subject. If the eye is unsharp, people will regard the entire photo as out of focus.

• A wonderful way to get natural smiles when taking portraits of people is, just before tripping the shutter release, to ask them to talk to you. All sorts of expressions develop as they try to think of things to say.

• Overcast light is perhaps the best light for taking most portraits.

• Have everyone look at a point of interest in a group photo. If even one person is looking the other way, it ruins the composition of the photo.

• Having people staring directly into the lens usually results in a poor photograph.

• Longer lenses allow the photographer to

get farther away from people, so that more natural expressions result; facial features are more flattering with a longer lens, too.

• Close-up macro shots allow your viewers to see many commonplace things in an entirely different way; close-ups are often the most interesting pictures you take.

• Some of the most beautiful insect and flower pictures are taken very early in the morning, when dew covers the subject.

• Remember, if the subject is smaller than you, to enhance it, try to take the photo at a low angle.

• To obtain good wildlife photographs, study the habits and habitats of the creatures you want to take pictures of. Also, most often, good photos are taken not by stalking a creature but by having the wildlife come to you—especially if you are hidden in a good blind.

• Patience is the most important tool in obtaining good wildlife photos.

Common Mistakes

Simple mistakes can often ruin a potentially good photograph. We must constantly remind ourselves to take a little more care before we press that shutter release. With most point-and-shoot cameras, you see the subject through a viewfinder and take your photograph through the lens. To protect the lens, a cap is usually installed, and, of course, if the cap is in place when you take the picture, all you get is a black photo. Some of the world's greatest photographers tell tales of how they missed important shots because they forgot to remove the lens cap. Constantly remind yourself, if you use any camera other than a single-lens reflex, that the cover may be on the lens. One of the best features of an SLR is that you see what the lens sees, so that if a lens cover is in place, you are immediately aware of it.

Don't allow the finger or the camera strap to fall in front of the lens while taking a picture. Because they are so close to the lens, they can appear out of focus and you may not be aware of them.

Until the rules of composition are learned, it seems to be a natural inclination for most photographers to place the skyline or waterline in the middle of the photograph. Look at most people's pictures and you'll see an interesting foreground and subject, but the upper half of the photo is a bald sky. If the sky is dramatic, fine, but most of the time the waterline or skyline should be near the top of a photo. This is especially important if you show slides. When slides are projected on the screen, what the viewer sees is the light reflected back to the eyes. There are usually several exposure stops of difference between the sky and the subject and foreground. For example, if the subject and foreground are properly exposed at, say, f/5.6, it is likely that the sky will require f/22, or three full stops' difference. If you allow some of the sky to appear in this picture, the viewer will be looking at a properly exposed subject and foreground, *but at a sky that is three stops overexposed—or snow white.* The brilliant white of the sky *reflected* back to the viewer will cause the eyes to close down from the glare, and the viewer will see only a portion of the darker parts of the photo on the screen. Test this, and you may be amazed at the difference between putting only a hint of the sky in the background and having a lot of sky. Project a slide that has considerable bright sky, then block out the sky portion with a piece of dark cardboard while looking at the screen. The moment almost all of the sky is removed, the viewer begins seeing all sorts of detail in the darker areas.

The bright sky will not cause the same effect in a print, since this is not reflected light, but it certainly doesn't add anything to the photo.

Don't forget, however, that reflection shots constitute the one case in which the

▲

This photo illustrates two basic photographic mistakes: the camera was tilted so that the sky and waterline are running at an angle—as if in an earthquake—and the upper part of the photo is bald, white sky.

▲

The same scene is improved by moving a little closer to the subjects, leveling the camera, and getting rid of most of the sky.

above rule is violated, and that the best reflection pictures are those in which the skyline goes straight across the middle of the photo.

When we first begin taking photos, we tend to place the subject in the center of a picture. But most often it's best to have the subject slightly off center (in either a vertical or a horizontal shot), with the subject facing or moving into the picture. A tall flower, for example, would be best if it were on one side of the photo, facing into the picture, rather than in the middle, fac-

ing toward the edge. The same could be said for a child hiking a path in the woods. Have the child walk into the picture, rather than center it and make it appear to walk out of the picture.

Perhaps the most common fault in picture-taking—even among many people who have been taking photos for a long time—is to have too much in the picture. Only put in a photo what you want the viewer to see; this is the single most important rule in photography. We have all seen pictures of a loved one standing on a lawn, with a house and a car in the background, a rocking chair on the porch, and

Another basic mistake is shown here. Just too much is included in the picture, and the road in the foreground adds nothing aesthetic.

▼

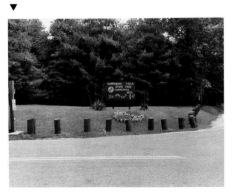

The photo is much improved when we move in and place in the photo only what the photographer wants to show.

▼

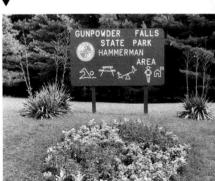

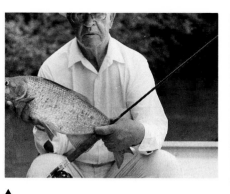

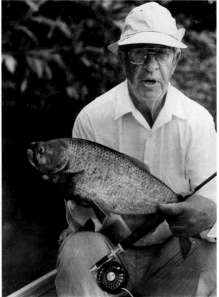

▲

There are two basic faults in this photo: the camera cut off the front of the fish, and because the shot is vertical, not horizontal, part of the person's head is chopped off as well.

▶

By placing the subject off to the side (fish facing into the picture) and making it a vertical shot, the photo is much improved.

maybe a dog scampering across the lawn. Yet what the photographer wanted to show was a nice picture of the person. In this case the subject was too small and there was too much else to look at.

One photo instructor I knew used to admonish his students that "it doesn't harm a camera to turn it on end to take a vertical photograph." What he was saying is that you should think about the picture and check it to see if it is better in vertical or horizontal format. Remember, we want to fill the frame with our picture, so vertical objects are almost always better displayed if we can make a vertical photo of them.

Frame a picture to add beauty to it. Before you press the shutter release, look around and see if shooting through an old wagon wheel, from under the cabin porch roof, or between the forks of a tree wouldn't add an attractive frame. It's surprising how much you can improve the quality of a photo by including a good frame in your shot.

Sometimes when we get a picture back,

nothing in it is sharp—everything is slightly fuzzy. If that's the case, it means that during the exposure the camera was not held steady—usually because the shot was made at a slow speed to accommodate the lack of good light. Of course, a tripod would take care of this, and many of us make it a practice to shoot as many pictures as possible with a tripod. But if you get a photo back from the processor and the subject is fuzzy and somewhere in the foreground or background there is a plane of sharpness, it indicates that you focused at the wrong place.

Another common fault that is easy to correct is to have a person stand with a tree or telephone pole immediately behind his or her head. When the photo is made, it appears that the pole or tree is growing out of the subject's head. A similar error is to shoot the picture with the subject holding something in front of the face. Fishing rods, hiking staffs, shotguns, and so on should always be held to the side.

When taking a photo with the sun di-

▲
Nothing in this photo is sharp. This means there was excessive camera movement (usually because a slow shutter speed was used).

▲
Here Beth Keyser is not sharp, but a close look shows that the sign in the background is. This means that the photographer focused at the wrong place.

An all-too-common mistake is demonstrated here, where a pole seems to be growing out of the subject's head.
▼

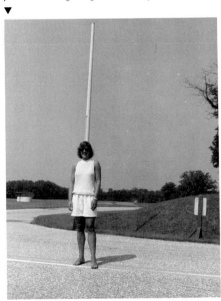

rectly behind you early or late in the day, be careful that you don't photograph your own shadow—it's easy to do.

After film has been exposed, keep it cool and take it to the processor as soon as possible. Sometimes vacationers will shoot almost an entire roll of film, then return home. Not wanting to waste the few remaining shots on the roll, they will wait months before finishing it off. But the best photos are those that are processed as soon after exposure as possible.

Showing Off Your Pictures

After the shooting sessions are over and you have your photos back, what is the best way to share them with others? First, remember that the garbage can is your number-one file; any photo that you have to apologize for should never be shown. Slides are not like wine—they don't improve with age—so throw away the under- and overexposed ones, the out-of-focus, poorly composed or just plain unattractive ones. A good way to store slides is in plastic sleeves, categorized by file folder.

If you are into color prints, display them in as large a size as you can afford in a good album. Small prints never have the impact of larger ones. And if you are showing a vacation or a sequence of something, such as a wedding or other event, try to arrange the prints in the album in the order that they occurred. For example, an album of your vacation should begin with the planning session pictures leading off, and end with the finishing of the vacation. What often adds to prints are clever little captions under the pictures. Art stores can supply you with pens that write in silver, gold, black, or white, and these captions can really set off your pictures. Color prints should always be stored away from direct sunlight, and if you have an enlarge-

A great asset in putting together a slide show is a sorter that will hold all of the slides needed for the show. A very simple one, which works extremely well and costs less than $20, can be made from a sheet of thin, milk-glass-tinted plastic sheeting, which is available from many large hardware outlets. Build a light frame around it to stiffen it and contain the slides. Then place it on two chairs as shown, with a floodlight beneath it.

▲

A very good way to store slides is in archival-type sheets that hold twenty slides. Archival sheets are thin, easy to store in hanging file holders, and don't harm the film. The author has mounted a small, inexpensive tabletop slide viewer at an upright angle on top of the file cabinet to quickly check slides.

▼

ment made and hung in a frame, it should be kept away from direct sunlight and never hung over a fireplace, where heat or smoke can affect the print. Cibachrome prints will last much longer than other types of color prints.

Color prints are fun to hand out to friends and for someone to look at your album, but many people feel that slides do a more impressive job. The reflected light of a slide on a good screen is many times more brilliant and richly colored than a print. The choice is yours, but if you plan to protect your slides, there are a number of things you can do to improve the presentation.

Be merciless and throw away any slides that are not top-drawer. Just make it a rule that you will not show a slide unless it's one you can be proud of. And remember, short slide shows—never longer than a half hour—are almost always better. What you want to do is leave your viewers saying, "Oh, I wish you had shown more," not with a sigh that says, "Oh no, not more slides." Also, make it a rule not to hold any one slide on the screen longer than fifteen seconds. Viewers will begin losing interest and start looking around the room. If you have to discuss a subject for longer than fifteen seconds, show two, three, or even four slides that are all about the subject, but are all different. Use a large viewer to lay out your slide show.

If you plan to show your slides to fairly large audiences in various towns, such as at a nature or wildflower show, it's advisable to get a projector that will accept Kodak Carousel trays (there are several brands besides Kodak that do this). Because the people at the show site can easily obtain a Kodak projector, you need only carry your slides with you—eliminating the need to haul a cumbersome projector. If you bring your own and it should fail, a backup can usually be quickly secured that will accept your slide trays. I prefer a pro-

jector that has automatic focus, but with a remote cord with the ability to manually focus. This way, if a slide does come up on the screen and is slightly out of focus, I can easily make it sharp. A pure autofocus projector without manual override means that you must leave the slide out of focus or go to the projector and manually adjust the focus knob. Always have a spare bulb handy, too.

Some projectors are much noisier than others when operating. I advise checking them beforehand. If you show your slides in a small room and have a noisy projector, you can often place the projector in another room and project the slides onto the screen through a doorway—thus getting the noise away from your viewers.

A white wall is an ideal screen (I have a four-by-four-foot panel of white paint on one of my office walls that works extremely well). A matte white screen is the preferred choice of most people who show slides professionally. A lenticular screen allows viewers off to the side to see brighter images than does a beaded

A simple device that will help you with minor leveling adjustments to the projector is made from a pair of plastic doorstops. Tie a string between them to keep them together.

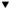

▲

A very simple fold-up projection table can be made from plywood and some wooden strips and dowels by most anyone handy with common tools. By studying the photo, you can figure out how to make one. The notches on the lower limb allow you to raise or lower the table to several heights, and it can be folded flat when not needed. Best of all, the table stays level through all elevations.

screen, which is generally regarded as the poorest type for good projection. Beaded screens work well if everyone can sit in line with the projector, but light fades off rapidly to the sides.

A zoom lens is also helpful, since it allows you to fill the screen with your image from a distance—and we always want to fill the screen.

When setting up your projector, try to get it as close to the middle of the screen as possible. If the projector lens is tilted at an angle to the screen, part of the picture will be out of focus, and if the projector is tilted a great deal, only a small portion of the photo will be in focus. One of the worst faults is to put the projector on a coffee table and tilt it up toward the screen; most of the picture will be fuzzy.

When you project the first slide to get everything in proper focus, don't use part of your slide show—it's like allowing

someone to read the first sentence in a story before they ever begin. Instead, have a focus slide. A focus slide can be anything that's attractive, with a subject that you can easily focus on, such as a bed of flowers. Make sure that it is a vertical slide, not a horizontal one. The problem when setting up for a show is how high you can get the slides on the screen, not how wide.

Before showing the first slide, try to arrange the chairs so that everyone is comfortable and has a clear view of the screen. The darker the room, the better. Stray light can spoil the rich tones of your slides.

Start your slide show with a title and end with one. Titles are very easy to make. Here are just a few examples: Use a stick to write the title of your vacation in the sand; lay common wildflowers, such as daisy blossoms, on dark green moss to form the needed letters; shotgun shells can also be used to spell words. A very nice way to make a title is to use a print made from one of your slides, and lay transfer letters

▲

Once you have arranged your slides in the proper sequence and have them in correct position, secure them with a rubber band and draw a line from one corner to the other (as shown). You will instantly know if any slides are out of position. The pen points to a pair of slides that are out of position; it's easy to see where they go. You can also color-code slide shows so that a green line indicates one show, red another, and black another. That way you can use slides from one show in another and always know their proper position at a glance.

▲

Simple but effective titles can be made by putting transfer letters on a print, as shown here.

someone who is vitally interested in wild-flowers to show others who are not as interested a series of flowers, simply identifying each flower and moving on. Instead, the presenter should give little tidbits of information about each flower. Perhaps this one only grows in certain areas and is pollinated only by a particular bird or insect, and another one may be used as medicine, and so on.

What really helps a slide presentation is humor; when building your shows, try to preplan and take some funny pictures. For many people, being able to share their outdoor photography with others is one of the major reasons why they so enjoy this rewarding activity.

(available in art supply stores) on the print. Then pin the photo to an outside wall where there is overcast light (sunlight will create glare spots on the picture) and take a slide of the picture with the transfer letters in place.

When showing slides, try to tell a little something interesting about each one. There is nothing more boring than for

▲

One very easy-to-make ending is shown here: some shotgun shells lying on burlap. Titles help dress up your slide show.

Glossary

Angle of view The portion of the scene or subject that is "seen" by the lens and is recorded on the film. A wide-angle lens "sees" more of the subject than does a normal or telephoto lens.

Aperture The adjustable "hole" in the lens that controls the amount of light passing through the lens and to the film. Nearly all SLR lenses have an adjustable aperture, and the size of the hole is indicated by the f-stop designations on the aperture ring of the lens barrel. The larger the aperture number, the smaller the hole. Thus, an aperture of f/22 would be much smaller than f/11.

Aperture priority camera A semiautomatic camera on which the photographer selects the aperture for making the picture and the camera automatically selects the corresponding exposure.

ASA A numerical scale developed by the American Standards Association, used for many years to indicate the speed or sensitivity of film. This scale has been adopted internationally and is now known as ISO.

Autofocus A type of camera that focuses automatically.

Autowind A device, either in the camera body or attached to it, that automatically winds the film after an exposure, readying the camera for another exposure.

Available light Simply put, the amount of natural light available to produce a film image.

Background That portion of a photograph that is behind the subject, and against which the subject is seen.

Backlight A source of light directed toward the camera and falling on the back of the subject.

Beanbag A small bag filled with beans, rice, or similar material, laid on a stationary object and used to provide a stable support for the camera.

Bellows A flexible extension that can be attached to the camera body, with the lens connected to the front of the bellows. The additional focal length provided by the bellows permits the taking of extreme close-ups.

Blind A natural or man-made structure that allows the photographer to be concealed from his subject.

B (or T) A setting indicated by one of these letters on a camera's speed ring. When the ring is set on T or B, the shutter will remain open as long as the shutter release is depressed.

Cable release A flexible cable with a plunger that screws into a camera's shutter release. Used when a camera must remain very still during a longer exposure.

Cassette A film container that is loaded directly into the camera. All 35-mm cameras use cassettes.

Centerpost The usually crank-operated column on a tripod that is used to elevate the camera.

Color print film A negative film from which color prints can be made.

Color slide film A film that produces a color slide. (See *slide,* below.)

Composition The esthetic arrangement of the visual components of a picture.

Contrast The range of light and dark tones in a picture. A photograph with heavy, dark

shadows and brightly lit areas is said to have high contrast; a picture containing subtle gradations of tone is described as having low contrast.

Cropping The removal of unwanted peripheral elements of a picture. Cropping can be accomplished by using frames or objects to hide or mask portions of a scene, or it can be done with the enlarger when printing a photograph.

Dedicated flash An electronic flash that is designed specifically for a given camera body or series of camera bodies. Through the hot shoe (see below), it is electronically linked to the camera and allows automatic exposure options.

Depth of field The range of distance in front of a lens over which objects viewed through the lens appear to be in sharp focus.

Diaphragm See *aperture,* above.

Diffused light Soft, even light with no strong source.

Diffuser Anything placed in front of a light source that causes the light to diffuse, thereby reducing shadows.

Diopter In camera terminology, a glass element mounted on the rear of the viewfinder, through which the photographer views the subject.

Double exposure Two exposures made on the same frame of film, whereby one image is superimposed on another.

DX coding A series of metallic impressions on a cassette, which can be "read" electronically by specially equipped cameras, and used to automatically set the camera for the correct ISO of the film being used.

Electronic flash A very brief burst of light, adjustable in its duration, created by sending an electronic charge through a transparent tube filled with gas.

Emulsion The chemical coating on film upon which the image is recorded.

Expiration date A date on a box of film that indicates the latest date when that film should be processed.

Exposure The amount of light allowed to strike a frame of film, controlled by adjusting aperture and shutter speed.

Exposure latitude The amount of over- or underexposure that a given film will tolerate and still produce an acceptable photo.

Exposure meter A device that measures the amount of light available for a photograph.

Extension ring A tube that fits on a camera body, to which a lens is attached at the other end, permitting closer focusing than the lens would normally allow.

Fast films Those films that require less light to make an acceptable image. Most fast films do not produce as sharp a picture as slow films.

Fast lens A lens with a very wide aperture, which allows for a higher shutter speed.

Fill light Light added to shadows, so that more of the photograph can be clearly seen. Fill light can be obtained with reflectors or with electronic flash.

Film speed A number (ASA or ISO) that indicates how sensitive the film is to light. The lower the number, the more light is needed for an exposure.

Filter A colored or optically treated disc of glass or plastic added to the front of the lens, which alters the light passing through it to the film.

Flare Extraneous light reflected or refracted within the lens or camera, which may degrade a photographic image.

Flash synchronization A mechanism that adjusts the duration of a flash to coincide with shutter speed.

Flat lighting Lighting that produces very low contrast.

F-stops Sequential numbers on the lens barrel that indicate lens aperture size. The lower the f-stop, the larger the aperture.

Focal length The distance between the front of the lens and the focal plane of the camera when focused at infinity.

Focal plane A plane that crosses the focal point of a lens. Within a camera, the focal plane is where a frame of film is positioned to be exposed.

Focus The point at which a camera lens, once adjusted, produces the maximum sharpness of the desired portion of an image.

Focusing screen A plastic or ground glass element inside the SLR viewfinder that allows

the photographer to view and focus the image.

Foreground That portion of a photograph that lies between the camera and the subject.

Frontlight Light directed at the front of the subject and coming from behind the photographer, or produced by lights mounted on or immediately adjacent to the camera.

Highlights The brightest part of a scene being photographed.

Hot shoe A device affixed usually to the top of a camera and containing electrical contact points that allow an electronic flash to be mounted directly on the camera without the aid of a cord.

Incident meter A light meter that measures the amount of light falling on the subject. (See *reflected meter,* below.)

ISO International Standards Organization; its initials are used internationally as a prefix to a numerical scale indicating film speed. According to this scale, the higher the ISO number, the greater the light sensitivity of the film, e.g., a film of ISO 400 is a "faster" film than one of ISO 64.

Macro lens A lens that permits closer than normal focusing and is designed for such work.

Main light When more than one light is used to illuminate a subject, the main light is the one that provides the greatest illumination.

Manual focus The standard method of focusing a camera. (See *autofocus,* above.)

Miniature tripod A small, portable tripod, sometimes called a "tabletop tripod."

Mirror lens A lens containing mirrors that reflect light back and forth inside the lens, thereby increasing focal length without increasing the physical length of the lens.

Mode Any of the various operational possibilities in a camera. Modes can be *automatic, manual,* or *aperture priority* or *shutter priority.*

Monopod A camera- steadying device with one extendable leg.

Motor drive Similar to an auto-winder, this device advances the film automatically after exposure. Most motor drives can be operated one shot at a time or in a high-speed sequence.

Negative The image created on film after exposure, which is then used to make the final picture.

Neutral-density filter A filter used solely to reduce the amount of light striking the film, when there is too much light for the subject. It does not affect color.

Nickel-cadmium battery A type of rechargeable battery used in photography.

Normal lens Considered to be a 50-mm lens on a 35-mm SLR, this type of lens "sees" the subject in about the same way as the human eye.

Overcast light Very even illumination usually produced by daylight diffused by clouds or cloud cover.

Overexposure A condition in which more light strikes the film than is correct for a proper exposure.

Overhead light Light coming from directly above the subject, such as the sun at midday.

PC cord An electrical wire that runs from the camera to the electronic flash.

Point-and-shoot camera A camera that focuses automatically on the subject and makes an automatic exposure.

Point of interest The main or most interesting feature in a picture.

Polarizing filter A type of photographic filter used to reduce glare and enrich colors.

Prime lens A lens with a fixed focal length, as opposed to a zoom or mirror lens.

Red-eye A reddish eye in a color photograph, caused by the flash being mounted directly on the camera, resulting in the blood vessels of the subject's cornea reflecting red light back to the camera lens. Moving the flash away from camera eliminates red-eye.

Reflected meter A light meter that measures the amount of light reflected from the subject. (See *incident meter,* above.)

Reflection picture A picture in which the subject is reflected in water or some other reflective surface.

Reflector A device used to reflect or

"bounce" light onto the subject.

Remote sensor cord An electrical connection between the flash and the camera that can automatically control the amount of light produced by the flash.

Ring flash A special type of electronic flash that encircles the lens, producing shadowless light, and is often used in close-up photography.

Self-timer A device on many SLRs that creates a timed delay between the pressing of the shutter release and the tripping of the shutter.

Sharpness The degree of clear focus in a photograph or part of a photograph.

Shutter speed dial A device on a camera that controls the length of time during which the shutter is open; measured in fractions of a second.

Sidelight A source of light directed toward one side of a subject.

Single-lens reflex (SLR) A camera that allows the photographer to view a subject directly through the camera lens.

Skylight filter A filter with a slight tint of pink, used to eliminate the slight bluish cast in a color photograph that often occurs on overcast days.

Slide A color photograph (also called a *transparency*) through which a beam of light may be projected to produce an enlarged image on a reflective screen or other surface.

Spot meter A light meter that measures reflected light over a very small portion of a subject.

Stop See *aperture,* above.

Telephoto lens A lens used to enlarge far-away subjects, but which flattens perspective and is characterized by apparent short depth of field.

Translucent Used to describe an object or substance that permits the passage of light, but through which objects or light sources cannot be seen clearly.

Transparency See *slide,* above.

Tripod A camera-steadying device with three legs.

TTL Through-the-lens; used to describe a type of light meter inside a camera body, which measures the amount of light coming through the camera lens.

Twilight Light available for a photograph before sunrise or after sunset.

Underexposure A condition in which less light strikes the film than is correct for a proper exposure.

Underwater camera A camera designed specifically for underwater use; some may also be used above the surface.

Viewfinder The part of a camera through which the photographer views the subject.

Wide-angle lens A lens with a short focal length, used to widen the area of a subject being photographed, characterized by increased depth of field and distortion of objects close to the lens.

X-socket A coupling in the camera body that allows installation of a cable from the electronic flash to the camera.

Zoom lens A lens that is adjustable through a range of focal lengths.

Index

A-clamps, 82
action photographs, 12, 116
advertising, 62
afterglow, 52
air-corrected lenses, 14
albums, photograph, 183
ammo boxes, 173
aperture, 3, 11, 37
 for close-ups, 137
 composition and, 66, 67
 depth of field and, 97
 for extension tubes, 133
 fixed, 27
 shutter speed and, 38
"archival" sleeves, 176, 183
autofocus, 12–13, 28, 116
autofocus lenses, 28
automatic exposure mode, 11–12, 13, 57–58, 116
automatic loading, 9, 13
automobiles, 82, 83, 119–21, 150, 152, 153
auto-winders, 12, 13

background:
 composition and, 62, 69–70
 in flower photography, 159, 160, 161
 panels for, 159, 160, 161
 in people photographs, 96–97, 104
 uses of, 24–25, 47, 111, 148, 159, 160, 161, 178
backlight, 44, 45–48, 49, 58–59, 109, 110, 111, 115, 122, 178
backpacks, 13, 79, 146
"bald sky," 65–66, 68
ball-and-socket heads, 75, 76–77
ball heads, 75, 76, 82, 84
Barnes, Bill, 168
barrels, rotating, 143
Bartlett's bowl, 60
batteries, 6, 7–8, 13–14, 39
 in cold weather, 150, 176
 conservation of, 55, 177
 contacts for, 8
 corrosion of, 167–68
 for flashes, 55–56
 for light meters, 7
 manganese-alkaline, 56
 nickel-cadmium, 55–56
 rechargeable, 56
 "throwaway," 56
beanbags, 80, 84–85, 121, 143, 153
bears, 146

ABOUT THE AUTHOR

Born in Frederick, Maryland, BERNARD "LEFTY" KREH is an author, columnist, and professional photographer. He is the author of *Fly Fishing in Salt Water* and *Fly Casting with Lefty Kreh* and co-author (with Mark Sosin) of *Fishing the Flats* and *Practical Fishing Knots.* Outdoor columnist for *The Baltimore Sun* and techniques columnist for *Fishing World* magazine, he is also editor-at-large for *Fly Fisherman Magazine, California Anglers,* and *Fly Fisher.* Mr. Kreh's photographs have illustrated his several hundred magazine articles, published over a period of some thirty years. In addition, he has illustrated all of his own books and provided photographs for numerous magazine and book covers. Photo consultant to L. L. Bean®, Inc., of Freeport, Maine, for whom he starred in the videotape version of *The L. L. Bean® Guide to Outdoor Photography,* Lefty Kreh has taught outdoor and nature photography at the National Wildlife Federation's Conservation Summits, and at both national and regional meetings of outdoor writers' organizations. He has also taught advanced flower photography and basic nature and outdoor photography for the North Carolina Forestry Commission.

When he isn't busy traveling, fishing, or taking pictures, Mr. Kreh can be found at home in Cockeysville, Maryland, with his wife, Evelyn, writing articles or books or developing and cataloguing his photographs.